Rejoice in the Light

A Woman's Journey out of the Mystery of Epilepsy

Amy E. Crane, M. Ed.

AGAPE PUBLISHING

Cover: Bruce & Sherrill Schaefer
Design and layout: Matt Donovan
Editor: Debbie L. Parker
Printed by: Eerdman's Printing—Grand Rapids, Michigan

Copyright © 2000 by Agape Publishing
All rights reserved.
Printed in the United States of America
First Edition
ISBN: 0-9669786-0-9
Library of Congress Catalog Card Number: 99-95323

No part of this publication may be photocopied, transmitted, transcribed, stored in a retrieval system, or translated into any language in any form by any means, without the written permission from the author, except for the use of brief quotations for a book review.

Agape Publishing
P.O. Box 4203
Greenville, SC 29608

Dedication

This book is dedicated to my parents for their unceasing moral support through times of trial and through the writing of this book; To Dr. Comair for his fine medical skill that led me to a new life; To Pastor Phil for providing spiritual guidance through my darkest days; And to my nephew Nicholas who was born during the writing of my book and later developed epilepsy.

Editor's Note

It's never easy to reveal some of our innermost fears, struggles, and emotional battles. Yet, Amy courageously ventured forth to do so. Having a unique and remarkable personal medical story to share, she presents it with keen insightfulness, a clever wit, and thorough research. During the editing stages of her chapters, she and I often punned about the "brainwork" involved in producing a book—and there's much truth to this statement! Amy rose to the challenge.

From beginning to end, her book reflects her fervent desire to look toward the light in the midst of every difficulty. In contrast to many individuals, Amy did not lose her desire to pursue her goals, ranging from athletics to academics, and ultimately, to help others. Even during some of her most difficult trials—from grand mal seizures to loneliness and extensive medical testing—Amy's smile and hope remained. While working with her on this manuscript, I saw and appreciated firsthand the fact that she continues to share that smile and hope with family, friends, her students, and all those that she meets.

As you read this autobiographical account, I am certain that you will be encouraged to look toward the Light of the World through even your darkest moments and know that you can always be assured of His abiding presence.

Debbie L. Parker, Ed.D.

Disclaimer

While providing a personal, factual account and researched information, the author of this book does not present the contents herein as part of a medical treatise. In addition, the author does not propose that the contents should supersede the medical counsel of one's family physician or other professional medical personnel.

Contents

1. Before Memories .. 1
2. Early Childhood .. 7
3. Darkness .. 13
4. Battles ... 31
5. Informed .. 43
6. Milestone ... 53
7. Adversity ... 65
8. Hope ... 79
9. Quake ... 85
10. A New Season ... 97
11. Opportunities .. 103
12. Determination ... 117
13. Burdens ... 125
14. Resolution .. 135
15. Uncontrollable Force ... 139
16. Preoperational Testing—Phase 1 147
17. Preoperational Testing—Phase 2 159
18. The Answer ... 177
19. Storms ... 189
20. Preparation ... 203
21. Approaching the Day ... 215
22. Binding Love ... 225
23. Final Tasks ... 231
24. The Transformation ... 241
25. The Great Awakening ... 251
26. A New Light .. 259
27. Aftermath ... 267
28. Victory .. 275

Appendices

Appendix 1—Personal Notes and Summaries 293
Appendix 2—Surgery and Treatment Centers 313
Glossary ... 327
References .. 329

Preface

With grateful heart, I wrote this book for every person who is searching for answers to the complexities of epilepsy. After having experienced seizures in my childhood and young adult life, I will tell you about my journey through sorrow and how I gained victory over epilepsy. Learn of my story of hope and how I coped with adversity during the darkest moments of my life.

Grateful acknowledgment is expressed to the Epilepsy Foundation of America for information on epilepsy brain surgery and treatment centers that is included in the Appendices. In addition, I want to express much appreciation to my editor, Dr. Debbie Parker, for the many worthy points of advice that she gave me throughout the writing and editing of my book. During several meetings, while advising me on the most appropriate approaches for presenting various aspects of my story, Debbie also provided me with her expertise in the area of editing. Her suggestions and editing marks made it possible for me to prepare my book for the designing and publishing stages. I much appreciate the encouragement and professional services that she provided for me as I wrote my personal story.

> *Behind every face there is a story.*
> *Within every story told, there are lives transformed.*
>
> — *Amy Crane*

CHAPTER 1
Before Memories

A‌fter arriving home from teaching one day, I picked up a piece of notebook paper and a pen and began to write these words: "Darkness can sometimes diminish the light and occupy the human mind, but the light can ultimately shatter the darkness and transform a person's brokenness into zeal for life." This truth I learned through firsthand experience.

My thoughts drifted back to twenty-seven years earlier to an ordinary autumn day in late September of 1971. Mom was at home fulfilling the traditional responsibilities of a mother. Like many mothers, she had diapers to change, mouths to feed, and a house to clean. In the afternoon, she finished rinsing the last dish and went to check on her eleven-month-old baby girl who was taking a nap. As she leaned over the crib, she noticed something unusual about her baby. The baby was breathing shallow, her face was pale, and she had aspirated some of her vomit. *My baby is dying,* Mom thought to herself. In shock, she ran to the phone to call the neighbor lady. The line was busy. With her baby girl in her arms, she ran four houses down to this neighbor's house. She explained that her baby had a fever, was lethargic, and needed to be rushed to the hospital. Providing needed transportation, the neighbor lady rushed mother and her baby to the emergency room.

In the emergency room, a nurse took the baby's temperature, only to learn that the baby had a fever of 105.5°. To make matters worse, Mother was informed that there was no doctor on duty and that she would have to take her baby to a doctor's office. With a furious voice, Mom told the nurse that she was not leaving until her baby received some baby aspirin and a cold cloth for her forehead. These items, of course, Mom had

to *ask* for. The nurse apologized and said that she was not authorized to do anything for the baby but was merely following the doctor's orders. After listening to such insistence, Mother rushed to the waiting room to inform her friend that they needed to go to a local doctor's office.

Upon arriving at the doctor's office, Mother was told to have a seat. Mom explained to the nurse that she had come from the emergency room and that her baby had a temperature of 105.5°. The nurse responded by saying that the wait would not be long. About ten minutes later, Mom and her baby were called back to the examination room where the nurse took the baby's temperature. The thermometer read almost 106°. Again, Mom said that her baby needed to be sponged with a cold cloth or given some baby aspirin to help bring down the fever. The nurse responded by saying she would still have to wait for the doctor. Another fifteen minutes passed before the doctor came into the examination room. By this time, the baby was lying on the exam table, and her eyes began to shift back and forth. The doctor's only response was, "This isn't good!"

The doctor immediately asked the nurse to get some cold towels. Before the nurse left the room, the eleven-month-old baby girl went into a convulsion. Minutes passed, and still the baby remained convulsing. The doctor said that he had nothing there to get her out of the convulsion. He handed the baby back to Mom and told her to go back to the emergency room at the hospital and have the baby admitted.

Back at the hospital, several nurses worked on the baby for a half-hour. The nurses hooked the baby up to intravenous equipment as the convulsion continued. The convulsion lasted for an hour and twenty minutes. Soon a doctor arrived and gently told the mother to prepare herself. He explained that anyone who convulses as long as her baby had would be brain damaged. Mother was devastated. Her beautiful, smiley, happy, baby girl was now brain damaged. *This can't be happening!* she thought to herself. *My adorable baby girl.*

The baby slept for several hours after the convulsion ended. When the baby rolled over, Mom noticed that she was not moving the right side of her body. *What does the future hold for her?* Before the baby was discharged from the hospital, the doc-

tor again informed Mom that there is bound to be brain damage. He told her to watch for anything unusual in her baby.

A week later on the baby's first birthday, something unusual caught the family's attention. As the one-year-old little girl sat in her highchair eating chocolate cake, she turned red in the face and began making gurgling noises in her throat. At first, both Dad and Mom thought she was choking, but she wasn't. No one knew exactly what had happened. About a month later, the same type of episode occurred. The baby's face got red, and then there was an unusual motion in her throat. Dad and Mom wondered if she was having some type of spell. At an appointment with the pediatrician, the doctor prescribed Phenobarbital, which the child took for many years. For my parents, only heartache, struggles, and sorrow seemed to lie in the future. The words of encouragement from the pediatrician remained in my parents' minds. At each appointment thereafter, the pediatrician repeated the same words, "She'll grow out of it." Even so, darkness remained in my life year after year.

1972

The treatment of my seizure disorder started long before I can remember. I was an eighteen-month-old infant when Mom was advised by my pediatrician to take me to a hospital out of town for an electroencephalograph (EEG). An EEG records brain waves and reveals abnormalities in the brain. The EEG was the first of several medical tests that I had throughout my lifetime.

On a spring day, Mom and I sat in the waiting room for my name to be called. A nurse eventually called us back to the examination room where the testing would occur. Soon a robust nurse with a German accent came in the room to begin the testing process. Mom did not know what to expect as she held me in her arms and waited for instructions from the nurse.

"Okay," said the nurse. "You can put Amy on this cart, and we'll begin the testing," she said in a firm voice. Mom looked at the cart and noticed that it was in rough condition.

"I'm not putting my daughter on that cart! The side rails are too far apart, and she'll slip right through!" Mom spoke in a very disturbed fashion.

"Oh, she'll be all right. We'll strap her down so she won't fall out." The nature of the nurse's response sounded like she strapped down kids all the time with no regard for the mental and physical health of the child. Then the nurse assured my mom that I would be safe. Mom was outraged. The nurse spoke the right words and was able to calm down my mom. With hesitation, Mom placed me on the cart. The nurse strapped me down, held me down with her arms, and said in a mean voice, "Now you go to sleep!" But being frightened, I screamed at the top of my lungs.

"What are you doing?" Mom said in a louder voice. "She is an eighteen-month-old baby. I'm going to take her! I will hold her and put her to sleep. . . .This is no place for children. I can't believe this!" Mom sat in an easy chair as she rocked me to sleep in her arms. She wiped my tears, and I fell asleep in her arms in a matter of minutes. I, however, was the only one in the room who was at peace.

Within a few minutes after the nurse left the room, two journalists arrived. "Hello, Mrs. Crane," one of the journalists said. "We are here at the hospital today writing an article for a magazine. Can we take a picture of you and your daughter for the article?"

"Absolutely not! That's not what I'm here for. I'm ready to leave," Mom replied in an angry voice.

"All right; well, thank you," a journalist replied. All of the journalists immediately left the room.

Shortly after this incident, the German nurse returned to the room to begin the EEG. As I continued sleeping in my mom's arms, the nurse began attaching electrodes onto my head. I remained in my mother's arms throughout the testing procedure.

I awoke once the EEG was completed and still remembered the nurse being rough with me. Having been strapped down on the cart had terrified me. Also, when the nurse attached the electrodes to my scalp, it felt as if she were pressing pins into me. Later as Mom and I left the hospital, I cried all the way home,

expressing my thoughts on this awful experience. As a typical toddler, I didn't hold back my feelings whatsoever.

At our next visit to the pediatrician's office, Mom explained to the doctor about our horrible experience at the hospital. "I don't ever want to take my daughter there again. The nurse treated my daughter terribly. You can send us somewhere else next time. Amy cried all the way home," Mom stated.

The doctor sighed and said, "I'm sorry, Mrs. Crane. I have sent patients there before, and they haven't had any problems. Maybe it was just that one nurse."

"Maybe so, but I'm not going back. It was one of the worst experiences I've ever had at a hospital. The nurse was rough on Amy and had no concern for the physical and emotional well-being of Amy," Mom expressed.

The doctor apologized for the unpleasant experience and continued discussing my condition with Mom. At that time, I was on Phenobarbital, which was one of the most commonly prescribed anticonvulsants for infants and children. Although I was too young to begin to understand my seizures or what was happening to me when I had them, my mom witnessed my seizures and experienced personal grief as a result of my condition. Not knowing what the future held for me was possibly the heaviest burden for my parents. As with virtually all parents who have an infant with a medical problem, my parents had no way of knowing to what extent my learning abilities would be affected by my condition. Only time and experiences would reveal the impact my seizures would have on my life.

Chapter 2

Early Childhood

On a cool spring day in 1973, I took a walk around my house carrying a rugged red bucket in one hand and wearing a grin that revealed my happiness. I had entered the land of critters—where various amphibians and reptiles unknowingly waited to be captured by the hands of a two and a half year old. I enjoyed finding and picking up virtually any little critter. Toads, however, were my favorite companions at that time. I enjoyed building them a home out of grass clippings, twigs, and rich black soil.

As I walked around the house, I peeked in each window-well with expectations of finding the biggest toad in the world. With enthusiasm, I leaned my little body over a window-well and placed my hand on the brick wall of the house. The sight of rocks and weeds were common and so was the lifelessness among those rocks and weeds. With an undaunted spirit, I meandered along to the next window-well in hopes of finding my first brown amphibian of the day. I eventually found a toad, and without hesitation, I stretched one of my legs down into the window-well. With gentleness, I dug out the toad from the hole in which he had buried himself. I talked to the toad as I took him from the hole he had made.

"Come on, you. I'm going to make you a home. . . . Now don't you wet on me," I would say in a firm voice to the harmless critter.

The moment of finding a toad was one of excitement. I placed the disturbed critter in my red plastic bucket and went on my way to find the next victim. I continued my journey as I expressed my joy by swinging the bucket in the air. When I completed the adventure, I stood outside the kitchen window

and talked to Mom through the screen. With enthusiasm I said, "Mommy, I found three toads!"

"There aren't any snakes in that bucket, are there?" she inquired.

"No, Mom. Just toads. They're my friends." Mom never liked snakes, and she knew I was gutsy enough to pick one up if I happened to come across one while I was looking for toads. She always refused to look in the bucket when she knew I had a slithery friend. Mom looked through the screen at the bucket to acknowledge my accomplishment.

"They're cute, Amy. Now what are you going to do with them?" she asked.

"I'm going to make them a home. I'll make them a home so they will be happy," I replied with a smile.

Hunting for toads and snakes became a favorite pastime every spring and summer. I was very intrigued with the fat bellies on the big toads, and later I developed my own system of distinguishing the boy toads from the girl toads. In my childish estimation, the boys were the ones with many spots on their bellies, and the girls had few spots or no spots at all. The innocence of childhood and my imagination played a part in my enjoyment of finding different creatures. Their lives would never be the same, and this unique hobby of mine was only the beginning of many memorable experiences that are still with me today.

September 1973

The summer passed, and the leaves were turning hues of red, yellow, brown, and orange throughout Battle Creek, Michigan. Angie, the oldest of three children, was entering the fourth grade. Steve, my closest sibling and the one who treated me like a little brother, was entering the first grade. Dad was at work, and Mom and I were at home.

I wasn't in grade-school yet, but I had the pleasure of being at home with our loving mother who did a lot of things with me that I enjoyed doing. Sometimes this meant Mom had to read the story, *Little Mommy,* four, five, six, or seven times in a row.

If it weren't for reading storybooks, playing games, and putting puzzles together, Mom could have accomplished much more housework. But I never passed up an opportunity for Mom to do something with me. Late one morning, I went into the kitchen where Mom was working.

"Mommy, will you help me with this puzzle?" I asked in expectation of her cooperation.

"Sure, Amy. Let me finish this last sink full of dishes, and then I'll be over to help you."

"Okay. I'll wait for you," I replied.

I pulled myself up onto one of the old kitchen chairs and waited with contentment for Mom to finish the dishes. Joy filled my heart as I anticipated spending the afternoon with Mom. As I sat at the table with my heart full of excitement, a rush of heat surged through my body, and my hands became ridged. All of my actions became involuntary. I slowly phased into a state of darkness and withdrew from the familiar world around me. Although Mom was only a few feet away from me, I was unaware of her presence. My sight was distorted as my mental alertness diminished.

"Amy. . . . ," Mom called out as I faded into total mental isolation. I awoke to my mom's presence and the puzzle box on the floor.

"Amy, are you all right?" Mom's voice had a tone of anxiousness as she gave me a hug and told me that she loved me. "Here, sit down and rest for a few minutes," she said in a gentle tone. "We don't have to work the puzzle if you want to sleep for a while. Do you want to go lie down?" With my thumb in my mouth, I nodded my head and went into Mom and Dad's bedroom to lie down. As much as I wanted to spend time with Mom, I had no energy to do anything. Mom followed me into the bedroom and sat on the side of the bed as I got underneath the covers. She kissed me again and left the room, closing the bedroom door behind her. I was asleep in less than a minute.

About two hours had passed, and I then awoke from my nap. After I felt revived, I got down from the bed to see what Mom was doing. I walked out to the kitchen where Mom had been before I took a nap. When I saw that she was not there, I wandered into the living room.

"Mom?" I cried out. "Mom?" Still there was no answer.

I went into the dining room. "Mom? Where are you?" I started to hear a faint voice in the distance.

"I'm in the basement, Amy. I'm doing laundry," Mom called out. I went to the top of the stairs and walked halfway down the steps to let her know I was awake. "How are you feeling?" Mom asked. "Do you feel well rested?"

"Uh huh," I replied. I was still a little drowsy.

"I'll be upstairs in a few minutes. Are you feeling up to working the puzzle?" she asked.

I wasn't too sure I was awake enough, but I wanted to spend time with Mom. "Yeah, let's work a puzzle," I replied.

"Okay, Honey. I'll be right up."

With my thumb in my mouth, I worked my way up the big stairs and sat down in the kitchen chair where I last sat before the episode. Since Mom knew that I had missed lunch, she offered me something to eat after she came upstairs.

"Amy, I bet you're hungry. You didn't eat lunch. What would you like?" I shrugged my shoulders as though I was saying, "just feed me something."

Mom knew my favorites. She fixed me a grilled cheese sandwich and raspberry Kool-aid. To me, that combination was one of the best. I enjoyed dipping my grilled cheese in my Kool-aid and then eating it. Angie and Stevie, my sister and brother, both thought it was gross, but I thought it was superb. Dipping my sandwich in Kool-aid may have started out as a way of getting attention from Angie and Stevie, but this combination sure did create a tasty lunch!

After eating lunch, Mom and I put together a puzzle, and then we played one game after another during most of the afternoon. Mom's sandwiches and our playing games together became a part of almost every weekday before I started school.

September, 1974

Mom enrolled me in preschool when I was almost four years old. I went to preschool two times a week. On the days that I didn't go to class, I pestered Mom about why I couldn't go.

One rainy day, Mom stopped by the preschool office to pay her bill. I patiently sat in the station wagon for Mom to return. On one such day, with little warning, and for a split second, my body felt like it were on a roller coaster. As I felt as if I were going over the top of a roller coaster loop, all awareness of my surroundings vanished. Only intense sensations and an increased body temperature were present in my mind. Seconds or minutes passed, and then I awoke to my saliva on the vinyl seats of the station wagon. Those occurrences, those things that Mom called spells, were very common and caused a certain amount of anxiety in my mind before they took full course. In an exhausted state, I climbed over the seat and lay down in the back of the station wagon. The next sound I heard was Mom's voice.

"Amy, did you have a spell?" I heard in the distance. "Amy, are you all right?"

"Uh huh," I replied in a tired voice.

"I'll let you sleep. I have a few more errands to run, and then we can go home." She rubbed my head and gave me a kiss. Even though I was tired and only a preschooler, I knew Mom was concerned for me. I knew I didn't need to explain what happened. She knew what it meant when I suddenly became tired.

In spite of the fact that my spells made me tired afterwards, I still had the enthusiasm of a young girl during the hours when I was not afflicted by those unexpected spells. As I played with dolls, crashed Matchbox cars with Stevie, and rode my tricycle, I did not think of myself as being different from my siblings. Though it was unknown to me at that time, I was the only child in my immediate family with any medical problem that required ongoing care. Still naive about my condition, I believed that those spontaneous fearful moments of slowly losing awareness of the surroundings were only natural occurrences in life.

CHAPTER 3

Darkness

1976

The day came that I was to get on the school bus for the first time. I was off to kindergarten to learn how to read, add and subtract, and pound a nail with a hammer. While wearing ponytails and a blue dress, I was about to begin my formal education. Along with the beginning of my schooling came the start of various struggles and attitudes. Mom had been advised by the pediatrician not to tell my kindergarten teacher about my spells. He said that by telling the teacher about my condition, she may form a misconception about me and treat me differently. His advice was to wait a month and let the teacher get to know me before telling her about my seizures. Mom disagreed, thinking that the teacher should be informed about my spells and that she should know what to do if I had one in class. As a result of Mom telling the teacher about my medical condition, my teacher was able to deal appropriately with my spells throughout the school year.

The third morning of school, Mom came in to wake me up. I covered my head with the covers and said, "School wasn't fun. It's not fun for me, and I'm not going!" This attitude didn't last long. When I came home from school that day, I showed Mom my "Mr. M" paper and told her that I had a good day. I started loving kindergarten about as much as I did preschool the year before.

My shallow understanding of my affliction at age five possibly prevented me from having negative thoughts about myself as I entered school. I knew I took medication on a daily basis, but I thought every kid took medicine. At this early stage in my life, I was just a smiley yet shy little girl who enjoyed

playing with dolls and catching toads. The warmth in my family gave me a sense of security as I entered school and engaged in making new friends and learning new things. I knew that I was loved by my family. In our household, there were always lots of hugs, kisses, stories read, toys, and plenty of food.

I was in the bluebird group in reading, and I knew that I was one of the slower kids. I read slower than the kids in the other groups, and there were very few words on the pages that I read aloud. I was also the only kid in my class that went to speech class. Twice a week, a man came down to take me out of class and to take me to his office for lessons in speech. I frequently mispronounced the letter sounds of *r* and *w*, and these problems were obvious in my speech. A *wabbit* was an animal with long floppy ears, and a *ralrus* was a creature at the sea. My speech teacher also helped me pronounce consonant blends such as *cl* and *cr*. I clearly remember the day when I finally pronounced "clown" and "crown" correctly. My speech teacher took me to my kindergarten teacher and had me say those two words to her. I hesitated to say them out of fear that I would mess up that one time.

"Amy, say *clown,* like a clown at a circus."

"Cl-own," I said slowly but correctly.

"Good job, Amy."

"Now say crown, like a crown on a king," my speech teacher stated. I paused to think about the sound of the word. Finally, I said *crown.* My teacher smiled at me and gave me a hug. I had graduated from the cr and cl blends. That year further marked the beginning of my long trek through hallways of academics.

In my adult life I learned that Phenobarbital, the seizure medication that I took in my formative years, can delay language development in some patients. My taking Phenobarbital was the likely cause of my language delay in my elementary years. In recent years, the chemical components of Phenobarbital were altered, so it is now considered by some in the medical field to be a more purified medication than it was when I was a child. Phenobarbital, however, still has side effects that parents should be aware of before giving it to their child.

During the summer after my kindergarten year, my family traveled to Gatlinburg, Tennessee, to the Great Smoky Mountains. Angie, Steve, and I took turns sleeping on one another's laps in the back seat of the old Ford station wagon as Dad drove. The long hours on the road got boring, but we kids gave Dad and Mom something to laugh at. About every hour or two, one of us would ask, "Are we there yet?" After about nine hours of traveling, we finally reached the Smoky Mountains of Tennessee. As the mountains came into my view, I saw for the first time mountains that were much bigger than the hill behind our house that my family called "the cliff." Seeing the mountains made me realize that the cliff was just a mere hill that even an ant could conquer.

The most unusual incident that I remember from that trip was the feeling I experienced when Dad drove into a car garage. Going from bright sunlight to sudden darkness gave me an eerie feeling. It was not until my adult life that I figured out why this was so. Sudden darkness in real life was similar to the onset of a seizure. As a child, I associated this experience of going from light to darkness with having spells. These occurrences scared me and made me unaware of the events around me. Riding through a dark car garage gave me the same feeling that my world was caving in around me in a similar way as it did when I had a spell. I cringed at the appearance of the close ceiling that passed overhead and the darkness that surrounded me. Going from light to darkness did not trigger a seizure in me as it does in some people with epilepsy. However, I simply did not like what sudden darkness did to my mind. I experienced this eerie feeling in car garages throughout my childhood and even into my adult life. But as a six-year-old little girl, I kept this experience to myself. I was used to feeling my life closing in on me, and sensations in my body were just a part of life. At least these were part of *my* life.

By the first grade, I had acquired a new friend who has become a lifetime friend. Marjorie and I played school together for hours at a time; we celebrated one another's birthdays together; and we were two of the most giggly little girls in

southwestern Michigan. The summer after first grade, I went to vacation Bible school at Marjorie's church. There I learned more about God, but my understanding of God was very shallow. I was taught about God's love for me, and I believed He loved me, but understanding deeper spiritual matters was beyond me at that time.

In addition to attending vacation Bible school with Marjorie, I went to church on Sundays with my family. One Sunday morning while I was getting ready for church, I had a seizure. With wet hair, I went back to bed without telling Mom what had happened. For some reason, seizures in the morning hours always seemed to make me more tired than those that I experienced later in the day. Soon after my spell, Mom came back to my room to see if I was about ready. When she found me in bed asleep, she instantly knew what had happened.

"Amy, did you have a spell?" she asked.

"Uh huh," I replied from a sound sleep.

"Church starts in twenty minutes. I wish you could be there," she said in a soft and disappointed voice. I wanted to be there too, but I was exhausted. I felt like I had not slept at all the night before. Seizures came at times that were inconvenient, but that was part of coping with a seizure disorder. I often had to choose sleep instead of the planned activities for the day. I did not particularly care for this, but when my eyelids would not stay open, I really did not have a choice. Sleeping was the only option. On those Sunday mornings when I had a spell, Mom stayed home from church to be with me.

Although Mom was sometimes disappointed that I was not alert enough to do what was originally planned, she and I made the most of every opportunity when I was alert. Mom stayed at home while us kids were still quite young. Dad worked second shift at Kellogg's and hoped to eventually get switched back to first shift. Even before elementary school, Mom acquainted me with the kitchen, showing me how to wash dishes and cook. Baking cookies was my favorite activity in the kitchen. I clearly remember one of my first experiences helping Mom mix up chocolate-chip cookie dough. Mom put an apron on herself and one on me before we started.

"Now, we need 3/4 cup of brown sugar and 3/4 cup of white sugar." Mom read the instructions as I listened. "You can pour the white sugar into this cup. I'll get the brown sugar while you do that."

"Mom, can I mix the dough? Please? I want to try."

"Okay, let me put the brown sugar in, and then we'll mix the dough together," Mom replied. "I'll push the mixer, and you follow me. I don't want your fingers to get caught in the mixer," Mom explained.

"They won't, Mom. I know what to do," I said with confidence.

I did not understand my medical condition at that time, but I knew that Mom was more protective of me than she had been with Angie and Steve. She did not allow me to try as many things on my own. It was not until my teenage years that I understood her reasoning. Mom was doing what any responsible parent would do who had a child with a seizure disorder. If I had a seizure while operating a mixer or any similar device, my fingers could have been severely injured. But back when I was only knee-high-to-a-grasshopper (as my dad would say), I thought Mom was setting too many restrictions and had different rules for me than she did for my brother and sister. She did have stricter rules for me, but these were for a valid reason that I did not completely understand at that time.

Even though I knew that Mom and Dad had more restrictions for me, I obeyed them whenever they laid down the law and made boundaries for me. There was always a voice inside of me that said, "Dad and Mom know what's best." Despite the limitations that were set for me in the kitchen, I enjoyed cooking with Mom and doing what Mom did very well. My first day of cooking was only the beginning of the baking events that lay ahead. In later years, I baked peanut butter cookies and sold them at our garage sales. I also made birthday cakes for the family. During my elementary years, I usually didn't eat desserts. For some reason, sweet items did not appeal to me. Even so, I thoroughly enjoyed baking desserts for others to enjoy. Mom never complained about my baking cookies and cakes. In fact, she often gave me orders to make a particular dessert that she was craving. Obviously, we had a good system going!

1978

After another year, I was promoted to the second grade where I found school more exciting than the previous year. My teacher was a delightful woman with blond hair and a smile that brightened each day. I felt like a big kid that year because my classroom was on the top floor of the elementary building. Each day, I went up that big staircase just like the third and fourth graders.

At the beginning of that school year, I acquired an enjoyment of the storybooks of *Curious George*. The many adventures of Curious George climbing buildings and washing windows easily captured my attention. For my birthday that year, I received a stuffed animal, Curious George. I adored him so much that I brought him to school with me almost every day. My teacher looked forward to having Curious George in the classroom, and she asked where he was whenever I forgot to bring him. Curious George sat in a chair by my desk as I did my work. On occasion, he "held" a pencil as he "watched" me do my assignments. Along with about twenty children, Curious George became part of the second-grade class.

During the second grade, I experienced two to four seizures a week. I was under the care of the pediatrician who had been my doctor since birth. However, Mom and Dad were concerned that I was not receiving the proper medical care for my seizure disorder, and they began searching for a neurologist. One fall day I rode the bus home from school, and as usual, I carried Curious George in a grocery bag. When I arrived home, Mom greeted me at the door and gave me a hug and a kiss.

"How was your day at school?" she asked.

"Oh, good. Curious George helped me do my work," I replied.

"Oh, he did, huh." Mom chuckled and took my book bag to check for any notes from my teacher.

"There's graham crackers and juice on the kitchen table."

"Okay. Thanks, Mom," I replied. Eating a snack after school was routine and necessary before I took my after-school dosage of medication. Mom continued to wash the dishes as I sat down and ate my snack.

"Amy, your Dad and I want to take you to a new doctor. We heard over the radio about a neurologist in Detroit, and we want to take you there because we think she can do more for you than the pediatrician. It will be a longer drive, but it will be worth it. There is not a neurologist in Battle Creek, and the closest neurologists are in bigger cities, such as Detroit.

"It's a woman doctor?" I asked with confusion.

"Yes, this doctor is a woman. Women can be doctors too. She will know more about your spells and what medication you should be on."

"When are we going?" I asked.

"I don't know yet. The pediatrician's office needs to release your records to the office in Detroit. I'm waiting for a phone call from the doctor's office in Detroit," she replied.

"How far is Detroit from here?" I asked.

"Oh, about two-and-a-half-hours. You will be absent from school for a day. But I will let your teacher know what we're doing. She'll understand."

A few days passed, and I was still thinking about the fact that Mom and Dad were going to take me to a doctor who was out of town. *Why do I have to go to a doctor far away and other kids don't have to? Every kid takes medication. Every kid has weird feelings throughout his body sometimes. . . . Or am I the only one?*

I started to think about how I might be different from the other kids in my class and from my sister and brother. Up until that time when Mom told me she was going to take me to a doctor two-and-a-half-hours away, it hadn't occurred to me that my frequent visits to the pediatrician's office and my taking medication everyday were anything out of the ordinary. I was a kid who played house, got bumps and bruises, and took medication two to three times a day. And the funny sensations that temporarily made me unaware of my family, friends, schoolwork, and the events around me were probably something every kid experienced. But then again, maybe not.

That same week, Mom told me that an appointment had been made to meet with the new doctor. At that point, the excitement of going to a big city overrode the comparisons I had drawn between other children and me. I was looking forward to going to Detroit, a place I had never been, and spending a day with Dad and Mom. *And* I got a day off from school!

On a cold winter day in January, Dad, Mom, and I went to Detroit for our first meeting with this new doctor. We drove through the inner city of Detroit as we looked for the right street. With some navigating and several quick turns, we made it to the tall building and the seventh floor of the Epilepsy Center of Michigan. As the doctor introduced herself to my parents and me, I heard her accent that was hard for me to understand. During the course of our appointment, Mom interpreted her questions for me so that I could understand what was being asked. Mom explained that I was on Phenobarbital three times a day, Zarontin twice a day, and Depakene three times a day. She also explained that during a seizure, I stared off into space, I often fell to my knees, and there was some stiffening on my left side.

"Her seizures last for about one minute, but she seems so scared during them. Her seizures are scary to me sometimes." Mom continued explaining the difficulties I was experiencing. "She has stomachaches and headaches quite frequently. I don't know if they are caused by the medication, or if it is her diet or what it is," Mom explained. The doctor nodded her head to acknowledge Mom's concerns but remained silent on the matter. "Amy stopped eating pizza and spaghetti because it doesn't settle well with her. She eats a lot of salads, but she won't eat spicy foods." I sat quietly listening to the adult conversation between my mom, dad, and the doctor.

The doctor explained that she was in favor of gradually tapering me off one medication and increasing another. She thought that this change might lessen the amount of stomachaches and headaches I was experiencing. The doctor also ordered for me to have an EEG and CAT scan, which took place a few weeks later at a hospital in Detroit. The results of the tests allowed the doctor to make a better assessment of my epilepsy and how to treat it. Mom and Dad had hoped that

future appointments and changes in my medication would lead to an improvement in my seizure frequency and my overall medical condition.

About a month after my first appointment with the doctor in Detroit, my seizure frequency began to increase. Mom witnessed me having five spells in one day, and she noticed that I was tired during the daytime hours. After a few times of my not being able to hold my bladder during seizures, Mom called the doctor in Detroit and explained how my seizures had become more severe. Even so, the doctor's opinion was that my dosages should remain the same. My parents were left with no indication of my condition improving as I continued having seizures every week, causing me to sleep for hours afterwards.

On several occasions in my childhood after I awoke from a long nap, I had lost track of the time of day. Frequently when I had a seizure in the late evening, I would fall asleep soon after the supper hour and wouldn't awaken until the next morning. After I had slept for ten to twelve hours, it was common for me to argue with my mom about the time of day. I'd awaken and ask, "When is supper?" Mom would respond by saying, "It's morning, Amy. You slept through the night." I'd snap back and say, "No, it's night." Again, Mom would say, "No, Amy. It's morning. Look outside. The sun is rising." Mom was always right about the time of day. If Mom said that it was night, then it was night. If she said it was morning, then it was morning. I soon learned that I couldn't argue with the sun that arose in the morning or the darkness of the night hours.

At age eight, I started to realize that my diet played a role in the timing and frequency of my seizures. I found out the hard way that if I ate a meal that consisted strictly of foods with sugar or contained little or no nutritional value, I was bound to have a seizure. In one incident, I became ill as a result of eating a lunch that contained mostly sugar. That day, Mom packed me a peanut butter and jelly sandwich, chocolate pudding, and a red juice for lunch. I loved chocolate pudding, and red juice was the best! But shortly after lunch, I started to get nauseated. As my teacher stood at the chalkboard explaining

our math assignment, I starting feeling warmer and warmer. I knew I was going to throw up. To be polite, I raised my hand to ask to go to the bathroom. The thought didn't occur to me that this situation was an exception to the rule. Then it was too late. The whole class gave out a big moan, "Ahh, yuck!"

"What is it?" the teacher asked.

"Amy threw up," one of my classmates called out.

"Amy, are you all right? You could have gone to the wastepaper basket," the teacher explained.

"I raised my hand," I replied in an innocent voice.

"Well, next time you can get up without asking. If you are sick, you can get up without my permission. But that's okay. I'll clean it up, and then I'll call your mom," she replied.

From that experience of throwing up my lunch and medication, I learned that I must eat mostly healthy foods and limit the amount of sweets in my diet. When I told my mom why I threw up, she was receptive of my reasoning and agreed that I should be careful of the amount of sugar I take in during any given meal or even throughout each day.

During this time diet sodas and artificial sweeteners were becoming popular items in the marketing industry. The first few times that I drank a diet drink, I had a spell shortly thereafter. I made a mental note of this, and with experience, I came to realize that every time I consumed any food or drink product that contained an artificial sweetener, I then would have a spell in less than an hour. I expressed my observation to Mom, and she agreed that artificial sweeteners might play a role in the trigger of my spells. She too wanted to find a way to control my spells and was encouraged when there was any sort of possible solution to controlling them. Epilepsy had not yet been clearly understood medically, and so there were limited answers to such a complex disorder. My parents and I seemed to be grasping at air in searching for answers, but we eagerly tried anything that could in some way improve my condition.

At that point in time, my discovery about artificial sweeteners triggering seizures had not yet been proven in the medical field. Little was known about artificial sweeteners, and medical professionals had not studied in great detail the possible triggers of seizures. Almost eighteen years passed after my

discovery before the medical world tested and proved that artificial sweeteners triggered seizures in some patients.

My desire to be a healthy kid was what prompted me to start a diary about my seizures and to watch more closely what I ate. As a way of eating healthy, I ate lots of salads. I even ordered salads in restaurants. I too wanted my spells to subside, and in my own childlike ways, I thought there was a science to stopping my seizures.

Although I was beginning to learn about my illness and the ways I could prevent having a seizure, the whole issue was still confusing to me. I knew I had something that no other kid around me had. I could envision what it felt like to have a seizure, though I could not remember any events that took place during a seizure. However, I was not sure what all of this meant. Various thoughts and fears developed within me from my uncertainty about my condition.

Through attending Sunday school at the Baptist church that my family was attending at that time, I started to learn more about God's love and that He watches over us. Each night, along with praying for Mom, Dad, Angie, and Steve, I prayed to God and asked for a magic pill to take away my spells. As my seizures became more intense and I fell to my knees, I started to wonder if I was going to die as a result of having a spell. Before a seizure took full course, I cried out, "Mommy, my knees." As an eight year old, I prayed to God saying repeatedly, *I don't want to die. . . . I don't want to die. . . . I don't want to die.* There came a point when I started to say, *I want to die.* Then in the next breath, I would say, *No, I don't want to die.* I wondered if God really heard me and if He was going to take my life since I asked Him to. These thoughts reoccurred for a year or more as I desired to better understand the reasons I had spells and whether or not a spell could result in death.

Later that year, I began to take an interest in the children's Bible I had received two years prior to this time. It was given to me by my Sunday school teacher when I was promoted to the next class. I desired to read the Bible, but the thought of reading a thick book was overwhelming. However, I did learn to read the verse listed in the opening pages of my Bible. I wanted so badly to memorize part of my Bible. Over several nights and

weeks of reading and memorization, I had memorized the "Twenty-third Psalm." One night, I recited the verses to Mom.

> Because the Lord is my Shepherd, I have everything I need.
> He lets me rest in the meadow grass,
> And leads me beside the quiet streams.
> He restores my failing health.
> He helps me do what honors him the most.
> Even when walking through the dark valley of death
> I will not be afraid, for You are close beside me, guarding, guiding all the way.
> You provide delicious food
> For me in the presence of my enemies.
> You have welcomed me as your guest,
> Blessings overflow!
> Your goodness and unfailing kindness shall be with me all of my life,
> And afterwards I will live with you forever in your home.

After I recited these verses to Mom, she gave me a kiss and told me that she loved me. She tucked me into bed in her usual way. Once again, I said my prayers before drifting off to sleep. To this day, I can still remember having nightmares about falling from tall buildings toward concrete, with the accompanying thought, "I'm going to die." I also had a dream that my mom had me in her arms and was going to put me into a roaring fire. In each dream, I woke up right before the seeming traumatic events occurred. My dream about a fire was certainly no reflection on the character of my mother. Her love for me and her desire for me to live a healthy life was very evident. However, my dreams clearly reflected the fear I had developed as a result of having seizures that made me fall to the ground. The internal sensations that I experienced before and during a seizure involved a surge of heat, involuntary movements of all my limbs, and the loss of awareness of my surroundings. The reoccurring traumatic episodes had become woven into my dreams and had led me to think along the lines of death.

That year, Dad went to Australia on business. Dad called two to three times a week to talk to all of us. He told us about the kangaroos, koalas, and the unusual birds he saw on the weekend on a sightseeing adventure. At the end of the phone calls, I heard the quiver in Mom's voice as she said good-bye to Dad and told him that she loved him. It had been a long month, but we all managed to hang in there. Near the end of one month, Dad called and told us that he was still needed at the plant and that he would not be home for another one to two weeks. This had been the longest time that Dad had been away from home. When he traveled, he was usually gone for five to seven days and sometimes one to two weeks. But his being away from home for over a month was like an eternity for all of us. It was during those long weeks of waiting for Dad to come home that we kids started to sleep in Mom's bed with her. We fought over who was going to sleep on Dad's side of the bed.

"I'm sleeping with Mom tonight," one of us would say.

"No, you did last night. It's my turn!" another one would respond.

Dad ended up staying in Australia for seven weeks. During the time that he was gone, Mom had many responsibilities with which to contend. Aside from the daily tasks she faced, the basement leaked during a heavy rainstorm, and I broke one finger and cracked the other during a Wonder Woman episode in my bedroom. I was pretending to be Wonder Woman by twirling around and diving into my bed—with my eyes shut! As a result of my poor judgment about where I was, I hit the edge of my bed, and my hand hit Angie's nightstand. I screamed bloody murder. Within a few minutes, Mom came in from mowing the lawn to see what I was doing. My fingers were black and blue, and I was still crying. That is how I broke one finger and cracked the other!

When Dad arrived home from Australia, our family spent lots of time together catching up on things. Dad had enough souvenirs to open up a store. Boomerangs, T-shirts, koala bears, and a kangaroo skin for Steve were among the items that seemed to fill the living room.

That spring, a talent show was to be held at the elementary school. I had learned how to play a few songs on the organ at home and had decided to play a few tunes at the talent show. I called several of my classmates and asked them if they were willing to sing while I played the organ. The only two brave ones were Marjorie and Tiffany. They sung the words to "Mary Had a Little Lamb," "Twinkle, Twinkle, Little Star," and "My Country Tis of Thee" as I played the organ at the talent show. After my performance, I whispered to my Dad, "It felt like there was fire coming out of my ears." The interpretation of this statement was that I was nervous. Not realizing at the time that I was experiencing my first encounter with stage fright, I didn't quite understand why he laughed at what I said.

> *Better to light a candle than to curse the darkness.*
> Chinese Proverb

1979

The school year ended, and I took Curious George home for the summer. I was looking forward to the days of running through the yard in my shorts and swinging from the monkey bars on the swing set that Dad had made. That summer, Mom encouraged me to sign up for little league girls softball. I was excited about the idea mainly because it was something that Stevie did, and I was often interested in doing the things that he did—even if it were a "boy thing!"

The month of June came, and I was playing shortstop and sometimes outfield. I was having a really good day if I got a hit and an even better day if I made it to first base. I was one of the youngest team members and often felt inferior to those big girls who got a home run in the blink of an eye. Despite my lack of skills in playing softball, Dad and Mom were always there to cheer on their little Babe Ruth.

I got to the point where I couldn't wait to get on the field to catch the ball and to get someone out. Sometimes the ball went right through my legs and right past my glove, but when I was fortunate enough to stop the ball, I couldn't get the ball to first

base fast enough. Nevertheless, being out there with a bunch of big girls was exciting. By the end of each game, I had a thick layer of the dirt on my hat, shirt, and pants that revealed how often I had hit the dirt in my efforts to try to stop the ball.

Along with the excitement of playing summer softball for the first time came the onset of seizures and confusion to follow. As I heard and spoke the words, "Hey batter-batter-batter-hey-batter-batter," the heat radiated not only externally but also internally as a rush of heat sped through my body. My ball glove became weightless, and the words that echoed in the ball field dissipated into the distance. My entire body became tense as my world closed in. I was a ball player in an open field who was lost in a world of his own. *Heat radiated from all directions . . . sunshine turned to darkness with a glimpse of swirling light mixed in . . . unawareness remained . . . no coherent game strategies within . . .* sensations and intense heat slowly faded into the summer breeze.

After I regained awareness, I glanced over the ball field to see what was happening in the game. My teammates were still in the outfield and filled with team spirit. I looked toward the sidelines to see if Mom and Dad were watching me. Being so far away from the spectators, it was difficult to see if anyone was looking at me. I hoped that no one had noticed the episode. I wanted to be considered part of the team by everyone without being thought of as a kid who has spells and who had a problem that no other kid had. Being part of the team created the spirit within me to keep going.

"You're out!" yelled the referee to the batter on the other team. That must have been the third out because my teammates started running toward the benches to begin the next inning. I ran in with them with a tired feeling throughout my body but with an inner hope of winning the game. Mom met me at the bench and put her arms around me.

"Are you okay, Amy? Why don't you sit out this inning?" she asked.

"No, Mom. I'm okay," I responded with little energy.

"I love you," she added as she gave me a hug to express her love toward me and to let me know that she had noticed that I had a spell. I found my name listed in the batting order, and I sat on the bench waiting for my turn to bat.

That year my team received second place in the tournament that involved a total of four teams. I really didn't mind being on the team that was considered second best. Playing softball wasn't about being on the best team or always being a winner. It was about having fun and being part of a team whose members had a willingness to work together.

During that summer, I thought deeply about how my parents wanted my spells to subside. Because I wanted to ease my parents' concern about I my condition, I started to lie to my parents and the doctor by telling them I wasn't having any spells. I knew that having spells was not pleasant for me, and I was also aware that my parents wished I didn't have them. The tone in my mother's voice when she asked me each day if I had any spells made me realize her hope for me to be healthy. Her disappointment was readily apparent when I told her I had one or more spells. In my little girl thoughts, I wanted to relieve my mom of the worry and pain that my spells brought her. Besides the spell that I had on the ball field during the summer, I had somehow managed to have spells only during the times when I was away from my parents. Though I knew I was wrong to do so, I started telling my parents and doctor what they wanted to hear as an attempt to cover up the pain that my parents and I shared.

Despite the secret that I kept, I remained on my medication and continued experiencing stomachaches as a result of the medications I was taking. Some nights I told Mom that I didn't want to take my medication because of the ill feeling in my stomach. When I did not feel well, I had a nauseated or shaky sensation throughout my body. The flavor of Depakene made me gag every time I took it, and the thought of taking it on a upset stomach was not appealing. Depakene tasted like medicated cherries, and I didn't even like cherries! On those nights when I felt ill, Mom allowed me to go to bed with little or no medication. It was a difficult decision on my mom's part to figure out which was worse: having me take my medication and possibly feeling worse or to have increased seizure frequency the next day due to a decrease of medication in my system. At

least once every three to four weeks, I felt sick to my stomach, and it was never easy on either Mom or me.

CHAPTER 4
Battles

1979

The summer soon came to an end, and once again it was time to start school. The previous year I had completed the second-grade math book and had started the third-grade math edition. As I prepared for the new school year, I looked forward to continue learning more math, the subject that came the easiest for me.

Although I was enthusiastic about going into the third grade, school was very difficult for me that year. I often did not do my work; and when I did, I didn't always hand in my assignment. Because I was behind in my classwork, I sometimes stayed after school to complete my assignments. Handwriting was the most difficult task for me to start and finish. There was one time during the school year when there must have been a few weeks of assignments I had not completed. One day I sat at a desk after 3:00 p.m. and stared at the blank cursive paper in front of me. I was very frustrated because I couldn't get myself to concentrate enough to write my name. It was as though my mind had no ability to calm down and focus on the work that was on my desk. After I fumbled to get a pencil out of my desk, I managed to get started on the stack of papers. The combination of seizure medications that I was on had possibly begun affecting my ability to concentrate. At that point in time in my medical history, my doctor's main focus was to control my seizures, regardless of the effect the medication had on my thinking ability. Mom became aware of the doctor's view and called the doctor whenever a situation arose that increased her concerns.

"Amy says that she has not had any seizures, but she is on so much medication that she is having a hard time concentrating on her schoolwork. And she often complains about having a stomachache right after she takes her medication. Is it really necessary for Amy to be on this much medication?" Mom asked the doctor during a telephone conversation.

The doctor's response was for me to continue taking the same dosages of the medications. Consequently, I continued taking Dilantin twice a day, Phenobarbital three times a day, and Depakene four times a day.

Upon my completion of the third grade, I entered another season of playing softball. My experience in the short stop position was coming to a close as the coach had me practice pitching. I had never dreamed of being a lead pitcher, but pitching sure did sound more exciting than having the ball miss my glove at short stop or chasing the ball in the outfield. With my ball glove in one hand and a water Thermos in the other hand, I went off to softball practice two nights a week to improve my pitching style. On evenings when there wasn't ball practice or a game, I often watched the Detroit Tigers on television with my dad. Because my dad had always been a sport's fan, he was able to explain to me the rules of professional baseball, and he told me some trivia about the players. As the professional ball game was being televised, I paid especially close attention to the pitchers' pitching style. After watching many games, I came to realize that overhand pitching was out of my league. Anyway, little league girls' softball might have been changed forever had I thrown an overhand pitch in the ninth inning. Even through the summer time, my seizures remained a secret as I experienced more seizures through my exposure to the summer heat.

1980

The fourth grade was one year I will always remember. My teacher was a jovial lady who gave big bear-hugs and wouldn't let go. Her laugh brought a smile to my face, and her personality was one that attracted anybody. In the afternoons, the principal came in to teach science. The group science project that year was to do a report on the solar system, and each group

member had to tell part of the report in front of the class. My group made all of the planets out of papier-mâché. After the entire solar system was formed in the classroom, we hung the planets proportionately apart in the hallway for all the students to observe. This endeavor was the first science project I ever had a part in, and it wasn't the last.

Underlying my enthusiasm of recreating planet earth and playing marbles, I held within me an insecure feeling about my seizures. At age ten, I continued to keep my reoccurring seizures a secret. My parents still had not witnessed me in a seizure for a year-and-a-half, but I knew that I had *spells* as we referred to them back then. I somehow managed to have seizures only when I was all alone or with friends. Whenever I went to the doctor for my four-month checkup and was asked if I had any spells since the last time we met, my response was "no." Just as I had felt since second grade, I wanted to give my doctor and parents the answer they wanted to hear. I didn't want to see my mom go through the pain that my seizures brought her. Consequently, I used my childish fantasy world to make her believe that I was a healthy child. When I went to the doctor back then, I felt like I was being put before a judge who asked me if I had committed a crime. Again, I knew what they wanted to hear. By lying about it, I was attempting to get rid of the shame that went along with having seizures, but I gained guilt as a result of not telling the truth. To this day, my medical records incorrectly indicate that I was seizure-free for a year and a half.

The day came that I could no long keep my seizures a secret. I was at Grandma's and Grandpa's house to celebrate my Grandpa Belcher's birthday. Several family members had gathered to have dinner, ice cream, and cake. As I sat at the table eating my meal, I felt an aura come on. Mom and some of my aunts and cousins were sitting next to me; they slowly drifted out of my field of awareness. After seconds or minutes later, though for exactly how long I was not sure, I heard Mom's voice.

"Amy, you had a spell. Are you all right? Come here," she wrapped her arms around my shoulders. "This is the first one you have had in over a year. You scared me. Do you remember anything that happened?" she asked in a soft voice.

"No," I whispered as I looked at the floor.

"I saw you fumble with your food, and that's when I knew what was happening. You grabbed your glass of milk and wouldn't let go. Your grip was so tight that I couldn't take the glass away from you. Your pupils got big, and you looked frightened. Then you swallowed oddly, and I thought you were choking on your food. I'm just glad you're okay."

The expression on Mom's face revealed that she was stunned by the incident. The fear that this seizure had brought her was very clear. I started to realize that I had to face up to my medical condition. There was no way that I could hide what brought my parents and me so much pain and unanswered questions.

My parents and doctor thought that this was the first spell that I had experienced in over a year, and they attributed this particular seizure to my medication. I had not taken my medication the previous night because I had a headache and stomachache. My lying about my seizures was smoothed over by the fact that I had missed a dosage of medication; therefore, the seizure that my mom witnessed was considered the result of my not taking my medication. Although the cause of this particular seizure was probably due to my skipping a dose, it was not the first seizure I had experienced in recent days. My parents and doctor drew their conclusions based on what they knew to be true, and I kept my mouth shut about the truth that I held.

After school recessed for Christmas, I spent more time in the kitchen baking Christmas cookies. In previous years, Mom showed me how to make shortbread cutout cookies and spritz cookies. I baked both kinds, and neither one of these stayed on the counter very long. We ate some of the cookies within a few days, but we hid most of them in the freezer in the garage in order to save them for Christmas Eve and Christmas day.

The times for putting up a Christmas tree came to be an event to look forward to for the entire family. Dad had made it a tradition of getting the largest tree possible, even if it meant that he had to cut off part of the top or the bottom in order to get it to stand erect in the dining room. The moment of adventure and laughter came about ten days before Christmas day when Dad put on a natural show by attempting to get a nine-foot-diameter evergreen through a four-foot doorway. Rope, blankets, and multiple demands were all part of this memorable occasion. As a long string was used to pull the chandelier toward one corner of the room, the dog and cat stood by to observe this belly-laughing event. I was handed the string that was connected to the chandelier and was delegated the responsibility to pull on the string as hard as I could. With the chandelier near the ceiling, I stood as still as possible, trying not to laugh at Dad.

Dad and Steve had the honor of standing up the tree in such a way that it would not tip over. Dad called to Mom to bring him some magazines to place under the cross boards of the tree stand. No matter what tree we got, the poor thing would not stand up straight without the aid of magazines under the stand. But our Christmas tree just would *not* have been complete without such support.

Once the tree was standing tall and secure, the fun work began with the placing of the lights and ornaments. This was a special time for the family. Mom brought out some Christmas cookies that she had taken from the freezer and thawed, and she offered us hot tea or milk to make the moment complete. Nothing could replace the decorating of the Christmas tree and eating homemade Christmas cookies. The aroma of warm cookies and the sound of "Greensleeves" in the background helped create the spirit of Christmas. I talked to Mom as I decorated the tree.

"I'm going to put my ornaments at the top of the tree. Oh, here's the one that Aunt Gladys made for me. This is one of my favorites," I expressed.

"You be careful, Amy. I don't want you to fall off the ladder."

"I know Mom," I replied.

Mom watched me as I took each big step up the ladder and reached out my arm to place on the tree that big shiny red bulb that had my name written on it. Mom was always cautious in allowing me to climb heights; she feared that I might have a seizure and fall a long distance. Her concern was valid and from a loving heart, but as a child I got tired of hearing those comments of concern and worry. I wanted to be free from the limitations that came with having spells, and I longed to do what my heart desired without having to hear those words of caution that were all too familiar.

The Christmas season was never complete without family. About two or three days before Christmas day, Dad drove to Grand Rapids in order to pick up Aunt Gladys and bring her to our house to celebrate Christmas. Gladys was my great-aunt, but we kids always called her Aunt Gladys or Gladys. Aunt Gladys had been widowed since I was a baby, and she and Hubert never had any children. Aunt Gladys enjoyed being at our house and spending time with us kids and all of the animals. We had a cat, a dog, tree crabs, frogs, and a hamster. Living alone with no children or animals, she looked forward to the change of life-style. And our family loved her to no end. Her mannerisms and phrases had become part of our family, especially during the holidays. One of the phrases she was known for saying was "hoooly gravy." Gladys watched football games and yelled "holy gravy" whenever there was an exciting play in the game. Or if she heard an exciting story from one of us, again she yelled "hoooly gravy." Her cheerful voice was always heard throughout the house.

After a quiet Christmas Eve around the fireplace and light-hearted conversation with Aunt Gladys, it was time to go to sleep and wait for Santa Claus to arrive. This was the first year that I didn't put cookies and juice out for Santa. I had talked with Mom earlier in the year and now knew the truth. I would have felt foolish putting cookies out for my own parents. Anyway, the previous year my parents forgot to play the game. I ended up putting the uneaten cookies back in the kitchen on Christmas morning. I was not going to go through that disappointment two years in a row! Steve and I were always the first ones up on Christmas morning. We were the youngest two and

couldn't wait to open our presents. Around seven o'clock on Christmas morning, we met one another in the hallway outside the bathroom.

"You get Angie up," he whispered.

"She's the hardest one to wake up!" I whispered back.

"I'll get Mom and Dad," Steve replied. "What about Aunt Gladys?" We both looked at one another with grins. I shrugged my shoulders, and we went to our assigned rooms to wake up the family.

I made several attempts to wake up Angie, as Steve attempted to wake up our parents. Aunt Gladys was awakened as a result of hearing our voices and the opening and closing of bathroom doors. Once everybody had a turn in the bathroom, we all lined up in the hall either from oldest to youngest or youngest to oldest. We usually alternated each Christmas to make it fair. But this year Aunt Gladys wasted no time in establishing that the oldest was going first. With her potent perfume filling the air, Aunt Gladys was waiting patiently near the doorway. I took the end of the line with Jack our dog.

Gladys sat in the rocking chair by the tree as she watched us kids open our gifts. The smile on her face said it all. She was in her glory. Each of us kids handed her gifts as we came to one with her name on it. Angie helped Jack and Crazy with their stockings so that they would feel like part of the group. A bag of catnip kept Crazy happy, and Jack wagged his tail as he chewed on his new rawhide bone. With wrapping paper being placed in black garbage bags and our personal stash piles growing in size, we had our traditional Christmas morning.

After we opened our gifts, I helped Mom cook breakfast. Mom came from a family of seven children, and it was a tradition in her family to cook a big breakfast on Christmas morning. Even though there were only three kids in our family plus Aunt Gladys, Mom always fixed enough food for an army. I made the scrambled eggs, as Mom made pancakes, sausage, bacon, and fried potatoes. Gladys washed the dishes as we dirtied them. She always gave us a serious yet humorous look each time we gave her another dirty dish.

I enjoyed having Aunt Gladys at our house and didn't want to see her go when Christmas was over. Her singing put joy in

the holiday season and throughout our household. On a spur-of-the-moment, Aunt Gladys started singing "Amazing Grace," or "Silent Night," or other hymns she had sung in church. She, with her operatic voice, made the holidays, especially Christmas, an extra special time at our house.

The long winter months passed, and spring arrived. I was nearing the end of a successful year in the fourth grade and looked forward to another summer of playing softball and finding toads. I was gathering my belongings for school one morning when the phone rang. When I heard the phone ring that morning, I knew there was something wrong before I answered. I picked up the phone and heard Grandma on the other end. Grandpa Belcher had a stroke that morning and was rushed to the emergency room by ambulance. Emptiness and the feeling of loss swept over me. Grandpa was so much fun to be with. He had just taken me shopping the previous weekend. He was in his glory because he was shopping with his granddaughter, and he was buying me whatever I wanted. The long nights of playing Yahtzee with Grandpa were also special times to me. I loved him so much; I couldn't bear to see him die. In her saddened voice, Mom called Dad on the phone and explained what had happened to Grandpa. I needed to catch the school bus in a matter of minutes. I kissed Mom good-bye and gave her an extra long hug. Later that afternoon, my teacher saw me crying as I sat at my desk. She came over to see what was the matter.

"What is it, Amy? Are you upset at Tiffany?" she asked. I shook my head no. There was a long pause. "Would you like to talk in the hall?" she asked. I nodded my head, and we went out of the classroom to the hall.

"What is it, Amy? You can tell me. It's all right," she said in a soft voice.

"My Grandpa is in the hospital," I replied.

"Oh, I'm so sorry," she said as she gave me a hug. "I know how you feel. It isn't easy. Do you know if he is going to be okay?" she asked. I shook my head no. "I'll excuse you from your work today. If you need to talk, just come see me. I know

it's hard for you to cope with your Grandpa being ill. Come here." She hugged me again, and she wiped my tears. Within a matter of minutes, we made our way back into the classroom.

Grandpa passed on later that day. This was the first funeral I had ever attended, and I had no idea what to expect. The whole family came together for the homegoing of such a loving man who was known and loved by many people. But most of all, I had lost the Grandpa who played games with me and gave hugs and kisses that melted my heart.

After grieving over the loss of Grandpa, it was once again time for me to go to my four-month checkup in Detroit. Throughout my elementary grades, I went every four months for an appointment with the doctor. On occasion, I went to Detroit twice within a four month period for further medical testing. My parents and doctor were aware that I was having spells, and my mom frequently asked me if I had experienced any recently. After the seizure I had at Grandma's house, I began admitting when I had one and talked openly about my spells with the doctor. During my appointment, my mom explained to the doctor that during a spell I stared, my pupils became large, and I did not respond to questions. However, even after my mom explained the nature of my spells, the doctor expressed that she did not know for sure if what my mom was describing were actually seizures. When the doctor asked me to describe my spells, I explained that I had a strange sensation in my stomach right before a spell, and I felt like I was on a roller coaster. I also expressed that I was never aware of what was going on around me during a spell.

My parents were glad to seek medical advice regarding the treatment of my spells, but they became discouraged to know that my spells were still occurring. Before going to this specialist, they had high hopes that this doctor would know the appropriate medication to prescribe that would totally control my spells. Although my parents had believed that I had been seizure-free for a year-and-a-half, they had seen me in seizures in recent days and knew that my seizures had not disappeared. The mystery of the disease had yet to be resolved.

As summer approached, my family prepared to spend many days at the lake where Dad and Mom had purchased a piece of property. Dad cleaned the pontoon boat, and Mom went to the basement to get the port-a-potty that we called "Rover." Boatrides, fishing, cookouts, swimming, and catching frogs were some of the highlights of our summer days at the lake. However, I was the only brave one who participated in the frog-catching.

On many Fridays after Dad arrived home from work, Mom already had the food together, along with our swimming suits and towels. All five of us then packed into the station wagon and headed about forty-five minutes north to Little Pine Lake. On the way to the lake, I thought about the frogs and fish that I wanted to catch and waited in anticipation to experience the smell of the lake.

What seemed like hours later, we finally arrived at the place where frogs croak, and the smell of charcoal and grilled food filled the air. With only thongs covering my feet, I got out of the car and ran to the shore in hopes of finding a lake creature of some sort. Some of the grass and cattails I passed were just about my height as the lake smell urged me to run faster to my destination. The hot sun beat down on my face, as my long hair flapped in the breeze.

I slowed down as I approached the shoreline where I hoped to find a frog, a snake, or a lizard. I had no idea what I would do with one if I found it, but it was the thrill of finding an animal at the lake that continued to motivate me. My fascination for frogs, toads, and snakes became my single focus. An hour and many exciting moments later, Dad called from a distance to announce that the food was ready. Without any critters, I ran toward the smell of hotdogs and hamburgers.

"Amy, do you want a hotdog, a hamburger, or a cheeseburger?" Mom asked. My appetite was quite unusual, and it was unpredictable as to what food would sound appetizing to me.

"I'il take half of a cheeseburger," I said.

"Did you find any frogs, Amy?" Mom asked.

"No, but I'm going to try again after I eat. It's a little scary down in the weeds, but I like it down there," I remarked.

"Just promise me one thing, Amy. If you find a snake, don't bring it to me. I hate those things," Mom added. I smiled at her comment. Without fail, I went back to shore after dinner, and once again began my expedition into the world of lake creatures. Dad prepared the boat for our evening boat outing.

It must have been the intensity of the sun's rays and the excitement of looking for frogs that led me into a spell. In spite of my consistency in taking my medication, I was bound to experience a seizure due to the summer heat and the excitement of being at the lake. As I felt the sensation of my aura increase in its intensity, I thought to myself, *No, it isn't going to happen.* This short phase of denial before a seizure took full course had become a common thought of mine as an aura began. Seconds of denial in the midst of an aura were part of my reaction to these traumatic episodes that brought both fear and anxiety to my life. Within a moment's time, cattails and the soft ground faded from my awareness as the thought of catching a creature drifted from my mind. Sun rays beat on my body as my mind was taken away by the shattering light and the tenseness of my existence. Unknowingly, I sat on the damp weeds where I was last searching for critters. Seeing clear light again was beyond my control as I struggled in a state of pure existence without purpose. The light was dimmed by darkness, and then slowly reappeared as weeds and lake water came back into my vision. After the seizure ended, I returned to our campsite. For the next hour, I slept in the back seat of the station wagon so that I could be revived to enjoy the boat later that evening.

The clear sky and mild breeze allowed for a peaceful evening on the boat for the whole family. Dad was the main captain of the boat, but he allowed us kids to take turns steering. Jack was right in there with the rest of us. He watched us kids fishing and thought seriously about jumping ship. We three kids often used pieces of hot dog left over from our cookout or cooked spaghetti noodles for bait if we didn't have any worms. The funny thing is we actually caught a fish one time using our inventive bait! Although the catch of that particular evening was seaweed and a turtle, the family time spent together proved to be rewarding and more important than any bass or bluegill in the lake.

CHAPTER 5

Informed

An Indian Tribe

Imagine yourself part of an Indian tribe that is traveling from Fort Sumter, South Carolina to the Rocky Mountains of Wyoming. Because these two locations are over a thousand miles apart, it is estimated that it will take about sixteen years for your tribe to reach their final destination. Over the years, the Indians travel northwest through fields and over river streams. Along the way your tribe finds time for leisure by turning somersaults in the wheat fields, climbing oak trees off the beaten path, and making necklaces from acorns and dried berries. Your tribe shares several memorable times, and each one looks out for the safety and well-being of one another.

About halfway to the foothills of the Rocky Mountains, you are informed by an Indian chief that there will be a feast served to every tribe member the day they reach the mountains. Even though all of the tribe members are traveling together, some tribe members will reach the mountains sooner than the others because each Indian walks at a different pace. Nevertheless, each member will be part of a marvelous feast upon arrival. However, the same Indian chief explains that every Indian will reap the benefits of the feast, except for you. Once you reach the Rockies, you will continue eating field corn, the same type of food that your tribe has eaten the entire trip. While the other tribe members enjoy a feast of a lifetime, you will eat field corn. There will be cooked stews, vegetables, cornbread with butter, and purified water—all of which you will not be allowed to taste. You are also

informed by an Indian chief that there is a possibility that you might not ever experience the flavor of homemade cooking and all the trimmings that go along with a big feast. Only time will tell.

After learning that you will not be attending the wonderful feast that the other tribe members are going to attend, you become discouraged by realizing that you will not be allowed to experience the pleasure of eating delicious food. You will not be a part of the feast. In fact, you will also be restricted from the full course meals that are offered throughout the days and weeks following the initial feast. *You are on the same journey, but you lack enthusiasm for the journey because of the discouraging reality regarding your future.* The idea of eating field corn for the rest of your life rests on your mind as you walk with other tribe members on the same trail that leads to the Rocky Mountains.

Months and years pass, and again and again you hear the other tribe members talk about the feast that they will partake in. You remain quiet as members of the tribe laugh and express their excitement for the meal to come. There are only two to three years before the tribe reaches the location of the prepared dinner. The journey is getting shorter as bitterness settles in your mind. You have bitterness because there is not a feast waiting for you. In fact, you dread the thought of reaching the mountains. The mountains and feast that seem so exciting to the other Indians become a sore point in your life. While the other Indians are enthusiastic about reaching the feasting area, you are depressed in a way that words cannot express. You think to yourself, *Why should I look forward to reaching the feast in the mountains if I am not allowed to taste the food?* But there you are, continuing on the journey with bitterness inside your soul over the reality of your future. There will be a feast for every member of the tribe—except for you.

I had spent my first five years of elementary school in average-sized classrooms, and I stayed in the same class for all the basic subjects. As I prepared for fifth grade, I was apprehensive about going to a new school. I didn't look forward to switching classrooms for each subject and being combined with the kids from the other elementary school. However, the prospect of learning the clarinet was one aspect that excited me. I had passed the music test in fourth grade and was considered to have potential for learning to play an instrument. I had heard Angie play her flute, and I wanted to be as proficient at playing the clarinet as she was at playing the flute. Learning the B flat major scale and the song "Mary Had A Little Lamb" ended up being the highlights of the year. As long as I kept my fingers on the right keys, I did pretty well.

When I entered the fifth grade, my seizures still persisted, in spite of my being on multiple medications. I was on three medications, and I took pills four times a day. That fall, I lagged behind in school in all of the basic subject areas. My academic problems might have been caused by my having changed schools that year, but the heavy dosage of medication that I was taking also affected my academic performance. That year was the first one in which I had social studies every day, and it all seemed abstract to me. This particular school had much more structure in the daily routine than the school I came from, and I wasn't able to adjust to what seemed like intense requirements.

As I struggled to complete my assignments, I started to wonder why I had spells and how I acquired such a condition. As I sat at the kitchen table one night talking to Mom while she washed the dishes, I brought up the subject.

"Mom, why do I have spells?" I asked. Mom grabbed a towel to dry her hands.

"You have had them since you were an infant. You had a convulsion when you were eleven months old," she said in a serious tone of voice. She sat down and further explained what happened to me when I was an infant. "You have epilepsy," Mom stated in part of our conversation. This was the first time

I had heard the term *epilepsy* as the name of my illness. Mom started to cry as she explained in detail about how I was not treated immediately in the emergency room when I was running a high temperature. As an eleven-year-old girl, I realized how traumatic my convulsion was for my mom. Mom had feared that I was going to die. She also carried undeserved guilt for what had happened to me, even though the circumstances were beyond her control.

It was on that autumn day that I first understood why I had spells, or seizures, as they are more commonly called. It was then that I saw the big picture. Although I knew before this conversation that I had spells which were very unpleasant experiences, I hadn't realized that there was a more elaborate term for my condition. I really *did* have something that most kids didn't have to contend with. I had epilepsy—whatever that meant. The word *epilepsy* seemed so unusual. For days and weeks after that talk with my mom, in class and on the playground I thought about the fact that I had epilepsy. *I have epilepsy,* I thought to myself.

As my mom explained to me about my seizures, she also told me that because of seizures, I might not be able to get my driver's license when I turned sixteen. Turning sixteen seemed like light years away; however, I knew that age sixteen would eventually arrive. Five years later, my friends would be able to get their drivers' licenses while I continued to rely on my parents for rides. In the midst of the dark clouds, my mom always encouraged me to count my blessings. But my focus kept shifting toward my fears, and my future seemed gloomy. Yes, I was traveling the same trail as my peers, yet I thought I would not reap the benefits that awaited at the end of the journey.

At the end of the school year, since I was continuing to lag behind, the teachers wanted to hold me back a grade. Based on my grades and overall work habits, they did not see how I could successfully make it in the sixth grade. At the last parent-teacher meeting, my mom expressed that she disagreed with the idea of holding me back a year and that she thought I would have a tougher time in the long-run if I were held back. Mom

did not deny that I had a rough year; however, she wanted me to be moved on with my friends and hoped that a new school year with different teachers would make a difference in my academic performance. Mom was also concerned about the amount of medication I was taking, and she knew that it played a factor in my poor grades. After an intense meeting with all five of my teachers, Mom had the final say in my being promoted to the sixth grade.

That summer, I went to summer school as a means of improving my academic skills. Soon after the regular school year ended in June, I again rode the school bus five days a week. The only relief I had that summer was playing softball after summer school ended.

The academic struggle that I had experienced the previous year was something that I wanted to put behind me and never go through again. Behind the evidence of my low academic achievement lay my desire to succeed and to receive passing grades like most of my classmates. I longed for the day that I could get an *A* or a *B* on an assignment or test. However, because I had been a low-achiever, along with being on thirteen-and-a-half pills a day and having one to three seizures a week, I did not know if it were possible for me to make good grades. Regardless of the obstacles, I took the approach that I would strive to receive *A's* and *B's* in sixth grade. As the summer came to a close and I prepared for the first day of sixth grade, I was excited about meeting my four new teachers and being at the same middle school that Steve attended.

On the first day of school, I woke up with a great attitude and eagerness to enter the sixth grade. Wearing a purple and blue-checkered shirt with matching purple pants, I resembled Holly Hobby as I got on the school bus and began a new school year. My heart filled with enthusiasm as I anticipated arriving at school where I would see my friends and find out who was in my homeroom for this school year.

Not long after the school year began, my science teacher announced that each student was required to write a science report. She explained that the report could be on any topic

related to science, but that no two students could pick the same topic. I knew immediately what I was going to do my report on, and I also knew that no one else in the class would pick the same topic as I had. Without hesitation, I decided to write my report on epilepsy. As a result of the conversation that I had with Mom the previous year, I desired more and more to obtain a better understanding of the disorder that affected every day of my life.

My sixth grade science teacher was the first teacher I ever told that I had seizures. When I told her that I had epilepsy, I knew it surprised her. As she listened, the wheels of science and health matters were turning in her mind just like Einstein working through one of his experiments. I was a quiet and polite girl who did my work. Prior to my informing her of my seizures, she didn't view me as a student with a medical problem. After knowing about my condition, however, she was excited that I was going to do my report on epilepsy. She and I probably shared some of the same questions about epilepsy, but obviously for different reasons.

I had never been so enthusiastic about doing schoolwork in my life. The idea of learning about something that was so personal to me was motivating in itself. I had many questions about epilepsy that remained unanswered. Some of the questions that I had were *What causes seizures? What treatments are there for seizures? Can a person die from epilepsy? How many people have seizures?*... and the list went on. Within a day, I started my research for my report. I gathered health books from Mom's shelf at home and made use of the library at school as well.

The research I did on epilepsy gave me an indepth understanding of my seizure disorder, and it also helped me to accept my condition. Knowing more about the matter also seemed to lessen my fear and anxiety about my seizures. Though I still had some insecure feeling about my seizures, through writing my report I learned more about how seizures occur in the brain and that there were other people that had the same disorder as I had.

At the completion of writing my report, I volunteered to give an oral presentation to the class on my findings. It was one of the most uncomfortable speeches I ever gave in school. I

was nervous about talking on such a personal issue in front of the class, but I also desired for my classmates to understand what I had so that they would know how to react to my seizures. Prior to my oral presentation, I feared being rejected by my peers. Even though there was the possibility of my peers saying mean and critical statements, I accepted the opportunity to explain to some of my classmates about my epilepsy. I was going to tell them an imperfection about myself that would give them an open door to either respond appropriately or to harass me. Nevertheless, I stepped forward and explained the depths of my disorder to about twenty-five other sixth graders and my science teacher.

After my five-minute speech on epilepsy, my science teacher came to me and told me how much she enjoyed my report. After a few days, I received back my report with a big *A* on the inside cover. My personal goal to receive an *A* had come true. At report card time, I received one *A*, three *B's* and one *C*. In addition to making the honor roll, I received some cold cash as a reward from Mom and Dad for my achievement in school. My family and I were encouraged to know that my grades had improved drastically since the previous year when my teachers were considering holding me back. My success in the sixth grade showed me that there *was* hope for me to achieve in school after all. I must add that the support I received from my science teacher that year made all the difference in my high achievement and my attitude toward learning.

> *When teachers cannot take away a student's painful circumstance, their show of support, encouragement, and love helps him make the grade and makes a world of difference.*
> Amy

In the midst of the cold winter months that year, I came down with the flu and was home for several days. The presence of an infection or a virus in my body always increased my seizure frequency. The combination of my immune system

fighting a disease and my consumption of cold medicine triggered more seizures and caused me to sleep more than usual.

One night I set all of my medications out on the kitchen table to prepare for my night dosages. The combination of medicines for my seizures along with medications for my flu symptoms made a grand total of thirteen bottles of oral and topical remedies. Mom was stunned when she saw all the medicines I had placed on the table. At first she thought I had taken all the medicines out of the medicine cabinet as a joke. After I convinced her that every medicine on the table was something I needed to take, she advised me to take only part of them and to take the rest an hour later. We both knew that taking multiple medicines had upset my stomach in the past, so the fewer medicines I took at one time, the better I would feel.

The next evening, as I lay on a sheet on the sofa, Mom came in to check my temperature. It was 104°. Knowing that my seizure disorder itself was caused by a high fever, I understood the importance of keeping my temperature down in the normal range. My parents had the same concern, and it was probably on their minds moreso than it was on mine. My high temperature remained an unspoken topic until Dad came through the living room and said, "We need to keep her fever down. Remember what happened last time."

"I know, Steve. I gave her Tylenol, and she has a cold washcloth on her forehead," Mom replied.

"When do you think I'll be able to go back to school, Mom?" I asked.

"That's hard to say. Maybe by early next week. Your fever will have to drop before I send you anywhere. But it's good to know that you miss being at school. You're liking school this year, aren't you?"

"Yeah, I am. I like my science teacher the most. She's a great teacher. I like taking in toads and snakes to her class. Mom, did I tell you that another girl in my class took home the two-tailed snake that I took in?"

"No, you didn't. I'm surprised you gave away that snake!"

"I would have had to let it go sooner or later. But I got extra points in science for bringing in snakes and toads. Not

many other kids are bringing in any critters. Maybe they can't find any toads or snakes in their yard."

"Or maybe you're the only brave one in your class who will pick up just about any critter out there!" she said with a smile as she jiggled me.

"I don't think so, Mom. The other kids are interested in what I bring in. Some of them touch the toads and snakes that are in the bucket in the science room."

"Well, that's enough snakes for now. Is there anything that I can get for you? Would you like more orange juice or crackers or anything at all?"

"I'll take some more orange juice, please."

"Okay, I'll be right back."

While I had the flu, my fever never exceeded 104°, which was only two degrees less than the temperature that I had as an infant when I went into a convulsion. We were all very grateful when my fever started lessening and dropped out of the dangerous range. One question that I had not found the answer to while writing my report on epilepsy was whether or not a seizure disorder could worsen as a result of a high fever. I was sure that it was possible, but I didn't want to find out from experience either. Within a week after recovering from the flu, I was back at school working diligently again to receive more *A's* and *B's*.

Toward the end of my sixth grade year, my doctor instructed me to increase my medication. My doctor's reasoning for increasing my dosages was the very fact that I was still having seizures. As in the past four years, her goal was to have my seizures controlled—at any cost. Anytime my medication was increased or decreased, I always experienced some type of side effect as a result of the chemical change that occurred in my system. This particular time when my medication was increased, my seizures became more intense, although they were less frequent. Once again, my medication was increased. Despite the adjustments in my medication that semester, I finished the school year receiving mostly *B's* on my report card. I attributed my success in school that year to two factors. The

first factor was that my medication level remained in a safe therapeutic level so that I was able to concentrate on my work. Second, my science teacher's enthusiasm for science helped motivate me, and she's the one who encouraged me to begin to understand my epilepsy. Knowing of the improvement I had made, my parents were glad that I had been promoted to the sixth grade the previous year. After a successful year in school, I was looking forward to another summer of swimming, playing softball, eating ice cream, and finding those beloved critters.

That summer, I played first base, and occasionally I played third base. I loved playing first base. Being one of the tallest girls on the team, I could catch almost any ball that was over my head as well as those that were several feet away from the base. I often went home with a sore left hand from the impact of the ball hitting my glove, but the pain never stopped me from enjoying a great catch. Again, the heat in the summer along with my physical activity on the ball field resulted in increases in my seizure frequency. After seven innings and several catches at first base, the combination of my energy being depleted and my being excited about the game triggered a seizure. Even though I was always tired after having a seizure during a game, I still had the strong desire to compete. After getting a drink of water from the community Thermos and receiving a courteous word from my coach, I was back on the field, waiting to catch the next firing ball. Having being undefeated all season, my team won the championship. The summer was completed after receiving a champion plaque and a team portrait for my scrapbook.

Chapter 6

Milestone

With summer's end, I once again started school. Having received good grades in the sixth grade, I anticipated receiving good grades in the seventh grade. To my surprise and disappointment, in the first quarter of seventh grade I received mostly *C's* and *D's*. During this time, Mom talked with a staff member of the school several times to discuss my grades and the possible solutions to my problems. After reviewing my academic record and learning about my epilepsy, a staff member told my mom that he wouldn't be surprised if I did not graduate from high school. At a time when my mom needed to hear words of encouragement, she received only gloomy words about my future.

I was aware that my academic struggles took a toll on Mom's emotions, and I dreaded to see her hurt over my effort to make the grades. Although I knew about the obstacles in my way, I didn't know what to make of them. I was aware that most of my problems were the result of having seizures and being on a large quantity of medication; however, I had no idea how to correct my problems. The only solution that came to my mind was for the problem in my brain to be removed. But at that time, the removal of the problem seemed too radical and highly unlikely.

By the fourth month of school, intervention took place. After the completion of an intelligence test and other academic tests, the results showed that I had an average intelligence, but lagged in the area of reading and writing. After an intense meeting involving both of my parents, all of my teachers, a school psychologist, and the guidance counselor, a decision was made to place me in the resource room where I would receive one-on-one

attention. I was pulled out of my English, science, and social studies classes, and I reported to the resource room three hours a day. Memories of being on the honor roll the previous year surfaced in my mind as I thought about being a student in the special education class. My circumstance just didn't make sense, but who was I to say that I did not belong in with the special needs kids. I was just a kid myself!

The special education teacher was a sweet lady who called my parents anytime I was absent to see how I was doing. She recognized that I was diligent in completing my work, and she often used me as an example for the other students who procrastinated in doing their work. In addition to attending the resource room, I was tutored at a college two nights a week. As my education required the aid of special services, I figured that going to college after high school graduation was totally out of the picture.

I had several obstacles to cope with that year. I was a thirteen-year-old girl who had just entered puberty and who had all the normal changes to contend with, in addition to matters related to epilepsy. I was on medication that affected my intellectual ability, and my grades were below passing in most classes. Even though I remained friends with Marjorie, things just were not the same since I was not in classes with her. Being separated from my closest friends and my peers for half the day made it difficult to maintain friendships and acquire new ones. Deep in my heart, I knew that I could learn—I just had circumstances to contend with that none of my classmates had to cope with. I was different from the others.

The most obvious sign of any emotional turmoil was my not wanting to get up in the morning. Mom took me to school about two to three times a week whenever I slept in so late that I missed the bus. Although I may have had a need for more sleep since I was on lots of medication, I had no motivation for getting out of bed. Staying in bed would prolong my experience of going to school. This reluctance to attend school was only the beginning of turmoil in my adolescent years.

Although my academic standing had stabilized with the aid of special services, Mom was still concerned about my being on a high level of medication. She was concerned that the medication would have a long-term effect on my thinking and learning abilities. But she was also aware that a decrease in my medication would trigger more seizures. That winter, I went for a blood test to determine if I had reached a toxic level of seizure medication. Thereafter, my doctor did not consider my levels as being too high. I continued taking the same dosages despite the side effects of the seizure medication. My taking a high level of medication made my ability to comprehend a reading text next to impossible. So the battle continued for my parents, teachers, and doctor to find a balance between trying to control my seizures and still having my medication at a level which enabled me to learn. In the midst of these struggles, there was no clear solution.

By the end of the school year, my parents did not notice any drastic change in my academic standing or medical condition. Neither were they content with the opinion of my doctor in Detroit. My ongoing problems led my mom to want to search for a different neurologist in hopes of hearing a different opinion regarding the approach to my medication therapy. Just as any mother would desire for her child, my mom wanted me to succeed in school and be a healthy child. She wanted to see me graduate from high school and go to college. But the lack of progress that I had in junior high school made Mom concerned about my future, and she knew that something had to change. The negative comments that my mom had heard merely increased my parents' concern about my future.

As my parents prepared to take me to another neurologist, Mom asked Aunt Gladys if she knew of any well-respected neurologists in the Grand Rapids area. My parents figured that a big city such as Grand Rapids was likely to have several neurologists to choose from. Aunt Gladys asked her church group about neurologists in the area; she soon gave my mom a list of the recommended doctors.

The summer between seventh and eighth grade, I played softball and experienced more seizures while I was out in the hot summer sun. For the third summer, I was the first baseman. I had a lady coach that summer who also was aware of my condition. I was well pampered whenever I had a seizure. After one of my seizures, she asked if I wanted to stay out an inning. I thanked her but grabbed my glove and ran out to the field. Although I felt a little tired, I had the team spirit and the desire to be out there with the rest of the team. There was no stopping me from playing first base. For me, I enjoyed being on an undefeated team. My weakness was at batting, but I made up for it in the many opposing players that I put out while I played first base. For the third year in a row, my team won the tournament.

In the middle of the summer, I went to the dentist for my sixth-month cleaning. I always liked going to the dentist because this was one doctor that generally gave me positive comments about the results. Throughout my entire childhood, I never had a cavity, and I did not have any major work done on my teeth. The only concern that the dentist always remarked about was my gums. I was taking Dilantin, which caused my gums to be enlarged. This condition is often called *hyperplasia,* which is "the increased production and growth of normal cells in a tissue or organ" (*Bantam Medical Dictionary*, p. 219). The dentist understood why my gums were enlarged, but I knew it bothered him. My gums were the only imperfect part on the inside of my mouth, and there was nothing the dentist could do about it. The problem was all related to my being on Dilantin.

By July, Mom made an appointment for me to visit a neurologist in Grand Rapids. This doctor had been in practice for several years and seemed like a great choice. After my mom made several phone calls to the doctor's office in Detroit, my doctor finally released my medical records to the new doctor. I clearly remember the first appointment with Dr. VanDyke.

As I sat in the clean and modern-looking waiting room, I wondered what this doctor looked like and what Mom would

think of him. Mom filled out all the paperwork that seemed to take hours. I was called back to the examination room within a matter of minutes. The doctor asked several questions about my history with seizures and seemed very thorough and precise. During the appointment, he asked about our family's experience with the last doctor.

"What is the name of the doctor to whom you took Amy before now?" he asked. My mom told him her name, and the doctor reached for a reference book on his shelf.

"She is not a neurologist. She is doing her fieldwork to become a neurologist," he said in a sincere voice.

"What?" Mom replied in shock. "You mean to say that all those years that I took my daughter to Detroit to see a specialist, that I wasn't seeing a specialist at all?"

"That's right. She doesn't have her degree in Neurology just yet. She is only practicing to be a Neurologist, "the doctor replied.

Mom was stunned, and so was I. Dad and Mom had taken me to the doctor in Detroit when I was in the second grade with the hope that a doctor who was trained in the area of neurology would be more equipped to treat my seizures, only to find out that I was seemingly a patient for her to practice on to become a neurologist. The trial-and-error treatments that the doctor in Detroit made on me would be the basis of her decisions for future patients. As one could expect, Dad and Mom were thankful they had decided to take me to another doctor—a *real* neurologist! After learning about the other doctor's position in the field of medicine, the phrase "practicing medicine" took on a new meaning for my family.

Dr. VanDyke reassured us that he had his M.D. in neurology and that he had done this type of work for many years. He then shared with us some matters about his family, and Mom shared similar things about our family. He was very personable and expressed concern and interest in my condition. In addition, Dr. VanDyke's views on the changes that should be made to my dosages of medications were well received.

"Amy may be better controlled with her seizures if she is on fewer medications. Some medications will actually fight

against one another, even though they are intended to do the same job," the doctor explained.

"Do you think that Amy's grades will improve once she is on a different medication? Amy often cannot comprehend what she is reading. My main concern is her learning capabilities and what the three medications she is taking are doing to her thinking ability," Mom expressed.

"After we decrease some of the dosages and Amy reaches a therapeutic level, we should see an improvement in Amy's alertness. Depakene is often more toxic than the other medications. I would like to eventually take Amy off the Depakene. By taking her off this medication, there is the possibility that her comprehension level will improve. We will need to keep in touch and determine along the way if the decrease of the medications is causing any difficulties or improvements in Amy's over all well-being. But first, I want to run an EEG, and we'll take it from there. Do you have any other questions or concerns?"

"No, I don't think so. But I want to say I am really happy that we came to you. You seem so knowledgeable in the area of seizures," Mom expressed.

"Thank you. I hope I can help Amy. I am willing to help in any way I can. Please let me know if you have any concerns. You can call my office anytime. There is always someone on call if there is an emergency after office hours."

"Thank you, and it was nice meeting you," Mom replied.

"It was nice meeting both of you. And smile, Amy," Dr. VanDyke said. I gave one of my half-hearted smiles as we walked out of the room to the receptionist's desk. As I walked out of the neurologist's office that summer day, I wondered if the medical and academic turmoil in my life would ever come to an end.

As I entered the eighth grade, I remained in the resource room for one hour a day and returned to social studies and science classes. In September, Dr. VanDyke changed my medication by adding Tegretol and decreasing Depakene with the intention of eventually having me completely off Depakene and taking only Tegretol. Dr. VanDyke explained that Tegretol was a new medication at that time and had fewer side effects

than Depakene. My switching to this new medication would hopefully help my alertness and my academic performance.

Within the second month of taking Tegretol, I started experiencing a drug reaction. My lips became swollen and took on a black-and-blue color. The pain I experienced in my lips made it hurt to smile. A rash developed on my chest and arms. For about three days I went to school looking as if I had been punched in the mouth by a football player. At a time when physical appearance was becoming more important, I had to contend with having enlarged lips that were discolored. I often wondered what my peers were saying behind my back about my unusual lips. A few of the popular girls in my class made a few comments, but most people, including teachers, didn't ask. Along with having a change in my appearance, I also fell asleep in some of my classes day after day. As I walked down the halls to my next class, it was all I could do to stay awake.

After a few days, Mom took me to my neurologist in Grand Rapids for an emergency visit. Dr. VanDyke said that this was the worst case of a drug reaction to Tegretol that he had ever seen. He mentioned that he would consult with another doctor about the likelihood of it being Steven-Johnson Syndrome, but in the meantime, he wanted me to decrease my levels by 100 mg over the next twenty-four-hour period and then totally discontinue the drug. I would then remain on the medication I was taking prior to changing to Tegretol. As Tegretol was decreased, so did the size of my lips. Within three or four days, I was able to enjoy a joke without feeling physical pain when I smiled. No longer did I have to tell my family not to make me laugh. Many weeks after Tegretol was discontinued, I experienced two or more seizures a week and battled with falling asleep in class after having two or more seizures during the school day.

In mid-October, one of my closest friends had a sleepover at a campground near our hometown. Four of my friends and I took sleeping bags, pillows, pajamas, and flashlights to get us through the night. After we arrived at the campground, we pitched a few tents and arranged our sleeping bags in preparation for the night.

Tiffany's mom along with my mom where there to keep the fire going and to look out for the werewolves and bears that might sneak up on us. After we played a few games of hide-and-go-seek, tag, and had a scavenger hunt, we each grabbed a can of Coke and rested. Mom went home to get some supplies that we were lacking.

Being at the campground reminded me of when I went to fifth grade camp, but without the teachers and the convenience of inside facilities. Under the starry sky, we ran through the forest, roasted marshmallows, and giggled over the most ridiculous things. We were just teenagers without a care in the world, having fun in our adolescent years. About an hour later, my mom drove up the wooded path that led to the campground. I was glad to see that she was back with us.

Tiffany's mom walked toward my mom's car to help carry the supplies. Both moms stood near the car talking for about five minutes. I figured they were planning the rest of the activities for the evening. I saw them embrace as I continued throwing popcorn up in the air and trying to catch it with my mouth. The smell of autumn and the thoughts of bears and snakes filled my mind.

"Hi, Amy. It looks like you are having fun," Mom said as she approached our camp. "Amy, I need to talk to you for a minute." There was a long pause. I walked over to her. I could tell by the expression on Mom's face that something serious had happened.

"Aunt Gladys died just a few hours ago," she said with tears in her eyes. All I could do was wrap my arms around my mom. The sweet songs of hymns and the jovial laughter were now silenced. Mom continued by saying, "When I got home, a nurse from the nursing home called and told me she had died." We both shed some tears as we began to grieve over the loss of a wonderful lady. I remained quiet as the seriousness of the situation settled over me.

"I still need to contact some of the family to let them know. I just told Betty that it will be best if I stay at home tonight. I need to be with your father through this. But I will be back in the morning to help with breakfast. I would love to be here and

that's what I had planned on doing, but under the circumstance, I need to be home. I hope you understand."

"I understand. I'll be all right," I replied.

"I love you, Amy." She bent down to give me a kiss, and we embraced even more strongly. "And you have a good time. Make sure you take your medicine tonight. Have you had any seizures tonight? You have been quite active."

"No," I said in a quiet voice.

"Good. Let's keep it that way. Betty knows that you take medicine, and she will make sure you take it."

"Don't worry about me, Mom. I'll be all right."

"I know you will. But I'm your Mother, and I'm just concerned for you. That's part of being a mother."

I was used to Mom being protective of me. Ever since I could remember, Mom made sure that I was well cared for and that I took my medication on time. During special occasions, I was more likely to have seizures and forget to take my medicine. But taking medicine was part of my life, and very rarely did I forget to take it. Taking my medication was as easy to remember as it was to remember to eat and brush my teeth. Taking pills was part of my daily routine.

"I had better go. Dad is at home, and he is expecting me to return right away. Give me a hug." Again, we embraced and expressed our love toward one another.

"Bye, Mom. I love you."

"I love you too."

She left, and I remained quiet for much of the evening. I thought about Aunt Gladys and all the joy that she had brought to our family. The previous two years she had remained in a nursing home, but someone in the family went to see her every week and on holidays. Even in her later years, she had a warm spirit about her that will always be remembered.

After hours of giggling and playing games, I took my medicine with a drink of Coke and then I drifted off to sleep. My childish thoughts swept over me as I thought about what or who might get me in the middle of the night. Every breeze and every roll of a body in a sleeping bag made me ask myself, *"What was that?"* I knew the morning would be there soon enough, and there was probably nothing to be concerned about.

Sure enough, I awoke to the smell of breakfast cooking over the campfire. Mom was there helping to make the pancakes and hot chocolate, just as she had promised.

The family grieved for days after the funeral, and still today, our eyes fill with tears when we talk about Aunt Gladys. She was my great-aunt, and *great* is an understatement. Even years later, I often imitate her operatic voice by singing "Amazing Grace" or other hymns. Jack always faired pretty well when my Aunt Gladys was at our house. Gladys often snuck food under the table to Jack while we were eating dinner. As for our family, her humor, her faith in God, and her singing will always be remembered and cherished.

The summer after I completed the eighth grade, I willingly inherited Steve's paper route. I pedaled up a hill to the nearby neighborhood each weekday to deliver about forty newspapers. Since Steve had the route, delivering papers had became a family event. It did not matter if the climate was sunny, rainy, or snowy; in all types of weather, my parents got up early every Saturday and Sunday to help me deliver the morning news. They looked forward to the exercise while I was motivated to get every paper delivered to the appropriate houses by 8:00 a.m. With Dad and Mom's help, I proved to be an on-time and efficient delivery girl seven days a week. Breakfast at a local restaurant often followed the delivery of the morning news and made awaking to the early alarm worthwhile.

Mom and Dad were a little apprehensive about letting me ride my bike up the hill to deliver the papers. They were concerned that I would have a seizure and not be able to get off the road in time if a car was coming. I explained that I knew when I was going to have a seizure, and that I had enough warning to be able to get off the road before a seizure took full course. Even so, they felt uneasy about letting me ride the hill everyday on my own. The majority of days Mom or Dad came home shortly after 4:00 p.m. and drove me and my bike up to the nearby neighborhood. On occasion, I rode my bike up the hill

when my parents had other obligations. About the only time that I had a seizure on my route was toward the end when I was physically exhausted and overheated. Although there were a few hurdles to work around with having seizures, the responsibility I learned and the opportunity of dealing with adults were two very rewarding factors of my having a paper route. I continued my paper route through most of my high school years.

That summer, I went with my cousin to West Virginia to a Christian camp. Dad and Mom took responsibility for my paper route as I rode a church bus southeast to West Virginia where I would spend time with other teenagers and hear some preaching. One evening as I sat listening to the preacher speak on Psalm Twenty-Three, I wept as my soul trembled with fear about my future. *How can God love me? My life is full of pain and problems that no one understands.* The tears that I shed that evening reflected the invisible prison cell in my life that only I could see and feel. My peers didn't understand epilepsy and frequently gave me condescending looks and remarks about my seizures. My falling asleep in class and my walking down the halls looking exhausted gave my peers even more reason to criticize me. In less than two years, my friends would receive their drivers' licenses. In a few months, I would enter high school where classwork would prove to be more challenging. Having been placed in a special education classroom in junior high, I doubted if I would even graduate from high school. As I heard the preacher say, "He restoreth my soul," I cried out to God, "Take this pain away! I can't take this anymore!" The grief of my past and the fear of my future pressed against my mind from every direction. Only God knew of the fear that ruled my soul which had created my quietness and introvertedness. My family, friends, and teachers seemed to be blind to the hurt that lay in my soul. The pain that came from my sorrowful experiences occupied every crevice of my heart—a heart that had not yet grown to full maturity.

> *Sorrow is better than fear....*
> *Fear is a journey, a terrible journey,*
> *but sorrow is at least an arriving.*
> Alan Paton: Cry, The Beloved Country

CHAPTER 7

Adversity

1985

As I entered my first year of high school, I enrolled in traditional classes. The school had determined that I no longer needed special assistance and was considered eligible to attend regular classes all day. After my teachers reviewed my eighth grade academic standing along with my formal testing scores, they came to a consensus that I was capable of keeping up with high school work. But I soon learned that being competent in a class and being comfortable in a class were two different things.

On my first day in health class, the class watched a film on alcohol and the effect it has on the human mind. After the video, a male teacher spoke with confidence and sincerity about the content of the video. He began by saying, "Alcohol can affect each person differently. Some people can drink three beers and not get intoxicated. Others can get drunk after drinking just one beer. As you saw in the video, people with epilepsy who consume any amount of alcohol are likely to have a seizure. . . ."

I froze as I listened closely. Although I had never taken a drink, I knew the truth of what he was saying. I was subdued and felt uncomfortable as the teacher spoke about a topic that was all too familiar to me. Such a personal issue as epilepsy was being addressed in the classroom, and I knew that I was probably the only one who could actually relate to what he was saying. The teacher then increased my uneasiness as he attempted to demonstrate to the class what a seizure looks like. Part of the class chuckled at the uniqueness of his motions. *You have no idea who I am!* I thought to myself. A topic that came to be an informative and light issue to the majority of the class came across to me as being very offensive. The deepest mystery of

my life was regarded as a humorous issue in front of several of my classmates. What the teacher had said in class and acted out was all too real and seemed more like a knife piercing through my heart than a piece of useful information that would be added to my bank of knowledge. The teacher continued his discussion on the use of alcohol and gave some precautions to the freshman class about such practices.

After this uncomfortable experience in health class, I didn't know if I could ever tell another teacher about my seizure disorder. Although this particular teacher had no knowledge of my condition and didn't intend for his comment to be directed at me, the attitude that he displayed about seizures made me think that he didn't have compassion for students who weren't considered "normal." My inner pain about my seizures and the future welled up inside my heart as I waited for class to end. After the bell rang, I walked out of class thinking that I would never tell another teacher about my epilepsy.

As I continued my education in a public school, I longed for my teachers and peers to have a mature attitude toward my situation. Throughout my high school years, I heard other casual yet unintended critical remarks about epilepsy from students. These comments that reflected their lack of understanding about epilepsy led me to have a lack of trust in many of those who I was around five days a week.

Although many people in my high school did not understand epilepsy, my band director was one who expressed much compassion toward my having seizures, and she showed flexibility when I had a seizure in class. The band students, my director, and I all worked together in such a way that we were like one loving family. The respect and team camaraderie among the band members and instructor made me at ease about the possibility of having a seizure in band as I knew that not one person in that class would criticize another member of his group. Several students had questions about my condition, but none of them were condescending in their reactions. The positive relationships that I developed with the band members, along with my interest in music, gave me a minute sense of encouragement about my future. In the marching band in con-

cert performances, I held hope in my heart that my epilepsy would *one day* be cured.

A few months later in English class, my English teacher took the students in my class to the library for an orientation session on how to research information in the library. When I first walked into the library, I noticed that the temperature was much warmer than in the halls and the classroom that I had just came from. During the presentation by the librarian, I started getting warmer and warmer. Soon I sat down and laid my head on a table. I thought I was going to faint. I had no indication that I was going to have a seizure, but I knew I didn't feel well. Within a minute, the teacher came over and put her arms around me.

"Are you all right, Amy?" she asked.

I shrugged my shoulders. "I don't feel well. I'm overheated." She felt my forehead.

"Do you want to go lie down in the sick room?"

"Yeah," I replied in a soft voice. She walked with me to the sick room and helped me onto the cot.

With a sincere voice she asked, "Amy, are you on drugs?"

I was shocked at her question. "No!" I replied in a firm voice. "I just feel warm all over. I was getting too hot in the library, and I thought I was going to faint."

"Okay, well you can lie down and come back to class when you feel better."

She closed the door as I lay there feeling ill in two ways. I felt sick due to being overheated, but I was also disturbed at the nature of the teacher's question. The fact that a teacher asked if I was on drugs seemed to build a bigger wall between me and my authorities regarding the understanding of my medical condition. Even though I was convinced that this episode did not relate to my seizures, similarities existed between this incident and the times when teachers and other adults didn't understand my personal medical needs. I was one of the "drug-free" students in a public high school. While desiring to be the best person I could be at school, a teacher asked if I was on drugs. I couldn't understand why teachers didn't know my character well enough to know that I was not one who took substances

that could be harmful to my body. Once again I was disturbed that a teacher did not really understand who I was.

About five years after this incident, my heart was tested, and it was determined that I have mitral valve prolapse, a condition in the heart in which a valve doesn't open all the way. Sometimes the valve comes near the closed position and will remain there for several minutes. This decreases circulation and oxygen to the brain, which causes a person to feel lightheaded. The warm temperature in the library that day only contributed to my problem.

Throughout that year, I continued having psychomotor seizures an average of two per week. Only on occasion did I feel like falling asleep in class, but I always managed to stay alert, despite my feeling exhausted. I completed my freshman year excelling in two areas: algebra and band. With the exception of my academic grade in social studies, I received average to above-average grades in all of my classes.

The annoying bell rang as I sat in English class waiting for the teacher to introduce the students to a new school year. As I sat patiently for my sophomore year in high school to begin, I wondered what events would transpire that year. I had made it through my first year of high school with passing grades, but I knew that having success one year did not always mean that I would receive passing grades the next year. However, since I was taking two medications instead of three, there seemed to be hope that I could achieve in school without the influence of heavy dosages of medication.

As I sat thinking about the year ahead, I was excited about taking the second part of algebra and being back with my friends in band. Math and band were what I lived for in high school. I was one of the top students in algebra class, and being in band gave me an opportunity to be with people who were a little crazy but who could also be serious and work together. Despite the squawks and multiple tempos throughout the band,

we were one happy group of musicians on the football field and in concert performances.

Later that year I took an interest in playing the saxophone. After five years of playing the clarinet, I wanted to learn to play another instrument. I pulled out my Grandpa Crane's C Melody saxophone and soon discovered that it needed many repairs. I also learned that people didn't play the C Melody saxophone any more, and it was an inadequate instrument to play in the band. Although I enjoyed playing with my grandpa's saxophone, I soon put it aside and began looking in the newspaper for a good used saxophone. In the meantime, I continued playing the clarinet.

That fall, I turned sixteen. Unlike most teenagers, I was not looking forward to turning sixteen. Having to face up to the fact that I was not allowed to drive seemed unbearable. I avoided discussing it with people who brought up the topic, and in fact, I didn't even care if I had a birthday party. The glory of turning sweet sixteen was nonexistent as far I was concerned. I remembered when Angie and Steve turned sixteen and the excitement that it brought to them. Mom and Dad purchased a used car for each of them. But I had no part in such an event. Reflecting on how excited Angie and Steve were when they turned the legal driving age made it that much harder for me to enjoy my sixteenth birthday. Yes, the Indian tribe members had reached their final destination, and I was the only one who could not partake in the feast.

Regardless of the bitterness that I held within, my family planned a surprise birthday party for me. With the company of grandmas, aunts, uncles, cousins, and friends, I put on a face of happiness and appreciation. I endured the day while I longed to be alone, away from the cheer and celebration.

After the festivity of my sixteenth birthday, life went on but so did my determination to acquire that which was considered off-limits in my life. Because of my seizures, Mom was apprehensive about letting me get behind the wheel, even to take a short drive. She did, however, allow me to drive to the grocery store with her in the car on two or three occasions. I

assured her each time that I felt fine and that I could make it to the store without having a seizure. In reality, that was not totally true because my auras lasted for fifteen to twenty seconds, and then I was in a full seizure. There simply was not a lot of time to do anything to prepare for a seizure. Nevertheless, on a few occasions I drove the family car to the store with my mom in the passenger's seat.

Each time Mom and I went to the store, I asked if I could drive. About four months after I turned sixteen, Mom told me that she was not going to let me drive anymore. Mom came to the conclusion that it was not right to put other drivers on the road at risk of getting in an accident, let alone her life and mine. She was right. If I had a seizure while driving, I would have lost control of the car and gone into the ditch, or hit another car, or who knows what else. After Mom stopped letting me drive, I stopped asking. Since not being allowed to drive became a sore point in my life, I avoided talking about the matter so that I didn't have to be reminded of my personal limitations.

Although I did not receive a car for my sixteenth birthday, I did receive a gift that Christmas that I was hoping I for. Dad and Mom gave me a used saxophone. I didn't mind that it was used because I knew saxophones were expensive, and Mom and Dad had already purchased a clarinet for me. After the Christmas season, I started taking private saxophone lessons. Once I knew the basic scales and a few songs on the saxophone, I joined three guys and one other girl in the saxophone section in the band and prepared for the spring concert.

During that winter, I went for my annual checkup at my neurologist's office. As with my prior appointments in Grand Rapids, I looked forward to this appointment. I enjoyed listening to what the doctor had to say about my seizures as I still had hope in my heart, just as I had when I was eight years old, that *one day* I would be cured of my seizures. Although the doctor did not perform any miracles at this appointment, he did bring my Mom and me a bit of encouragement. After the nose to finger test and walking across the floor toe-to-heel, then Mom, the doctor, and I sat down to discuss my level of medication.

"Let's see. You are on 60 mg of Phenobarbital, 1250 mg of Depakene, and 325 mg of Dilantin," the doctor reiterated. He also reviewed with us the times I should take each dosage to insure that I was taking my medication appropriately. "I would like to start tapering her off Phenobarbital. Amy has been on Phenobarbital since Moby Dick was a minnow." We all chuckled, but agreed with the truth behind his statement. Phenobarbital was the first medication that I was on as an infant. He continued explaining his reasoning for wanting to discontinue my use of Phenobarbital.

"One of the side effects of Phenobarbital is that it can make a person tired. It can also affect a patient's clarity of thought. There is a possibility that Amy will feel better and her seizure frequency might improve once she is taking only one medication instead of three medications. Because Amy is going through adolescence, it is even harder to control her seizures. Amy has the type of seizures that are the hardest to control, and the physical and chemical changes that she is going through are increasing her seizure frequency. If we can get her on just one anticonvulsant, she may have fewer seizures. I have found this to be true with several of my patients."

"That sounds all right with me," Mom replied. "I have always been concerned about the high level of medication that Amy has been on. I know it has played a big role in her ability to concentrate, and sometimes she has felt sick to her stomach as a result of taking so many different medications. What do you think about this, Amy?"

"That's fine," I said in a quiet voice. I felt inferior to Mom and the doctor. Actually, I couldn't agree more with the doctor, but I didn't think it was my place to say what and how much medication I should take. Even though I had experience with having epilepsy, I viewed my epilepsy as being a complicated matter and had no knowledge of which medication was best for my seizures.

"We tried Amy on Tegretol about four years ago, and she had a drug reaction to it. I would like to reintroduce Tegretol to see if Amy's system will accept it this time. Because her body chemistry has changed since she was last on Tegretol, we may find that Tegretol will prove to be effective the second time. If

this approach sounds all right with you Brenda, I'll send you a letter explaining how I want you to taper off the Phenobarbital."

"I'm fine with that idea. I don't see any harm in trying Tegretol again," Mom replied.

"If you have any questions or if Amy starts to have any problems, just give me a call."

"Thank you. You are a wonderful doctor. I am so glad that you are willing to try something different. Sometimes I worry about her. I want her to go to college and to live a healthy normal life," Mom expressed.

"I understand. And that's part of my goal—to get Amy to a tolerable range without the heavy side effects. Amy is a bright girl. You should be proud of her," the doctor replied.

"I am. On her last report card, she received an *A* in band and an *A* in algebra! Amy has always excelled in math," Mom said with a smile as tears came to her eyes.

"How are her other grades?" asked the doctor.

"Oh, she struggles in social studies and science. I think she got a *C* in science and a *D* in history this last quarter. I know she studies a lot, but it just comes hard for her. Her science teacher said that Amy pays attention in class and that she does her assignments. But she works hard to get a *C*."

"Well, taking her off the Phenobarbital may help the situation. Phenobarbital can be a dangerous drug to be on. If seizures increase, I may increase the Depakene. Although Depakene has side effects, it isn't as dangerous a drug as Phenobarbital. Well, Amy, I wish you the best as you finish up this school year. Keep up the good work."

"Thank you," I replied.

Dr. VanDyke shook Mom's hand and led us to the receptionist's desk. Mom and I left there that day with a positive outlook about my going off Phenobarbital—the drug I had been on since Moby Dick was a minnow. We both knew my going off this seizure medication was long overdue.

Over the course of a four-month-period, Phenobarbital was decreased from 60 mg to 15 mg. Despite my experiencing a minimal increase in my seizure frequency, I was able to receive passing grades in school and remained my quiet self. Dr. VanDyke, however, decided to increase my Depakene dosage. A blood test

showed that my Depakene level was low, which was attributed to the developmental changes that occur during adolescence.

During my second semester of my sophomore year, I had a basic writing class first hour as one of my English credits. At the beginning of that semester, I looked forward to this course and hoped to be able to express myself through writing. Although I had an interest in the subject, there was an environmental factor that bothered me in that class. The teacher wore a certain cologne, and I disliked that cologne like a cat dislikes being rubbed the wrong way! If the teacher had been a friend instead of an authority figure, I might have told him I didn't like his cologne. But I couldn't bring myself to ask a teacher to stop wearing that awful stuff!

Unfortunately, it was not just a personal preference that became the issue. Quite often when I smelled colognes or perfumes, I felt an aura begin within a matter of minutes. During that semester, I had more auras in that class than any other class. However, not every aura turned into a seizure. In and out of class I had auras as a result of smelling particular scents. Sometimes my auras dissipated and weren't anything more than an internal sensation. But when I could smell his cologne, I usually experienced an aura, and sometimes a seizure.

One day in basic writing class, one of my auras turned into a seizure. After I came out the seizure, the teacher motioned for me to come up to his desk. I told him that I was all right, but I did not mention what had happened. I wasn't sure if he knew I had epilepsy, or if he would understand if I told him the truth. He asked me if I could find my next class on my own, and I assured him that I could. The following day, he talked to me in the hall after class.

"What happened yesterday, Amy?" the teacher asked.

"I had a seizure. I have epilepsy," I replied.

"I didn't know that. How often do you have seizures?"

"I usually have two or three a week. I'm changing medications right now, so I'm having more seizures. Once I am on one medication and my levels stabilize, I should have fewer seizures. But during this transition period, I'm experiencing more seizures."

"I see. How are you after a seizure? Do you need anything afterwards?"

"No. I am usually tired, but there's nothing I can do about that while I'm in school. I just have to keep on going. I never know afterwards what happened during a seizure, so there may be times when I need to stay after class in order to find out any assignments. But I can usually pick up where I left off with little or no help," I explained.

"Okay, I'm glad to know that. You scared me yesterday. I could tell that something was wrong, but I didn't know what. One of the other students noticed that you were experiencing something, and he came over to you. Do you remember that?"

"No. I have no idea what's happening around me when I'm in a seizure. It's best not to touch me or talk to me during a seizure. I get more confused and my seizures often intensify when someone talks to me or touches me. My seizures just have to run their course."

"Okay, thank you for sharing that with me, Amy. I'll write you a pass to your next class. What do you have second hour?" he asked.

"Typing," I replied.

"Okay, here's a pass. And you have a good day, Amy."

"Thank you. You too."

As I walked down the hall to typing class, I wondered why all of my teachers were not informed about my seizure disorder. Though I wanted them to know about my medical condition, I didn't want to be the one to tell them. As a teenager, I didn't have the courage to go up to each one of my teachers and explain that I was *different!* Plus, I just figured that all of my teachers should have found out that type of information by reviewing my academic file.

During that semester, I fell asleep in basic writing class several times. The combination of the medication change, the early hour of my class, and the smell of the teacher's cologne in the room all attributed to my seizure frequency and my falling asleep during class.

At times, even though a seizure may have appeared to have ended, it was still running its course. Before I could regain full awareness after a seizure, people would often ask me if I was okay. Others assumed that the seizure had totally subsided since my eyes were no longer contracting or dilating and since my right hand had stopped making unusual movements. In reality, even when there was minimal or no indication that anything unusual was happening, the seizure was decreasing in its intensity, but it had not completely ended. As early as my high school years, I had formed a subconscious response to peoples' questions of concern that came toward the end of my seizures. Even though I had not regained my clarity of thought at that stage of my seizures, my reaction to other peoples' questions was always, "I'm all right." However, very rarely after my seizures had fully ended did I ever remember speaking these words to others. In essence, I had developed an automatic defense mechanism in order to lessen other peoples' concerns and adverse reactions to my disorder.

As with many high school students in today's society, several of my peers went to a lot of parties. Drinking and getting drunk was the norm. Unfortunately, some students drove cars while under the influence of alcohol. Every year during my high school years, there was at least one death among the students. The morning after each tragic accident, I could have heard a pin drop in the halls of the high school. I didn't always know right away who had died, but I knew that *someone* had.

Sometimes I thought that the students at my high school were cold and heartless, until I saw the students' reactions when a fellow student was killed. Scenes of girls sobbing on a friend's shoulder where seen throughout the halls. For several days after the death of a student, the guidance counselors and a local pastor were available on campus for those students who wanted emotional and spiritual guidance. A common phrase around my high school was, "who is going to be next?" For several of the students, it was an eerie feeling seeing an empty seat in class that would no longer be filled by a particular classmate.

Although I still had bitterness over not being able to drive, my parents had reason to be thankful that I was not a licensed driver. Because of the death rate among the high school students, my parents feared that Steve or I would become a victim of the carelessness of a drunken driver. The highway that led to the high school had become a dieway in this well-to-do community.

The year progressed as students continued to grieve over the loss of a close friend. I was never close with any of the students who were killed, but I understood the grieving over a loved one. The deaths of the students in these accidents seemed so senseless. The source of these deaths was teenage drinking and a desire for peer acceptance. Drinking was the one activity of teenagers that I could not identify with. I had never taken a drink, nor had I been to the parties that several of my peers attended. It never made sense to me that some of the students who went to parties also made the honor roll each semester. As for me, I had to study long hours to make passing grades, and I had no desire to spend my time trying to be accepted by those who were considered popular. Anyway, I realized that I had a medical condition to contend with that required that I not put myself in a situation that could endanger my health. If I stayed out late, I was at a higher risk of having multiple or more severe seizures the next day. Because I was unable to drive and had personal medical needs, I had very little social opportunities as a teenager. During my adolescent years, I marched in the band, stayed home and studied, spent minimal time outside of school with my friends, and played games at Grandma's house. My life was not the typical life of a teenager, but it was all that I knew.

During my yearly health exam in April, Mom expressed her satisfaction with the medication changes and the resulting improvement in my grades. Although I was making better grades, my mom still wondered if there was anything else that could be done to improve my medical and academic standing.

"I have been really happy with all that you have done for Amy. I have seen a significant improvement in her seizure frequency since she has been taking just one medication. Things have improved so much since we first started coming to you. But just because I am her mother and I want the best for Amy, I would like to take Amy to another specialist for a second opinion. I think you are a wonderful doctor, but I just want to hear what another neurologist has to say about the medication Amy is on and to see if there is anything else that we could be doing to help Amy's situation."

"I totally understand, Brenda. That is not a problem. There is a lot to be said about getting a second opinion. Hearing another doctor's opinion may even help me better assist Amy in the future. There is a good neurologist at the Mayo Clinic whom I can refer you to. Many people from all over the country go there each day seeking professional medical treatment. I will have my receptionist help you fill out the appropriate forms so I can send the Mayo Clinic a copy of Amy's records," the doctor replied.

The three of us concluded our meeting, and the doctor led us to the receptionist's desk. As Mom and I left the doctor's office that day, we both felt encouraged that we would soon hear a second opinion about my seizures and the medication I was taking. Deep in my heart was the continued hope to *one day* be cured of my epilepsy.

> *There are difficulties in your path. Be thankful for them. They will test your capabilities of resistance; you will be impelled to persevere from the very energy of the opposition. But what of him that fails? What does he gain? Strength for life. The real merit is not in the success, but in the endeavor; and win or lose, he will be honoured and crowned.*
>
> W. Punshon

Adversity is . . .

adding the fear of death to an eight-year-old's mind.

con**ver**sing with a friend one moment and suddenly feeling your body tense up as your mind gradually loses awareness of the surroundings.

sitting in class and hearing a teacher make light of your disability in front of the entire class.

asking **why** you have a medical problem only to find out that the future appears gloomy.

<div style="text-align:right">Amy</div>

Chapter 8

Hope

1988

Toward the end of my junior year, I gave up the paper route because I wanted to obtain a job so that I could interact with people my own age. A friend of mine was working at McDonalds and encouraged me to apply. Within a few days, I talked with my parents about the possibility of getting a job in town. We talked about my seizures and how having seizures on the job would be a factor. I expressed that I would save money for college and that I would have an opportunity to meet new people in my peer group. They were supportive of my desires, but they also gave me words of caution. They were concerned that I would push myself too far and have a grand mal seizure or get hurt on the job. They had a point, but I also didn't want to live a sheltered life just because I had a seizure disorder. My opportunity for social gatherings was already limited since I wasn't allowed to drive, so I needed the social interaction with my peers outside of school. My parents agreed, but with some hesitation; they decided to allow me to apply for a job and that one of them would come home each day in time to take me to work. I was grateful that they didn't let my lack of a driver's license prevent me from holding a job. Later that week, I applied at McDonalds and was hired to work in the kitchen. Each day after I got off the school bus, I changed into my uniform, and soon Mom or Dad arrived home to take me to the Golden Arches.

During this time, Mom received word from the Mayo Clinic that an appointment in July had been scheduled. Even though I was interested in going to another doctor, I held little hope of finding a cure for my seizures. However, I did have a

small hope that I might learn something new regarding other medical treatments for my condition. The hope to be seizure-free had remained since childhood, but every time I attempted to help my condition, I was always discouraged when my seizures reoccurred. My instinct told me that the other doctor who I was going to see would want to put me on another medication, or in some way, change my medication level. All of my experiences with neurologists involved medication as the only form of treatment for seizures. It seemed as though some doctors viewed seizure medication treatment as an easy way for them to give the patient and parents a slight hope of a cure with the remote hope that "maybe this will work."

The heaviest emotional burden that remained in my life was the fact that I couldn't drive. I was seventeen and past the legal driving age. All of my peers had a driver's license, and most of them drove to school. They were allowed to go where they wanted and when they wanted with minimal restrictions. I, on the other hand, was limited to riding the school bus to and from school, with an occasional ride to school by the good graces of Steve. Sometimes I caught a ride with Marjorie when I knew that she was going to drive on a particular day. If there was one thing that I had longed to be able to do, it was to drive like everyone else my age. In my late teen years, I was often tempted to have a friend drive me to the secretary of state's office and lie about my medical condition so I could get my driver's license. However, I knew that I would be taking my life and other peoples' lives into my own hands, not to mention the legal repercussions.

I often cried myself to sleep, wishing that I had the same privileges as did Angie, Steve, and my peers. They had a life that, for some unknown reason, I was not granted. Their lives seemed to be so easy and full of social and recreational opportunities. If I wanted to go somewhere, I had to rely on the schedule and flexibility of another person. As a teenager, I was in an ongoing battle between accepting the limitations that were imposed on me and wanting to experience the freedom to drive and be involved in more extracurricular activities with other teenagers. I knew that I didn't do anything to deserve such limitations, but my acceptance of these limitations did not

come overnight. I often thought about the many undisciplined teenagers at school that should never have been issued a driver's license. But that didn't matter. No reasoning was going to change what I had to overcome. Unless some unexpected method of treatment was suggested at the Mayo Clinic, I figured I would have to live with seizures indefinitely. At that time, I viewed myself living with Mom and Dad all my life for the sake of having a ride to work. As a teenager who was old enough to drive, I dreaded having to explain why I didn't drive. Having to cope with peoples' reactions to my seizures was bad enough. But having to admit that I had epilepsy was like telling people I wasn't normal or that I wasn't capable. During a time that involved natural emotional and physical changes, my personal limitations made it even more difficult for me to cope with my adolescent years.

As I continued holding bitterness about my situation, I wished someone else would experience the same emotional pain as me. It was not that I wanted someone else to hurt, but that I wanted someone else to be able to relate to my pain. While some of my peers experienced the difficulties of a broken home or the pain of broken relationships, my problems were quite different, yet just as complex. Because I was in an unusual situation with no one to talk to who fully understood epilepsy, I remained shy in most social situations and often cried myself to sleep at night. Living a full, active life seemed next to impossible.

At the end of July, my parents drove me to Rochester, Minnesota to the Mayo Clinic. At the outset of the trip, I had a small hope burning inside my heart that we would hear some encouraging words about my condition, and just maybe, the doctor would know of a cure for the mystery behind my epilepsy. After several minutes of silence while riding in the car, Dad spoke up.

"You know, we are going here to see if another doctor can do anything for Amy that the other doctors have not been able to do. But we shouldn't expect any miracles while we're here. All I'm saying is don't expect any great results from this

appointment. This doctor may totally support what Dr. VanDyke is already doing and not have any additional advice to tell us. Don't get me wrong—I'm glad that we're going for a second opinion. But let's not go into this appointment with high hopes either."

"You're right, Steve. This doctor might say the same opinion as the other doctors. But we would be wrong not to hear the opinion of another doctor. One way or the other, this trip will be worth it," Mom replied.

No miracle, I thought. *I want to live a normal life.* As we approached the streets of Rochester, the thought of living all of my earthly days with seizures and emotional turmoil went through my mind. *I need a miracle.*

The Mayo Clinic seemed huge in comparison to all the other hospitals I had been to. The first appointment was a blood test that required fasting, which began the evening before. After having several pokes of a needle and a Band-Aid to cover up the wound, I went with Dad and Mom to the cafeteria for breakfast. I never minded getting my blood drawn. What I *did* mind was having to eat breakfast so late.

After breakfast, we went to my appointment with the neurologist. He was a professional-looking man with a mannerism about him that revealed his dedication to his job. My parents explained my medical history to him and the nature of my seizures. Then he asked me a few questions.

"Is there a particular time of the day that you are more susceptible to having seizures?"

"I am more likely to have a seizure in the morning if I don't eat breakfast right away. If I don't take my medication on time in the morning, I will most likely have a seizure later that morning. But other than that, I am prone to have seizures anytime of the day," I explained.

"Doctor, there's one thing that you may want to know," Mom spoke. "Amy has seizures if she takes cough drops that contain alcohol. She found this out when she took cough drops when she was sick. She doesn't take them anymore, but in the past when she would take one, she would have a seizure within about ten to fifteen minutes."

"I can see where you might think there was a cause-and-effect between the cough drop and her seizures, but I highly doubt that the cough drop could cause her to have a seizure," the doctor expressed in a firm voice. "I suspect that Amy had a seizure as a result of her being ill, but not from taking a cough drop." My parents and I shared the same reaction. He was basing his knowledge on what had or had not been proven in the medical field. Since such an occurrence had not been medically tested, he could not believe what I had found to be true from my personal experience. Our silence expressed our disagreement, and we began discussing another topic.

"Do you have more seizures during the time of your menstrual cycle?" the doctor asked.

"Yes. I have more seizures just before I start and usually at least two during my cycle," I replied.

"I'm not surprised. The menstrual cycle creates changes in hormones, which consequently, increase the chance of seizure activity. Are you on any other medications?"

"I take a vitamin that consists of calcium, magnesium, and zinc. I have taken this supplement since about fifth grade. Taking this vitamin tends to help with seizure control," I explained. Mom supported what I was saying.

"When Amy was in elementary school and struggling with her schoolwork, I starting reading about vitamins and found that magnesium can help keep up a person's energy level. When Amy is involved in high physical activity, such as playing ball, she is more susceptible to having a seizure. But since she has taken the calcium, magnesium, and zinc supplement, she has had better seizure control during times when she is involved in physical activity. In fact, Amy often has a seizure when she goes without taking the calcium tablets for one or two days."

The doctor nodded his head as he wrote down our comments. The results of the appointment were that the doctor agreed that I should remain on Tegretol, but he ordered for me to increase my dosage. As we drove home to Michigan, I resumed the forlorn thought that I would have seizures and would be taking medication for the rest of my life. Dad was right—we shouldn't have expected a miracle to have occurred

in my life in Rochester, Minnesota. Nevertheless, I held hope in my heart that a medical miracle would *one day* come from God.

> *He who does not hope to win has already lost.*
> Jose Joaquin Olmedo

CHAPTER 9

Quake

Following years of turmoil and lots of hard work, I finally arrived at my final year of high school. The senior spirit filled the halls as the seniors looked forward to homecoming and graduation. I couldn't believe that I was less than a year away from graduation. I was so thankful for having passed every grade and for every extracurricular achievement. Having senior pictures taken that September marked the beginning of my senior year.

Although I was not among the group of students who were class representatives and considered popular, I was a leader in the band and had acquired some underclassmen as friends. In fact, I was more their mentor than I was a casual friend. Several freshmen and sophomore girls came to me for advice on matters related to music terminology and boys. I was more knowledgeable with the first, but I managed to give my conservative view on dating and what to look for in guys. Each morning before school started, three other girls and I walked the halls, talking about girlish ideas and which guys we liked.

During my senior year, I managed to achieve at or above grade level in every class, with the exception of economics. Since switching to Tegretol, I experienced fewer side effects and felt more alert throughout the day. Being on Tegretol, however, I was not totally free from side effects. The main side effect I experienced from taking Tegretol was a feeling in my head as though I were on a ship. I felt this sensation in my head at various moments throughout each day, and it felt as though my head were floating in the air or that I was on a ship and

experiencing the impact of the waves. As I walked to class each day, I wondered if I was going to smack right into the cold hard wall. My head literally felt spacy. But I had something to be grateful for. Since I had been on Tegretol, I hadn't fallen asleep in class from the heavy dosages of medication. If I ever became tired in class, it was due to having a seizure, and not due to the side effects of my medication.

The band soon prepared for the spring concert as my senior year came to an end. This was the last high school band concert that me and six other senior classmates would play in. It was a special time in our lives as we reflected on all the good times we had out on the football field while marching in the cold weather and of the dreadful cold bleachers we endured for the sake of cheering on our home team. All of those memorable events we'd had together were coming to an end.

The spring concert was also the award concert in honor of the seniors. I received the Best Senior award for having shown leadership and having contributed hours of practice for concerts and the marching band. My band teacher shook my hand and handed me a plaque that represented eight years of squeaks, dedication, musical talent, and close friendships.

The lilacs were in bloom, and the smell of spring filled the air as the family prepared to attend my high school graduation, an event that many of us had wondered if it would ever arrive. The last few weeks before final exams, however, brought a great deal of stress and excitement. Like the other one-hundred-and-ninety seniors, I had exams to study for before saying my final good-byes.

As exam time approached, I became more nervous. Thoughts of fear went through my mind. *What if I fail my finals and don't graduate?* Some of my grades were in the C range, and one low grade could easily pull a grade even lower. *How much should I study? . . . What is the most important class to study for? . . .* Fears of failure wrestled in my mind.

Through my senior year, I worked at McDonalds about three nights during the week and two days on the weekends. My dedication to my job, however, sometimes took a toll on my health. When I worked long hours, I often experienced more seizures. Despite the ramifications of working in a fast-paced environment, I continued working to save money for college. Through working, I came to realize that being allowed to work and meet other people my age helped fill some of the void of not having a driver's license. The circumstance that often bothered me was being faced with personal questions from my co-workers. Many people asked me why I didn't drive. I often struggled to find the right words to say whenever someone asked. I was always truthful, but I felt very uncomfortable sharing that information with just anyone who asked. But I also knew that other people needed to accept who I was. The battle not to be withdrawn from others continued as I considered how different my life was from the lives of my peers.

The Saturday night before my final exams, my manager asked me to stay late at the restaurant. I worked until about 2:00 a.m., even though I felt exhausted. While I was at work that night, I felt my eyes roll up involuntarily. I knew it was quite unusual. I had not remembered experiencing that sensation ever before. It was the strangest experience in that I was totally conscious, and yet my eyes moved to the upper left part of my eyelids without a warning, and then they would come back down. This incident put some fear into me as I contemplated why this was happening.

After work that night, some of my friends and I went out for a Coke at a restaurant that stayed open all night. I finally went to bed around 3:15 a.m. and planned on sleeping until about noon. I knew I needed to study for exams on Sunday, but I also needed rest. Little did I know what the next morning would bring.

I was in a deep sleep when the sun rose. Unknown to me, the time was 8:30 a.m. when our family dog barked at my bedside. Mom ran to my room to stop the dog from barking so that I could sleep in peace. Mom's heart dropped to her stomach as

she saw the state in which I was in. My body shook as my eyes rolled back to the point where no pupils could be seen. There was blood on my pillowcase. The ultimate tragic scenario crossed her mind.

Mom ran to the phone and called 911 for an ambulance. An ambulance arrived at our house within a matter of minutes.

"Amy, can you hear me?" He gave his name and why he was there. The paramedic rolled me onto a stretcher and carried me out of my house to the ambulance.

"Amy, you just had a grand mal seizure, and I'm going to take you to the hospital to have you examined." The words that the paramedic spoke were only a faded sound in the distance. The voice seemed so far away, and no meaning was derived.

"Can you tell me your name?" he asked. I gave no response. The paramedic placed me in the ambulance and took my vital signs. Then he spoke to me once again.

"Amy, do you know where you are?" he asked. I barely opened my eyes and closed them right away. The words that he spoke were starting to make sense.

"We're on the way to the emergency room to check you over. Your Mom said that you had a grand mal seizure in your sleep this morning. Do you remember what happened?" I nodded my head left to right. I couldn't recall a thing.

"Your Mom is right behind us. Can you lift up your head so you can see her?" he asked.

I lifted my head and saw Mom in the blue Cadillac. The reason for my being in an ambulance was beginning to form in my mind. However, I felt exhausted and was unable to rationalize the event.

We arrived at the local emergency room in what seemed like a matter of seconds. Nurses and other medical staff began taking my temperature and vital signs in the midst of my unconsciousness. I had fallen asleep during the ride in the ambulance and was awakened by the deep voice of the paramedic and an annoying touch of human hands on my side.

"Amy, wake up. I need to ask you some questions," I heard a man say. It was so hard to wake up from the comatose-like sleep. My mind and body were overly exhausted and unattached from life's activities.

"Amy, wake up." I opened my eyes slightly to see a male nurse standing over me with a sincere expression on his face.

"Amy, do you know where you're at?" he asked.

I nodded my head "no." I was too tired to care and too unaware to know.

"You are in the emergency room," he replied. Again he told me about the seizure I had and why I was there.

"Do you have a headache?" I nodded my head "yes."

"I'm going to give you some Tylenol for your headache," he said. "Your Mom will be here in just a minute." He walked away and came back a few minutes later with some pain reliever.

Shortly thereafter, Mom walked in the room. I was awake enough to see the tears in her eyes that reflected her love toward me and her unspoken fear of losing a child. She came close to me and leaned over to hold my hand.

"I love you, Amy," she said so softly. She reached to give me a gentle hug.

"I love you too, Mom."

"How are you feeling?" she asked.

"I have a headache," I said in a tired voice.

"Amy, look at me. . . . You have a broken blood vessel in your eye. It's in your right eye. It must have happened during your seizure."

I could tell by what she said that I had experienced a severe seizure. This was the first time that I had ended up in the emergency room as a result of having a seizure since the convulsion I had as an infant. I started to wonder if this seizure had done more damage to my brain and if my seizures in the future would be this severe.

"Amy, I'm going to go call Dad to let him know what happened. He had to work today. I'll be right back," Mom said with a tear in her eye.

By that time, I was more awake but still a little drowsy. I lay on the hospital bed as my mind wandered to the events of graduation that would take place in two weeks. Final exams would start the next day, and I hadn't cracked one book. A special time in my life had been interrupted by the abrupt event of unconsciousness that took over my thinking and depleted my energy, which prevented me from pursuing my personal responsibilities.

The instability of my life brought questions of concern to my mind as I lay on the bed and wondered about my future.

Mom returned within a matter of minutes and let me know that she talked to Dad and informed him about my seizure. She still seemed traumatized from my seizure and overly concerned about my condition. She rubbed my forehead as she fought back the tears. A loud beeping noise radiated throughout the room. Just then, the male nurse came back to my bedside to check on me.

"How are you doing, Amy?" he asked.

"Okay," I replied, acknowledging his question. Again, he took my vital signs.

"I want to monitor her for a little while to make sure she is stable. Once she is stabilized, she can be discharged. Her temperature is still slightly elevated. It should go down pretty soon," he informed us.

Later that day I was discharged, and Mom walked me out to the car as she held on to my arm. The time was close to noon, and I had not eaten all day. We stopped at a fast-food restaurant, and I got a sandwich to go. I remained in my sweatpants and sweatshirt that I wore to bed the night before. As I ate my sandwich, the reality of having had a grand mal seizure started to settle in. I had never been so frightened of the coming days than at that moment of accepting the severity of my recent seizure and the possibility of having another one. As we drove home, Mom and I talked about the recent episode.

"I heard Katie in your room barking, so I went in to stop her because I knew that you were out late and you needed to sleep in. That's when I realized that you were in a grand mal seizure. Your eyes were rolling back in your head, and you were making a strange noise in your throat. . . . I thought I was losing you."

I didn't say anything. I couldn't be sorry for something I had no control over, and yet I shared my mother's pain that came from the shock of having a grand mal seizure. Our perspectives of the event were different, but we both experienced a certain degree of emotional turmoil from the episode. Mom's statement about thinking that she was losing me stuck in my mind. That morning, *my life* had flashed before my mother's

eyes. I wondered if I really was close to death during that seizure, or if Mom's thoughts of me possibly dying were just her thinking the worst. I was not in her position, but I could imagine what she must have been going through. I had no recollection of the event prior to when the E.M.S. attendant put me on the stretcher and began talking to me in the ambulance.

Through reflecting on the events that occurred that day, I realized that for those who witness a grand mal seizure, fear comes during the seizure. But for the person who has experienced a grand mal seizure, a different fear comes when the seizure is over and reality sets in. In other words, a grand mal seizure is more terrifying for those who are watching than it is for the person having one, but the aftershock is felt more by the seizure patient. The aftershock involves thoughts of instability, fear of experiencing another grand mal seizure in the future, and the fear of losing one's life the next time. Only unanswered questions remained. *What if the next grand mal seizure is even more intense or lasts longer? I could die if one lasts too long. A lack of oxygen to the brain could worsen my condition. How will I know when it will happen again?*

Although I was still devastated over knowing I had a grand mal seizure that morning, there was a quiet spirit within me that echoed, *I want to live. I have my entire life to live. I want to live.* Nevertheless, the battle between light and darkness and between consciousness and unconsciousness remained.

I was exhausted when I got home, and I refrained from all studying the remainder of the day. I could only hope for blessings during my final exams. I dreaded going to school the next day for two reasons. First, I feared having another grand mal seizure. Second, I knew that the broken blood vessel in my eye would generate some questions from my teachers and peers. Questions about my seizures were the last thing I wanted to hear.

Sure enough, on Monday morning my business math teacher asked what had happened to my eye. I noticed several students looking at me with questioning looks as well. I didn't give a direct answer. I wasn't ready to face up to the reality of my condition, and I didn't want to take the risk of my teachers thinking differently of me. I preferred to keep the emotional pain to myself and avoided having to tell anyone about the disorder

that continued to affect my life. I figured that a person either has seizures or does not have them. I could not expect someone else to understand epilepsy since I didn't even understand it's complexity, and *I* was the one who experienced seizures on a weekly basis. My knowledge of my condition and my desire to keep such circumstances to myself led me into a world of insecurity and fear that someone may find out about my seizures and think of me as some weirdo. I longed to rid myself of the uncontrollable force that had shaped me into the insecure person that I had become. As I lived my last few days of my high school experience, I wondered what type of job I could hold that would not be hindered by my seizures. The challenge awaited for me to find that one area of study that would be suitable for a person with seizures.

> *It is always darkest just before the day dawneth.*
> Thomas Fuller

Graduation night arrived, and my family prepared for this special event. The highlight of the evening was Steve driving me to the high school in his limousine. He owned his own limousine for something cool to drive around town and as a source of income. I had to twist his arm only once, and he was in agreement to give his younger sister a limousine ride to her high school graduation. Grandma, Mom, Dad, Steve, Angie and her fiancé David, and a few extended family members came all dressed up to see me graduate.

As I sat in the gymnasium and watched the crowd of people shuffle in, I thought about the teachers who helped me reach this point in my life and about the days I went to school feeling too tired to learn. I knew that my achievement of graduating represented more than just passing grades. For both of my parents and me, we had been through a world of emotional, medical, and academic battles. I was not in the top ten of my class, but I was as content with my success as those who were publicly honored for their high achievements. One achievement that I did have over most of my classmates was a perfect

attendance record for my senior year. I had refrained from participating in senior-skip-day for the sole purpose of receiving a perfect attendance award at graduation. I was accompanied by a few other seniors who shared the same honor.

When I left my high school that evening, I took with me knowledge, triumph, optimism, and multiple emotions that could not be expressed in one sentence. My talents, my job skills, and my interests in relation to a career choice would soon be explored. Despite the uncertainty that I had about my future, I rejoiced in my accomplishments of graduating from high school. My family expressed the same happiness as we embraced after the ceremony.

An all-night graduation party had been planned for that night and was scheduled to go until eight o'clock the next morning. Mom and I agreed ahead of time that it was in my best interest for me to get on the bus around 2:00 a.m. to head back home. After having a grand mal seizure only two weeks prior to graduation, I would only be taxing my system unnecessarily and putting myself at risk for another severe seizure. In the few hours that I had at the graduation party, I played games with some of my long-time friends and stuffed myself with soda pop and junk food.

That evening as I sat on a sofa watching some of the popular students create the spirit of the moment with their party-hearty attitude, I was sure that none of them knew the battles I had fought to make it to this evening of celebration. Although there wasn't any alcohol at that party that night, I knew that many of them would have liked to have been elsewhere indulging in something stronger than carbonated water. Having spent my entire childhood enduring the side effects of prescription medications and the confusion that came after my seizures, I couldn't understand why anyone would willingly intoxicate himself into a state of belligerence and irrational thinking. But I knew I had a different perspective about the matter because of my personal circumstance that had to be resolved.

After my graduation open house and all of the celebration was over, I started working more hours at McDonalds. I had

decided to start my college education at Kellogg Community College. This college was close to home and less expensive than a four-year university. Neither one of my parents pressured me to go to college. They left the decision up to me. But after all that I had been through in earlier years, they were excited to know that I wanted to pursue higher education.

The memory of the grand mal seizure that I had the last week of my senior year was still vivid in my mind as I thought about starting college in the fall. With college would come a certain amount of stress, and late-night studying may come to be a routine. Since I knew that both stress and the lack of sleep caused me to have seizures, I began to wonder how the responsibilities of going to college would affect my seizure frequency. As I continued working to save money for college, I knew that only time and experience would reveal how my epilepsy would affect the process of obtaining a higher education.

> *I am only one; but still I am one.*
> *I cannot do everything,*
> *but still I can do something;*
> *I will not refuse to do something I can do.*
> Helen Keller

Quake to Quake

All is calm as a cool breeze blows,
The sun sets, and the tide is low.
With a short notice, tremors erupt,
The earth shakes, and nerves stir up.
A moment in the distorted light,
Precious life passes in the timeless night.
The Richter scale varies from quake to quake,
Structures are ridged, and life is at stake.
Rotation continues with fog all around,
Life is in a twirl on unstable ground.
As towers sway throughout the town,
Voices are heard as the temple falls down.
Nothing else matters as trembling sustains,
Uncontrollable forces in living veins.
Unknown voices and trickles of light,
Pass through prisms of the ongoing fight.
No one knows quite what to do,
Or the damage that's done, or the presence of who.
In a moment's time, the tremors vanish,
The continuous light is only a wish.
Strangers pass by with faces of greetings,
Not having a clue of the recent beatings.
Emptiness fills the mind of the homeless,
One life that's uprooted and quite a mess.
The reality of confusion hits like a brick;
The recent events are like a burned-out wick.
Yet life resumes as the light is revived,
A life of turmoil—but one that's alive.
And so the tremors sleep night and day,
Just waiting to strike whenever they may.
So the longing remains to resolve it all,
To one day say, "It was worth it all."

Amy Crane

Chapter 10

A New Season

1989

The fall semester approached for my first year in college. I had not yet decided which degree I wanted to pursue, but I knew I wanted to obtain a higher education. I started college that fall with a desire to expand my personal knowledge *and* with a case of laryngitis. Some moments I had a voice that sounded similar to that of a mouse, and other moments I had a voice that was similar to the sound of a bullfrog. When one of the professors called roll, I raised my hand and said in a high-pitched voice, "I have laryngitis." Everybody laughed, including me. That was my introduction to my joys of college. In sickness and in health, I was going to attend.

At age eighteen I began college, and I still did not have a driver's license. Mom and Dad were supportive of my decision to go to college, and they provided me with transportation to and from the campus. On the days when neither one of them could leave work to pick me up, Grandma Belcher accepted the responsibility to drive me home. Grandma and I had spent a lot of time together in previous years playing games and taking an occasional shopping trip. We had laughed together and shared stories about the family and about boyfriends. After I started college, our time together was minimal, but she enjoyed helping out my family by giving me a ride from college when the need arose.

Although my transportation to and from school was all arranged, I still held bitterness about not being allowed to drive. It was emotionally hard on me to see other college students with cars and their freedom to travel around. I often had to wait ten to fifteen minutes for my ride, and I became

irritated just knowing that I was going to have to wait for my ride to arrive.

Thoughts of my limitations also bothered me when I saw a sign in the cafeteria stating that there was going to be a blood drive on campus. I wanted to give blood for the sake of helping others in need, but I couldn't because I was taking a prescription medication. In addition, I could not give blood because I could have gone into a seizure as a result of having a substantial amount of blood drawn from my system. Somberness settled over me as I mulled over the fact that I was restricted from giving blood that could have helped out someone else who, like me, had a medical need. In spite of these limitations in several areas of my life, I still had a personal desire to pursue higher education.

Although I still felt insecure about my seizure disorder, I started to be more open about my condition. I realized that I could no longer keep my epilepsy to myself and risk the possibility of having a seizure in class without someone knowing what to do—or what *not* to do! At the beginning of each semester of college, I informed each professor about my seizures. Each one seemed to appreciate my telling him, and a few of them asked further questions. I started to realize that part of being a mature adult was telling the truth, even if it meant taking the chance that someone would think differently of me because of my seizures. One specific lesson and spiritual principle that my dad had taught me was to tell the truth, and the truth shall set you free. Dad also believed that a person should be himself without worrying what others think. Knowing these simple principles helped me be more at ease at telling others that I had epilepsy. The part of me that I had always wanted to keep a secret had become a topic that I could now speak freely about to my authority figures as well as to my college friends. Although my seizure disorder was still a sensitive topic, my having courage to talk about my seizures was indeed a significant step toward appropriately dealing with my epilepsy.

My informing my professors about my seizures proved to be very beneficial for many people. I recall one day when I had a seizure in my physical science class. The professor didn't draw any attention to me during or after my seizure. He continued his class lecture and let my seizure run its course just as I

had asked him to do. After class let out, he motioned for me to come up to his desk.

"I noticed you had a seizure. Are you all right?" he asked in a sincere voice.

"Yeah, I'm fine. I'm tired, but I'll snap out of it," I replied.

"I'm glad that you told me that you have seizures. A few of the students wondered what was happening, and I let them know that you would be all right. Is there anything that you missed?"

"I copied someone else's notes after my seizure. I believe I'm all caught up. Thank you, though." I then picked up my bag and made my way to my next class.

There were several other incidences similar to this one that gave me the assurance that my decision to inform my college professors about my seizures was a positive one. In contrast with how I felt in high school, I now had the courage to let my disorder be known to others. My taking responsibility for my epilepsy was the first step to coping with and accepting my seizures. I had reached the conclusion that I would probably live the rest of my life with seizures, and therefore, I needed to take responsibility for the burden in my life of which I was in for the long haul.

One day as I sat in the library studying for classes, I stretched by putting my hands clamped together and raising my arms over my head. Just then, I heard my sternum pop and instantly I froze in place. The popping sound my sternum made was probably heard from across the room. The grand mal seizure that I had six months prior must have caused damage to my sternum. With my college textbooks spread on the table in front of me, I wondered what the future held and if I would ever endure a grand mal seizure on the college campus. Within a moment's time, I put that thought aside with the assurance that if I did experience a grand mal seizure on campus, there would be many highly-educated and caring people nearby to assist in any way possible. With my faith in God and the knowledge that I had made the right decision to go to college, I couldn't let uncontrollable circumstances discourage me from pursuing the higher training that I knew God wanted me to receive.

Around the third month of the semester, a young man entered my life whom I will refer to as Marvin for privacy's sake. I was studying to be an elementary teacher, and he was studying to be a history teacher. Marvin and I went on dates almost every week. He was a kind and gentle guy who became very familiar to my family. After learning of my medical condition, Marvin made it a routine to take me to and from school. Circumstances were favorable for him to give me rides since he and I had similar schedules, and he lived only about five minutes from my house. We also frequently went out to eat after school, and over the course of our first year in college, we became close friends.

Upon the completion of my first year of college, I received above average grades in most of my classes and looked forward to another year of taking courses toward a degree in elementary education. Having studied and coped with the typical stressful situations of college life, I realized that my epilepsy was not going to prevent me from pursing a college degree. Even though I knew that I needed to study a significant length of time in order to receive passing grades, studying became enjoyable.

As I encountered college-level material, I decided that I needed to stay awake during the college lectures, no matter how much willpower and self-control it took to remain alert. Being on a tolerable level of Tegretol, I had less of a challenge in staying awake than I did in my junior high and high school years. No longer did I experience a spacy feeling in my head, nor did I go to class feeling deprived of sleep. Anyway, the bazaar illustrations my psychology professor told were enough to keep anybody awake!

On a cold December day in 1991, I received a call from my neurologist's office in Grand Rapids asking me to come for an annual checkup since I had not been there in two years. The receptionist and I set an appointment for me in March. After I

hung up the telephone, I said to myself, *More medication, more tests. Same thing, different day.* Discussing the alternative medications in the doctor's office seemed so routine and pointless. I was a twenty-one-year-old young woman who had been on six different seizure medications throughout my life, all of which had proved to be ineffective in controlling my psychomotor seizures. Having to use a part of my busy day to hear the same analogy to a big mystery seemed unnecessary. But with a good spirit and a seed of hope planted in my heart from my childhood, I kept the appointment for that spring day in March. I went to tell Mom about the call.

"Mom, that was the doctor's office. They want me to come for an annual checkup in March. Who do you think will take me? You or Dad?" I asked.

She placed her cleaning rag on the bathroom counter and said, "Oh, probably your Dad will take you. He can take the afternoon off work and go pick you up at college. I know I won't be able to go. We see patients at our office that afternoon, and I need to be there to work the desk. But I'll talk to Dad about it. I'm sure it won't be a problem," Mom explained.

Dad and Mom were always eager to meet my medical needs and provide me with transportation to my doctor's appointments. They were almost as discouraged as I was with hearing of the latest seizure medication that might be the answer we've been waiting for. Regardless of past experience, they continued to support my current medical needs and provided me with every opportunity that might lead to a solution aside from medication therapy.

After considering the probable outcome of my next appointment with the neurologist, the thought crossed my mind that I was going away to a four-year college in less than a month, and yet I was still coping with the same medical condition as I had when I began kindergarten. I was in another part of my life and more mature, but I was still going off to school with an affliction that few people were familiar with and one that brought a sense of fear, insecurity, and instability to my life. Aside from my inner feelings, I was excited about my plans to attend a four-year college and didn't allow the complexity of my seizure disorder and side effects of medication to alter my dreams.

That Christmas season, my wish list consisted of items for college such as a first-aid kit, bedsheets, soap, clothes, and food. My mom had mixed emotions about my leaving home. She wanted me to obtain an education and be able to support myself, but she didn't want me to leave home either. Mom and I had always had a close relationship, which made it that much harder for her to let go of me as I made my way out into a dangerous world. As the time approached for me to leave home for the first time, Mom expressed to me her concern about me having seizures on campus.

She said, "Amy, what if you have a bad seizure and nobody is around to help you?"

With a sigh I replied, "I will be all right. Even now I have seizures when no one is around, and I come out of them all right. I have had enough seizures all my life, Mom. I know how to deal with them. And anyway, even if someone were there if I had a grand mal seizure, nobody could do anything to stop the seizure. I'll be all right," I assured her.

"I know you will be all right, Amy. I just worry about you. You have your head on your shoulders, but you're still my daughter and I love you. I just don't want you to get hurt."

I understood her concern, but I also knew that what she was saying was a normal response for a mother. Since I was a female, the youngest of the family, and the only child out of three that had endured a long-term medical condition, my parents had significant reasons to be concerned about me moving away from home.

On Christmas Eve, I sat and gazed at our Christmas tree with its colorful lights. As I bit into one of the Christmas cookies that Mom and I had baked, I thought about all of the times our family had Great Aunt Gladys at our home during the Christmas season. Indeed, Aunt Gladys had helped form my childhood memories. I also thought about the challenging circumstances I had faced over the years. All of my experiences, the good and troublesome ones, were traveling with me as I made my way to a college campus.

Chapter 11
Opportunities

1992

As I continued my education at a small liberal arts college, various experiences only added to my education. By the first week, I knew that my roommate did not care to be there, and that attitude really irritated me. She soon moved in with a friend who had the same undisciplined behaviors as she did. I was glad it worked out that way. For me, it was important to spend most of my time studying, and I sometimes even completed my assignments in advance. My former roommate, on the other hand, thought college was a big party and attending classes was something she did in her spare time. I couldn't understand that mentality. I knew that if I slacked off, my grades would suffer. My hard work soon paid off. At mid-term, I was making *A's, B's,* and one *C.* I wanted so desperately to make the dean's list.

In addition to my roommate situation, I observed everything from the party-party attitude to hair styles and clothes that disgusted me. Pledging for societies began that semester, of which I wanted no part. Drinking was a large part of secular campus societies, and I did not drink. I viewed societies as an excuse not to study, and the last thing I wanted to do was develop poor study habits. I took my studies seriously. I also took my seizure disorder seriously and knew that it was my responsibility to do what was best for my health. With that mindset, I chose to refrain from pledging and gaining the wrong friends through participating in social activities that I did not find appealing. Nevertheless, chants and songs from several society groups filled the campus both morning and night.

One day in sophomore core as I sat taking a test on art history, I felt an aura come on. When the aura began, I stopped writing and kept my pen in my hand. I waited for the aura to disappear or to develop into a seizure. My surroundings closed in on me as the professor and students disappeared from my view. When I came out of the seizure, I noticed scribble marks on my test. The marks were in pen and could not be erased. I completed my test and thought about how I was going to explain this episode to the professor. I was one of the last students to complete my test, which made it easier to explain without other students listening. I explained to him why the marks were on my paper. He nodded his head and said that was okay. With his professional attitude and highly educated mannerism, he did not ask me any questions but just listened to what I had to tell him.

After dating another young man for eight months, I decided to break off the relationship. We were in two different worlds. I was a college student, and he was a hotel manager. I wanted my independence at college and the freedom to date with no long-term commitment. Come midterm, I felt comfortable with my decision to complete my degree and pursue a career in education. I was not too sure how my seizure disorder would affect my ability to teach, but I loved working with kids and I also had a desire to be a positive role model for children. Becoming a teacher just seemed like the most appropriate goal for me to pursue.

Shortly after midterm exams, I had my annual neurology appointment in Grand Rapids. Dad worked that morning and arrived at my college dorm around 11:00 to pick me up. My appointment was at 1:00, and we anticipated an hour-and-a-half drive. This appointment was the first time for me to go the neurologist's office from the college. Dad was responsible for finding the most direct route. He was usually talented in the area of navigating, and I trusted that he knew what he was

doing. As expected, Dad knocked on my door about ten minutes early. I was just finishing my make-up and hair.

"Come in."

"Hi. Are you ready?" He gave me a fatherly embrace.

"In just a minute." I gathered my purse and sprayed another squirt of hair spray on my hair, and we were on our way.

As we ventured on our way, I was wondering which route he had chosen. "So, Dad, which main route are we taking?"

"By looking at the map, we can go through Lansing and than head west. Or we can take this other route that heads through the country, but it may be longer. So let's go through Lansing this time."

The route through Lansing proved to be longer than expected, and I was getting nervous about being late. I was as punctual as he was when it came to being somewhere. We could have stopped and called, but we were both focused on getting there. We also knew that the office would understand and would be flexible in working me into the schedule.

During our long drive to my appointment, I began to think that maybe this visit was going to be a waste of time anyway. Again, I was not looking forward to hearing that the doctor wanted me to try another seizure medication. I had spent my entire life on medication that never cured me of my affliction, and I had lost all hope in medication regarding my condition. Going to another doctor's appointment seemed more like a matter of legality than for an actual purpose.

We arrived at the doctor's office about an hour late. Upon arriving, I walked up to the receptionist's desk and gave her my name. I apologized for being late and explained the reasons.

"We'll work you in. It may be about twenty minutes. Here are some papers for you. Please fill them out and return them to the desk when you're finished."

I thanked her, and I sat down next to Dad. I completed the paperwork and returned to the seating area. Before I sat down, I selected a brochure on epilepsy from the display on the wall. I never passed up an opportunity to learn more about epilepsy and the steps that I could be taking to prevent seizures. On the front of the brochure were some articles with content that was all too familiar. On the inside was an article about Peter the

Great who had epilepsy and how he didn't let it affect his role in Russia. I found it intriguing that a medical condition of a famous person was reflective of the affliction that existed in my life. There was another article that caught my attention more than the one on Peter the Great. The content included the characteristics of temporal lobe epilepsy and how technology can aid in the cure for the condition. I did not know if my seizure disorder was classified as temporal lobe epilepsy, but I was inspired to know that surgery had proven to be successful in some patients. This was the first moment in a long time that my mind was captured by the developments in epilepsy research.

Shortly after I finished reading the article, I was called back to meet with the doctor. A nurse led me to a room and asked me some general questions so that she could update my chart before the doctor arrived.

As I waited for the doctor, I sat looking at the poster of Ernest on the wall. Ernest's ridiculous smile and his unique appearance brought a smile to my face as I thought about his humor in those crazy commercials. As I gazed into Ernest's face, I thought deeply about my past and what I was currently doing with my life. I was a junior in college majoring in elementary education. My grades had drastically improved since grade school. And yet, underneath the surface lay a very complex disorder that affected my analytical thinking to some extent and created emotional turmoil in times of failure and physical exhaustion. I pondered these ironies of my life. Then I heard a gentle knock at the door, and the doctor entered.

"How are you doing? You're looking great."

"Thank you," I replied. "I'm doing fine."

"What are you doing these days? Are you still in college?"

"Yes, I am. This is my first semester away at college. I'll be a senior next year.

"What's your major?"

"I'm majoring in elementary education," I replied.

"So you want to be a teacher. How are you doing in your classes?" he asked.

"Classes are going wonderful. I'm receiving all *A's* and *B's*."

"Well, that sounds great, Amy."

He than shared with me what his son was studying in college and expressed his awareness of the challenges that come with pursuing higher education. He said he knew that going to college takes a lot of finances and discipline, but he encouraged me to continue with my education.

"Do you live on campus?"

"Yes, I do. It's a small campus, so it doesn't take long to go from place to place. I enjoy it there."

He continued his questions by asking, "Do you drive?"

I thought the answer to this question was obvious, but I proceeded. "No, I don't." Still, this question bothered me. He was knowledgeable in epilepsy and was aware of the limitations that come with having seizures. But then I began to wonder if there was something he was leading to. With a pen and a legal pad in hand, he continued his questioning regarding the frequency and nature of my seizures.

"Amy, you're on Tegretol. Is that correct?"

"Yes, that is correct."

"And how many milligrams are you on per day?"

"I'm on 1300 mg. I take 400 mg in the morning, 400 mg in the afternoon, and 500 mg at night." The doctor took notes as I told him the dosages I was taking. He was always a very thorough doctor and cared about every concern that I had.

"Are you experiencing any side effects from Tegretol?"

"On occasion I have a sensation in my head that feels like I'm a ship on the sea. When this occurs, my head feels like it's moving from side to side." I expressed the sensation the best I could. However, expressing such a sensation was difficult to put into words. Some things had a feeling all to themselves.

He replied with confidence, "That is a common side effect of Tegretol. There isn't a clear explanation for this, but I can tell you that it isn't anything to worry about. You're not the only one who has experienced that sensation. Are there any other side effects?"

He continued to write on my chart as I expressed my concerns. Then we reviewed the medications that I had been on over the past six years and the amount of time that I had been a patient at his office.

"How many seizures do you have a week?" he asked.

"It varies, but probably one or two a week. Sometimes I have three in one day, but I can also go two weeks without having any at all."

"Is there any particular time of the day that you are more likely to have a seizure?"

"For the most part, no. But I can easily have a seizure in the morning if I sleep in late. Or if I don't eat breakfast and take my morning dosage on time, I will have a seizure by late morning." He continued taking notes on everything I said.

"You are now twenty-one years old and have been in my care for the past nine years. We have tried many medications, and none of them have controlled you seizures. Since your seizures have not been controlled by seizure medication, we should consider another means of treatment. There is a procedure being done at various clinics in the United States that may decrease your seizure frequency or possibly cure you of your seizures. Brain surgery is now an option for several seizure patients like yourself whose seizures have not been controlled by medication." *Brain surgery!* I sat listening with suspense.

"In order to be a candidate, your seizure disorder must be focused. It must be in one central location and not scattered throughout the brain." He used his hands to communicate what he was saying. "I didn't suggest brain surgery to you before now because you were going through major physical and emotional changes, and it was much harder to control your seizures. Now your body has leveled off, and you're a young woman." *Hope, relief, answers.* "I cannot promise you that you will be a candidate, but I think it is something worth pursuing." He continued by explaining the nature of the procedure and the qualifying factors for the surgery. "There are doctors at clinics here in the States who do this procedure. I know of some excellent doctors I could recommend you to. The results of the surgery have been encouraging in several cases."

Is this real? Am I hearing what I think I'm hearing? Could this be the answer I've been waiting for? What will Mom and Dad think? I was stunned, yet encouraged. My expectations of this appointment dissolved as I learned of this amazing opportunity.

"If you are interested in finding out if you are a candidate for this surgery, I will refer you to either the Mayo Clinic in

Minnesota or to the Cleveland Clinic in Cleveland, Ohio. You will go through several tests that will determine if you are a candidate. At both clinics, there are highly trained doctors for specific areas of medicine. Each clinic has a department for every area of study of the human body. They have specialists from cardiology to neurology to gynecology. If anyone can cure you of your seizure disorder, it would be the doctors at one of these two clinics. What do you think?"

I believe my expression told it all. *Amazed ... in shock ... encouraged ... optimistic.*

After a brief pause, I said, "I am very interested." I didn't know what else to say. It was all too new to really know what to say. He then said he needed to do a routine exam and that he would give me a few minutes to undress.

Still speechless and mentally stunned, I resumed preparing for the psychomotor exercises that I had done ever since I could remember. The routine exam seemed juvenile, but it must have told the doctor something because every doctor I had consulted had asked me to do the same exercises. I had been through it so many times that I thought I could give the doctor the exam. I also wondered if he had to experience the same embarrassment in medical school by doing these exercises. Along with the exercises that are specific for neurological problems, this doctor did a routine physical to check my reflexes and physical strength. Soon, Dr. VanDyke returned to the examination room to begin the tests.

"Move your index finger from my nose to your nose ... Okay, now squeeze my two fingers together as hard as you can." He soon found out that I had a lot of physical strength for a female. He completed the exam by having me walk by putting one foot in front of the other and touching heel to toe.

"Everything looks good. I'll leave so you can get dressed. I'm going to have your mother join us to talk about referring you to the Mayo Clinic or Cleveland Clinic."

I responded with a chuckle, "That's my dad in the waiting room!"

"Oh, I'm sorry," he replied. "I just saw someone sitting by you, but I guess I didn't pay attention to the face." We both laughed at his mistake, and he proceeded toward the waiting

room to get my dad. It was an easy mistake to make, considering the fact that my mom was usually the one to take me to my doctors' appointments. It seemed odd that my dad was going to be in the doctor's office room with me, but it was for a special reason.

The doctor came back with Dad, and we sat in the room as Dr. VanDyke informed him of this proposal, over which I was still in awe. As the doctor repeated what he had just explained to me, I watched my dad's face in hopes of reading his internal response. He asked a few questions and appeared optimistic about the idea. I couldn't wait to hear his true reaction once we were in the car.

"There has been just one case of death during this surgery, and it was a case in which the doctors and the patient knew that he may not come out of it alive. It was a severe case to begin with. Amy's seizures are not as severe as some peoples, but they are the type that cannot be controlled by medication. Fortunately, Amy has the type of seizure disorder that is the most operable. Again, I cannot guarantee that she is a candidate for the surgery, but I am certainly willing to refer her to a specialist who will be able to determine if she is a candidate."

A new emotional sensation came over me that I had never experienced before. The hope that I had throughout my childhood to become seizure-free may actually amount to a reality. *But someone would need to open my skull in order to solve the mystery.*

Before we left, the doctor said, "Amy, I want you to think about this and not make a decision overnight. Talk it out with your family, and if you decide that you want to go through pre-operational testing, you will need to write me a letter confirming your decision. I will need that letter before I send your records. But just in case you decide this is something you want to pursue, you can sign a release form today at the receptionist's desk so that we already have that on file. Signing a release form doesn't obligate you to go to the clinic. It will just make the process go more quickly if you do decide to go."

The doctor led my dad and me toward the receptionist's desk where my dad would sign an insurance form for the appointment and I would sign a release form. The decision was already made in my heart. Convincing Mom was going to be a

chore. As we left, my dad shook the doctor's hand, and Doctor VanDyke patted me on the back.

As we drove back to college, we both exchanged our personal reactions to the news that brought us both hope and questions. Dad seemed relatively calm but positive about the opportunity that lay ahead.

"So, Amy, what do you think you're going to do?" Dad asked this as if he had no say in the issue.

"I think it's something to look into. The worse thing that can happen by my going through all the tests is that the doctors would say that I'm not a candidate for surgery. And then I would know that I will be living the rest of my life with seizures.... What do you think Mom is going to say?"

"The idea may not go over that well at first. She will need time to think about it. I'm sure she will be scared, and she'll have lots of questions. But we'll see. You may or may not be a candidate for the surgery. We will just have to take it one step at a time."

The rest of the time driving home was mostly spent by talking about how having surgery would change my life. If I had the surgery and it proved to be successful, I would no longer deal with the aftereffect of a seizure, side effects of medication, and a major inconvenience would be taken out of my life. I would be able to drive a car and not have to rely on another human being every time I needed to go somewhere. We returned back at my dorm in less time than it took us to get to the doctor's office since Dad took the country road on the return trip. He dropped me off at my dorm, and we exchanged some final words before saying "good-bye."

"I'll tell Mom the news, and I'll have her call you tonight," he said.

"Okay," I said. "Good luck." Dad and I parted with a hug and "I love you."

I made my way back up to my room, still absorbing the complexity of what the doctor had communicated. I had little time to meditate on such an issue because I had band class fifteen minutes later. My anxiety and excitement had to be put on hold until the next available moment. That evening, Marvin came over to visit.

"So, how did your appointment go?" I looked at him and shook my head.

"What is it?" he asked. Again, I was at a loss for words. I wondered how Marvin was going to react. He was an overly sensitive guy, and I knew he cared for me, maybe a little too much. I paused and revealed to him the awesome news that I received that day.

"I'm going to pursue brain surgery." It was the first time I had spoken those words, and they sounded so unreal. "I'm going to go the Cleveland Clinic for several tests to see if I'm a candidate for brain surgery." He reached for me and gave me a hug.

"Oh, Amy. I'll be there for you. . . . It's okay."

Marvin knew much of what I had been through in coping with seizures and heavy medication. He would do anything for me after I had a seizure or any other time if I needed something. But he especially had a heart for the medical side of my life. He wanted to see me live a normal life and succeed in what I set out to accomplish. He got upset if anyone tried to harass me for any reason. I viewed Marvin as a big brother who watched out for his sister, and I didn't look at him in any other way.

With amazement and sincereness he said, "So, when you are going for your tests?"

"I don't know yet. I need to write a letter to my doctor in Grand Rapids confirming my willingness to have the tests. Then I will need to wait until the clinic calls me for an appointment. There is no set time for when I will have my first appointment. I just hope it is soon."

As we departed, there seemed to be several questions that rested in the silence of the moment. Hope and suspense would remain part of everyday life until I went through preoperational testing and the results of the tests were revealed. I saw the concern in Marvin's eyes that reflected only a fraction of the overwhelming emotions that I held deep within me. Only time would tell and only God held the answers to the most complex situation that I may ever face. The rest of the story was unknown. *Is this just a dream, or is it for real? Am I chosen to endure such an unusual situation? How many other people had experienced the same emotion of not knowing whether or not an affliction would be carried with them throughout their lives*

or if there were possibilities for them being cured and having the trauma end?

The time was coming when I would know the fate of the mystery that I had wondered about since my childhood. Answers... positive or negative... lay in the near future. But if my dreams were going to be fulfilled, I was going to have to face some serious trials. All my life I had viewed myself as the weaker one but had recently been put in a position that required me to be strong. Later that evening, the phone rang.

"Hello."

"Hi, Amy. Dad just told me the news. . . . What do you think of all of this?"

"Mom, I have to at least go and find out if I am a candidate for surgery. Even if I am a candidate, that does not mean that I have to have the surgery. I think it is something worth pursuing."

"I agree. But I have to admit, this sounds scary. The thought that my daughter could go through brain surgery just sounds unreal." I heard her begin to cry. "But we will just have to wait and see what happens."

"You know, Mom, we have always wanted me to be seizure-free. No medication has ever completely controlled my seizures. This may be the only possible solution."

"I know. There's just a lot of questions that I'm sure both of us have. I mean, it's not like you might have your toe or a finger operated on. We're talking about the brain!"

"I know. But like you said, we will just have to wait and see what happens. After the first appointment at the Cleveland Clinic, we will have more information about the possibilities of having surgery and what we can expect."

"That's right. But I can't image how you must be feeling. Isn't it a strange thought to know that you could have brain surgery?"

"Yes, it is. But if it happens, I'm sure I'll get through it."

"You really want this to happen, I can tell."

"Yes, I do. All of my life I have wanted to be truly cured. This may be the only chance."

"Wow. . . . All of this still needs to settle in. I hope you understand where I'm coming from. I love you, and I don't want anything to happen to you."

"I understand. I love you too. We will all have to feel comfortable with the idea before it happens. It can't happen overnight."

"That's right. Anyway, it can't happen too soon. You still have two years left before you get your degree."

After we hung up, I returned back to my studies while the deep thoughts of brain surgery echoed in my mind. Concentrating on my homework without thinking about brain surgery was next to impossible.

> *The joys of parents are secret,*
> *and so are their griefs and fears;*
> *they cannot utter the one,*
> *nor will they not utter the other.*
> Francis Bacon

Within a month's time, I went to the computer lab on campus and typed a letter to my neurologist in Grand Rapids confirming my decision to pursue brain surgery. The many questions that I had pertaining to brain surgery would have to wait. The one thing that I knew for sure was that I could not pass up an opportunity to see if my seizure disorder was curable.

Soon after I sent out the letter to my neurologist, I received a packet of information from the Cleveland Clinic. In the envelope were several pamphlets and papers that explained the presurgical evaluation process. I spent hours one weekend reading over this literature. Some of the tests listed were ones that I had already undergone, and the other tests I did not recognize. Under the section explaining the WADA test, I read, "A catheter will be inserted in an artery in the groin and threaded up to the cerebral artery in your head." The seriousness of this particular preoperational test became instilled in my mind. CAT scan, PET scan, MRI, field of vision, and psychological testing were the other tests listed as part of the testing process. Just as I had searched out learning about epilepsy when I was a child, I took it upon myself to learn about the procedures involved with brain surgery. The effects of my disorder and the knowledge of a possible cure for it had all become a part of *me*.

One weekend when I was home from college, Marjorie and I went shopping and then out to lunch. Marjorie had been a close friend of mine since first grade and was very familiar with my seizures. As heavy thoughts rested on my mind, I waited for the right moment to inform Marjorie about the opportunity for me to pursue brain surgery. Over a sandwich, fries, and a soft drink, we engaged in light conversation. There was soon a pause in our exchange.

"Marjorie. There's something I need to tell you," I expressed.

"What is it, Amy?" she asked as her facial expression changed to a serious look.

"When I went to my yearly exam at my neurologist's office, my doctor presented to me the idea of pursuing brain surgery as a means of possibly curing my seizures."

"Oh, wow! What do you think of the idea?" Marjorie asked.

"I'm at least going to go through preoperational testing to see if I'm a candidate for the surgery. There is no harm in finding out if I have the type of seizure disorder that is operable. You know much of what I've been through. I've wanted to be cured of my seizures ever since I was a child. I can't pass up this opportunity that could possibly change my life."

Marjorie was very supportive of my new endeavor and responded in just the way that I had expected her to. Like many family members and friends, she wanted me to be cured of my seizures, but the idea of my going through brain surgery brought her a certain amount of uneasiness. As with most people, the thought of my having brain surgery brought her the fear of losing a dear friend. The seriousness of brain surgery rested on both of our minds as we shared the remaining of the afternoon together.

Over the next two months, I made several phone calls to the Cleveland Clinic in an attempt to make my first appointment. It was a challenge in itself to connect with the appropriate people

who were in charge of scheduling. Once I connected with the right person, I was told that I would have to wait until there was an opening. They scheduled only a certain number of people in advance, and I would need to wait until the next month's schedule was written. My anxiety increased as I anticipated having an appointment with the professionals who could possibly cure me of my seizure disorder. The thought alone took my breath away. Near the end of that semester, I received a phone call from the clinic with an appointment date. Great relief flooded over me in being able to have an appointment for the first part of June.

Chapter 12

Determination

With much enthusiasm, I packed an overnight bag in preparation for my first appointment at the Cleveland Clinic. Dad was out of town, and Mom and Steve planned on going with me. Mom had difficulty driving the highway, so Steve agreed to be our chauffeur. As we rode in the blue Cadillac to a city in which I had yet to visit, I thought about how brain surgery would change my life and the trust I would have to have in the medical profession. My resident doctor in Grand Rapids expressed great confidence in the medical care at the Cleveland Clinic and referred to it as one of the top ten hospitals in the United States. As the three of us drove to Cleveland, Ohio, I knew that I was possibly on my last resort of finding a cure. If the doctors at the Cleveland Clinic couldn't help me, then I would have to accept that fact that I would be dealing with the side effects of medication and the ramifications of seizures for the rest of my earthly days.

As my mom, brother, and I rode down interstate 80-90 on our way to Cleveland, I thought about how my quality of life might be improved. . . . So many questions had yet to be answered. . . . *My family would need to be behind me one hundred percent. . . . My lifetime dream of living a life without seizures would soon be fulfilled. . . or destroyed.* I knew that I had to let this matter be in the Master's hands.

We finally approached the big city filled with skyscrapers and two-story houses with appearances that resembled what I remembered about big cities. Boarded up buildings and unkept lawns reflected the inner-city way of life. As we drove over a bridge, I took in the view of the enormous buildings and wondered if I were looking at part of the clinic. The city seemed so unfamiliar and

cold as I considered the personal changes that may take place there in the future. A city of opportunity was in view.

Steve stopped at a gas station to get a car magazine before going to the hotel. When he got in the car after buying a magazine, he informed us to lock our doors and told us about the event involving the police that just occurred in the one moment of his being in the gas station. We hoped that the atmosphere of the hotel brought more comfort.

The next morning, Mom and I arrived at the Clinic by 7:30 a.m., which gave us enough time to register and make it to the lab by 9:00 a.m. Steve often got sick at the thought of blood or even the smell of a hospital, so he took it upon himself to tour the city and look for cars during my appointments. As my mom and I walked through one of many buildings of the clinic, I observed the doctors and nurses that passed by us. Each professional that passed by had a mannerism of one who had a mission and who cared about their patients' well-being. I wondered if we were passing a neurosurgeon who knew the depths of the human brain. People smiled as we approached in the hall.

After I had my blood drawn, I went to have an EEG. The reading of the EEG would give the doctor a view of the abnormal brain waves that existed in my brain. As the afternoon approached, we were sitting in the waiting room to meet with a resident doctor. I hoped and prayed that he would say he wanted me to come back for preoperational tests. After all, I had endured five different seizure medications in my lifetime, all of which proved inadequate for controlling my seizures.

"Amy Crane?" spoke a nurse. "You can come on back."

My mom and I made our way to the examination room. My mom wanted to be a part of this appointment as much as possible. The idea of her daughter going through brain surgery was heavy on her mind, and she was almost as excited as I was that there may be a doctor who could cure me of my seizure disorder. Within minutes, the doctor entered the room.

"Hello," he said in an unfamiliar accent.

He introduced himself. "And you must be Amy?"

"Yes," I replied with a smile. "And this is my mother, Brenda Crane."

"Nice to meet you," he replied. "I see you are from Battle Creek, Michigan. About how far of a drive is it from there?"

"It took us four-and-a-half hours." I said.

He asked some more questions about my life and my personal goals. I informed him about my career plans and expressed my enjoyment of going to college. Being the proud Mom that she was, my mom remarked on that fact that I made the Dean's List and had dated several young men. I tried to keep my composure as I held a knowing smile.

"So you are here because you have seizures, and you're interested in seeing if you're a candidate for brain surgery. How long have you had seizures?"

"Since I was 11 months old. I had a convulsion when I was 11 months, and I've had seizures ever since," I replied.

"And how would you describe your seizures?"

"Before a seizure, I have an aura, which is sensation of a rush of heat that goes through my body. This lasts for maybe ten to fifteen seconds, and then I go into a seizure. During a seizure, I am unaware of my surroundings. I can hear faint voices, but I cannot understand what anyone is saying. When my seizure is over, I am usually tired, but I can sometimes fight it off if I have responsibilities to attend."

Mom added, "She rubs her right arm on her right leg during a seizure." She demonstrated the involuntary movement that I was always unaware of during a seizure. "Her eyes either dilate or contract during a seizure. If I speak to her during a seizure, it only makes it worse. She gets scared if anyone tries to communicate with her or touches her." The doctor wrote on the chart as my Mom spoke.

"What medication are you on?" he asked.

"I'm on 1300 mg of Tegretol per day." I also explained how many milligrams I took at different times of the day.

"How often do you have seizures?"

"It varies. I can have anywhere from two to seven seizures a week. If I am stressed out or if it's during my monthly cycle, I can have three, four, or even seven in one day," I replied. "When I have several in one day, all I want to do is sleep. Sometimes that isn't possible because I have classes five days a week." The doctor nodded his head.

"What medications have you been on?"

"Let me think . . . I've been on Phenobarbital, Dilantin, Depakene, Zarontin, and Tegretol. None of them controlled my seizures." I wanted the doctor to know that my seizures had not been controlled by any medication in hopes that he wouldn't consider medication therapy as an option.

"Amy was seizure-free for about two years back in elementary grades when she was on Dilantin." Mom added. I cringed at her comment.

After discussing my medical condition, the doctor put me through the usual neurology exam that was so familiar. I walked in a straight line across the room and looked from side to side as I followed the flashlight. He then told us he needed to take a look at my EEG reading and that he would return in a few minutes. As he disappeared, Mom and I exchanged smiles.

"I wonder where he is from. He has a distinct accent," Mom whispered. "Well, I wonder what he's going to say when he comes back."

"Mom, I have to tell you something. I was never seizure-free. I had seizures back then, but I didn't tell you or the doctor about them. I wanted so badly to be seizure-free, and I knew that was what the doctor and you wanted to hear. It was my childish way of coping with something that was difficult for me to understand. But I was never seizure-free. I just wanted you to believe that I was," I said with a grin.

"Amy . . . I never knew that. Why, . . . I have believed all along that you were seizure-free during that time, and I have even told doctors this." She started to smile at the truth of it all. "Well, just wait until the doctor hears this one!" We both chuckled as we waited for the doctor to return. Soon we heard a knock at the door.

"The EEG reading shows that Amy has electrical discharge in her brain. An MRI will show the location of the scar tissue. Let me tell you about the process of evaluating seizure patients." We both listened attentively. "Before we schedule a patient for preoperational testing, we need to know beyond a shadow of a doubt that the patient cannot be controlled by seizure medication. We treat seizure patients by medication if at all possible. It just makes sense to attempt the simple possi-

bilities before proceeding to the more complex solutions. What we do is put the patient through three different medications to see if any of them control the seizures. If medication does not totally control the patient's seizures, then we pursue the next step, which is preoperational testing."

My hopes fell as I heard the truth of the long road ahead. *More medication . . . more time spent on something that I knew would not control my seizures . . . more medication.*

"If you're willing, I will begin by increasing your Tegretol to 1500 mg daily. You will increase it 100 mg each week for three weeks. A gradual increase will be easier on your system and will decrease the likelihood of side effects. If the increase in Tegretol doesn't control her seizures, I will try Mysoline and probably Dilantin. These are medications that will have the least amount of side effects, and these have controlled some patients with similar seizure disorders. Are you two in agreement with this?" he asked. We both looked at one another with the same expression of uncertainty.

"Sure," I said. "How long will it take to put me through three medications?"

"It will take six months to a year. If one medication fails to control your seizures, we can begin to decrease that medication and introduce the next medication," he replied.

"I will be starting classes again in August. I want to be at a stable level of medication by then. I would rather not make a medication change while I'm in school. Is this possible to work around?"

"Yes. We can begin the increase of Tegretol now and by August, we will have you at a comfortable level of medication. If we need to switch your medication again, we can make the changeover during one of your breaks from school. When is your next break?" he asked.

"I have some time off at Christmas and then my next break isn't until spring. I just don't want the changing of medication to interfere with my studies. When I go through medication changes, I tend to have more seizures during the changeover, which brings down my overall energy level."

"I understand. We will need to make those decisions as the time approaches. Because of your school schedule, it may take a little longer to put you through three medications, but we will

work together in figuring out when is the best time to make the changes. And maybe we won't have to put you on three medications. If one medication controls your seizures, then there will be no reason to switch medications," he said. I heard his reasoning, but I knew that going on three medications was just a matter of meeting the Clinic's requirements for preoperational testing. Deep in my heart, I was determined to get what I had desired for so long—to be seizure-free. As I listened to his last few words that reflected the reality that I didn't want to think about, I said silently to myself, *I will go through preoperational testing. I will.*

The doctor handed me a schedule to increase my medication, and Mom and I shook his hand. We thanked him for his counsel as we walked out to the front desk. Mom and I made our way to the parking lot where Steve was waiting for us. Few words were spoken on our long walk to the car. Mom finally broke the silence.

"He seems like a nice doctor. But what do you think about all of this?" she asked.

"I don't understand why I have to go through more medication. I have been on five different seizure medications, and none of them worked. What makes a doctor think that he has to start from square one as though what other doctors have tried with me is of no significance? Is it because he wasn't the one who prescribed the medication that he thinks my experience with those medications is invalid? What is the point of repeating something that has proved to be inadequate?" I said with frustration.

Mom nodded her head in agreement. "I was thinking the same thing, Amy. We will have to think about this," she replied.

We met up with Steve and instantly started driving back home. Silence remained in the car for the first twenty minutes on the road. I laid down in the back seat as I felt the disappointment of having to go on more medication. The pathway to being cured of seizures was longer than expected. I would have to walk the path that I had walked numerous times in my life. My having to endure chemical changes in my system due to medication changes lay ahead. The side effects of medication and the increase of seizures during the changeovers might hinder my studying. And if the doctor wants to put me on a brand

new medication, who knows what side effects I will encounter? My personal well-traveled path was one in which I longed to depart. All I wanted was brain surgery, and I did not want anything to delay the process. The silence broke as Steve asked how the appointment went. Mom explained what was discussed at the appointment.

"It went all right," Mom replied. She spoke softly and said, "The doctor wants Amy to try three medications before he puts her through testing for surgery. Amy is disappointed that she has to go on more medication before the testing."

Her explanation was only a reflection of the deep frustration that nestled in my mind. I realized that the results of the medication changes and medical tests partly depended upon my determination to press on toward the ultimate goal and upon my reliance on God for guidance and emotional support through a very trying time. I couldn't carry on by myself. A trial of faith and patience had only begun.

Chapter 13

Burdens

Over the next two weeks, I increased my medication until I reached 1500 mg per day. My seizure frequency increased slightly due to the increased amount of medication in my system. I had expected this to happen because past experience had taught me that any significant change in my internal system would make me have more seizures. Since the first day that I increased my Tegretol dosage, I not only had more seizures but also more headaches. By the second week, I started to have a spacy sensation in my head. That was an indication that I had reached the maximum dosage of Tegretol that my body could handle. My gut feeling was that if I increased my dosage any more, I would start to experience severe side effects and wouldn't be able to function properly. College classes were beginning soon, and this was no time to go into the zombie stage of medication therapy.

The higher level of medication combined with the stress of going back to school triggered eight seizures the week prior to school starting. Most of the seizures were clumped together in a two-day period. I had three seizures in one day, four the next day, and one later in the week. Sleeping during the daytime hours became routine. I began to question how I was going to handle the semester and feared that I would experience side effects of Tegretol that would hinder my grades. Despite my concerns, I went to campus, settled in my dorm, and hoped for the best.

The challenges I faced combined with my determination to overcome my epilepsy created a unique mindset or psychology within me. I knew that everyday I was subject to having seizures, which made me enter a world of total isolation from

the real world. Having seizures meant that my mind momentarily did not connect with the events and things in the environment. Everyday, I took precautions that would make me less apt to have seizures. From taking my medication on time to examining the list of ingredients on food packages and avoiding foods that triggered seizures, seizure-prevention was a daily task.

Three weeks of the semester passed, and I managed to keep up in my classes, despite the recent medication increase. However, there were several times when I wondered if I could juggle a chemical change in my system *and* maintain good grades. By mid-September, my medication level reached a high level of 1800 mg per day, as prescribed by the doctor. I started to experience more headaches, and I became tired during the day. My eyes rolled up into my eyelids periodically, and my memory was not as good as it had been.

I had posted my class schedule on the door at the beginning of the school year so I would have it to refer to each day. I was taking seven classes, all of which added up to sixteen credit hours. Although I was extremely organized in my planning and often had my assignments completed a few days in advance, lapses in my memory started to show through in my daily routine.

One Tuesday in October, I was lying on my bed studying when I realized I had forgotten to go to my sophomore core class. I had a different schedule on Tuesdays and Thursdays than I did on the other three days, but I had been into that routine for over a month. Half the class period had already passed. I had always been on time and usually early. The reality of it all started to hit me as the tears rolled down my cheeks. *How am I going to be able to complete college without losing my mind?* Thoughts of doubt swept over me. The battle between seizure control and maintaining mental clarity seemed like a lifelong event. The same battle that my parents and I faced when I was a child was still going on in my adult life. After reflecting on my life's circumstance and regaining my composure, I grabbed my books, ran out the door, and hurried on to class. I walked in

and sat in the back where I could not be seen by many students. As I listened to the professor lecture on the Renaissance Era, I started to cry again. I felt as though I had lost control of my mind and my life. Although I knew that being late to class did not mean that I would fail the class nor would it end my college career, the reason behind my lateness is what disturbed me. *My medication is taking over my life. . . . I'm losing my mind, and I have no control over the situation. . . . What will I forget next?* These thoughts went around and around in my mind as I attempted to focus on the lecture material. After class was dismissed, I waited for other students to leave before approaching the teacher. I figured he probably wouldn't completely understand, but I had to explain to him why I was late.

"I'm sorry I was late," I said as I started to cry again. I knew I had not told him in the beginning of the year that I had seizures, so this was going to be even harder to explain. He handed me a tissue.

"Is there something wrong?" he asked. I paused as I wiped the tears.

"I haven't told you this before, but I have seizures. The medication that I am on has affected my memory, and I forgot I had class. My medication level has been increasing over the past month. I am at a high level of medication right now, and it's affecting my memory."

"I see," he said as he nodded his head

"Will this late hurt my grade?" I asked.

"No, you can have a few lates a semester without it hurting your grade. Your grade is based on points, and a few points won't hurt your grade."

I asked him about the material that I missed during the beginning part of the class and the next homework assignment. After talking a few more minutes, we walked out of the classroom together and parted ways.

As I walked back to my dorm, I wondered if I was being too hard on myself for being late. *After all, I am human. How much error should I allow myself without equating it with my medicine? . . . But I have never forgotten to go to class. I must be losing my mind. I must have reached my toxic level of this medication.* Acquaintances passed by as I was in a world of my

own. When I got back to my dorm, I called my nurse and discussed the possibility of decreasing my dosage. My nurse agreed that I had reached a toxic level and got the doctor's permission to decrease my medication. The chemical change that was taking place in my system, combined with the stress of midterm exams, resulted in an increase of seizures. Over the course of the following week, I had eight seizures. Staying alert during class was a chore. Fortunately, after that week my seizure frequency returned to its regular intervals, and I regained my mental clarity.

I knew that many people who pursued college degrees were healthy human beings who did not have to contend with seizures and taking medication. I knew I was different in that regard, but I also knew that I had a responsibility to make the most of every opportunity and to receive a higher education. My personal ambition and determination to complete the task that God had called me to do were the factors that drove me to carry on.

The fall activities of the small college town began near the end of October. On a cool Saturday morning, I sat at the street corner with my college friends and watched the members of the marching band come down the road. A parade of bicycles and floats followed the trumpets and flag core. The society members were standing on the sidewalk, dressed in fall colors and their society jackets. An enthusiastic spirit was heard throughout the town as people sat on their porches and watched the parade. The main attraction of the town was over in a matter of a half hour. Once again, the town became a quiet place to study and take casual walks. Only an occasional shout came from one of the sorority or fraternity houses.

After three months of increasing my medication, Tegretol proved to be inadequate to control my seizures. The next step was to proceed to a second seizure medication. Once again, I called my nurse at the clinic to see how the doctor wanted me to make the switchover. My nurse called me back later that day and explained the possibilities.

"I realize that you have some time off over Christmas. We can either have you gradually change medications starting at the beginning of your break, or you can come to the clinic as an inpatient while we switch your medications over a five-day period. If you decide to come here for the changeover, we would take you off Tegretol and put you on Phenobarbital for a few days. Once your level of Phenobarbital is up, we will introduce Mysoline. Mysoline breaks down in the system into two elements; one is Phenobarbital. That is why we would put you on Phenobarbital first. Your system will adjust to Mysoline better with Phenobarbital already present. The reason we cannot have you make a fast change at home is because during a fast medication change, you are at a higher risk for having a grand mal seizure. You will need to be under close monitoring during a fast medication change in case you have a severe seizure. Our staff would be able to assist you if that were to happen. I will let you think this over and get back with me later. I can almost guarantee that there will be a bed available. During the Christmas season, we don't have many patients in that ward. But I will still need to know what your plans are so I can schedule you for a room. Do you have any questions?"

"Yes; how long would it take to make the medication change at home if I were to do it gradually?"

"It would take about four to eight weeks. I know that you don't have that much time off from school, and I thought this would be a better alternative. But if you are willing to make the change during the semester, you can do it that way. It is totally up to you."

"Okay, I'll talk this over with my parents and let you know what I'm going to do. Thanks, Wendy."

"You're welcome, Amy. Give me a call once you talk with your parents, and we'll go from there."

"Okay, I will."

"Good-bye."

"Good-bye."

It took only a few conversations to convince my Mom that she and I should go to the clinic for the medication change. She mentioned that she could write in her Christmas cards and if I were up to it, we could play cards or work a puzzle. She said

that our stay there would be like a mini vacation. *A vacation?* I thought. *My bodily system is going to go through a chemical change, and my Mom thinks it's a vacation!* I understood her thinking, but the word "break" seemed more appropriate. I didn't envision a sunny beach and surfers when I thought about lying in a hospital bed for five days. Having all the iced tea I wanted was about as close to a vacation setting as I would get.

I completed that semester receiving five *B's* and two *A's*. I was so glad to have that semester completed. The side effects that I had experienced from the high level of Tegretol had brought an added burden to my college pursuit. After having doubted if I was going to make it through college without losing control of my mind and life, I rejoiced that God had enabled me to receive the good grades that I did. What a relief it was also to know that the high stress that accompanied studying was over for another month.

Only days after the stressful week of final exams, I prepared for my stay at Cleveland Clinic where I would go through a fast medication change. Mom was glad that I'd be monitored during my medication change because she didn't want me to have a grand mal seizure at home. My experience with my grand mal seizures had brought so much fear and concern to us that Mom couldn't fathom seeing me in another one and not having a medical professional nearby for support.

My desire to have preoperational testing for brain surgery was my driving force in going through another medication change. Based on my experience with Mysoline and multiple other seizure medications, I had reason to believe that this one would be unsuccessful in controlling my seizures as well. If my theory proved to be correct, I would have just one medication left to try before I would be eligible for preoperational testing. And that, of course, is what I ever so deeply hoped for. Preoperational testing would then hopefully lead to brain surgery.

In the middle of the hustle and bustle of the Christmas season, Steve drove Mom and me to Cleveland, Ohio for my five-

day medication change. Mom brought Christmas cards to write, and I packed my CD's and a book on brain surgery that I checked out from the library. The content of the book was directed toward other types of brain surgery, but at that point, I took an interest in any information about the topic of brain surgery. Between watching television, working a puzzle with Mom, taking pills, and sleeping, I figured I would have plenty of time to read about the intricacies of the brain.

During my stay in the clinic, I experienced six seizures, one of which a nurse thought was stronger than usual and possibly a generalized seizure. As I slept for several hours after each seizure, Mom stayed nearby as she was concerned about me having a grand mal seizure. As the level of Mysoline increased in my system, I felt an increasing heaviness in my knees. I explained the sensation to my resident doctor.

"How's Amy doing today?" my resident doctor asked as he entered the room.

"All right, but I feel like I have rocks in my knees," I replied. He chuckled at my unusual response.

"You feel like you have rocks in your knees. Stand up and let me see these rocks." By this time, Mom, doctor and I were laughing. I stood up and walked across the room. There was no change in my walking, despite the sensation in my knees. I remembered having that same sensation another time when I was on Mysoline. It wasn't a painful feeling, but it felt as though there were weights in my knees. The simplest way to describe it was to say there were rocks in my knees.

The doctor asked how I was doing and how many seizures I had since I was there. Besides taking my vital signs and seeing that I was coherent, there really wasn't much the doctor or anyone else could do for me. With the support I had from the nursing staff, neurologists, and my dear mother, I was well cared for and had plenty of iced tea to quench my thirst. I couldn't ask for much more during this time of transition in my system. The nurses treated Mom and I like we were part of their family by bringing me fluids, adjusting the television, and carrying on casual conversation that made the transition easier to endure. The spirit of Christmas and a time of renewal was felt throughout the floor that I was on.

Although we were there for a medical purpose, Mom and I made the most of this opportunity as we talked about mother-daughter things and the possibility of brain surgery and all that it would entail. Our time together was refreshing. Mom took me for walks each day so that my muscles and joints wouldn't become tight. I wasn't allowed to go for walks on my own since I was considered to be at a high risk for a grand mal seizure. Wearing a nice pair of cotton-knit pajamas that Angie had given me, I became very familiar with the halls and windows of the modern building. The floor was very quiet. It was the Christmas season, and there were few patients at the clinic during that time. Not many people wanted to stay in a hospital bed by choice during the holiday season. I, on the other hand, thought it was neat to be there during the Christmas season. The anticipation of the celebration of the birth of Christ combined with the tender care that I received from the nursing staff gave me a unique sense of warmth during my stay at the clinic. As snow fell from the sky, and we heard Christmas songs in the distance, my mom and I followed a similar path each day through the halls of 'H' wing as we greeted the nurses, doctors, and patients that we passed.

We also joked about the pathetic Christmas tree that we left behind in the dining room at home. It looked more like a bush than a Christmas tree. During one of our phone conversations with Angie, we were informed that our Christmas tree wouldn't stand up and that it was leaning in a corner of the room because of its poor condition. Dad was out of the country on business, and we were in Cleveland, Ohio. We knew that when we got home, we had some serious work to do to make the Christmas "bush" look like a Christmas tree in the upright position.

On December 16, only nine days before Christmas, I was discharged to go home. The blood test showed that my medication level was at an appropriate level to consider me stabilized. I was greatly relieved to have the medication change completed. I had never gone through a medication change so rapidly before. Gladness filled my heart as I left the clinic that cold day in December. The spirit of Christmas filled our minds as Steve drove Mom and me home through a light snowfall. A gentle snow fell across the farmers' fields of Ohio as I patiently

awaited my arrival home in order to bake Christmas cookies and to help save the Christmas bush.

Chapter 14

Resolution

The arrival of the New Year brought a different and refreshing New Years' resolution. As the New York Apple dropped from town's square, I hoped I would go on a third anticonvulsant and that my seizures would not be controlled by any medication. If I continued to have seizures while on each medication, I would then be scheduled for preoperational testing.

Twelve, eleven, ten, nine . . . While Americans counted down the seconds left in 1992, I anticipated the length of time I had before preoperational testing, and hopefully, a new life. I thought about the possibility of having brain surgery and how the positive results would change my life. The prospect of my becoming seizure-free and eventually going off all medication was an amazing thought. Being able to drive a car one day was just as exciting. *Four, three, two, one.* Shouts of excitement and the blaring from horns filled America as I hoped that I would soon be able to count down the months and days before the medical tests, and then surgery. *The events that transpire in the New Year might lead me to a life I have so longed to acquire.*

Soon after the New Year, college classes resumed, and I settled back on campus. Being a senior in college meant having harder classes, including botany and music theory. Some of my classes brought some anxiety to my life, but I studied long hours and managed to receive average- to above-average grades early in my courses.

Although being on a different medication had proven to be relatively successful, one side effect became obvious. I started to lose weight. During that semester, I usually was not hungry,

and I ate only a small amount of food at each meal. Consequently, I lost ten pounds over a four month period. Several times throughout that semester, I had received comments from people about being skinny, but I did not think much of it. I had always been skinny and often heard people say something about my waistline. Because of my history of being thin, the thought did not occur to me right away that I was losing a significant amount of weight. I did not notice the drastic weight loss until one weekend in spring when I weighed myself on my mom's scales. I had gone from weighing 143 to 133.

Despite losing weight, I was in good health and continued my studies toward a degree in education. Marvin and I remained friends and had only an occasional dispute. We spent time together in a few classes, at mealtime, and sometimes during the evening hours. Although our relationship appeared like something more, we were just two close friends who laughed together, who kept one another accountable for our goals, and encouraged each other when college life seemed like too much to bear. Because we lived so close and had developed a close friendship, Marvin was usually my ride between home and college. He would show up at my parents' house with a bag of Oreo cookies in hand, and I would provide a half-gallon of milk. I have to say, some things never change between grade school and college. However, there are other things that change that make life much more complicated. (But I'll save that topic for my next book.)

The semester came to an end soon enough, and I had final exams to prepare for. After long hours of studying for six exams, I felt mentally exhausted and just wanted to relax on my bed. As I lay on my bed thinking about my finals, I felt an aura begin. The intense studying triggered a seizure in the same way that stressful situations had on numerous other occasions. At that point, having a seizure did not really bother me. I was tired and needed to rest anyway. I never *wanted* to have a seizure, but I knew that some moments were more convenient than others to have one. After an hour nap, I felt refreshed and eager to study for my exams. With a glass of red

punch and a bag of chips, I prepared for the many hours of studying that lay ahead.

Although studying brought much stress and more seizures, I adapted to my personal situation by allowing for several short breaks to lessen the stress level or, in other words, to air out my mind. Short visits to my friends' dorms and walks across campus allowed me to take a break away from the books. Various incidences made me realize even moreso that I was in an unusual situation. If I didn't study, I was sure to do poorly on my exams. If I studied for long periods of time, I would go into a seizure and possibly have multiple seizures in a short amount of time. The consequence of having one or more seizures would be having to sleep instead of study. Finding a balance between studying long hours to get good grades and monitoring my stress level in order to limit the amount of seizures I had was one of the greatest challenges of going to college. I didn't want to use my seizures as an excuse for not studying, and I did not want to put myself in a position where I was compromising my health for the sake of a good grade point average. The need for balance in everything become very apparent. After studying long hours and going through many bags of snacks, I received all *A's* and *B's* on my final exams and semester grades.

That semester, I had the usual amount of seizures, despite being on a different medication. Experiencing between five and eight seizures a month, it was obvious that Mysoline was not controlling my seizures. Making the switch to another medication would be more convenient now that the semester was over. After speaking with my nurse and under the doctor's orders, I started Dilantin, the third medication since my first appointment at the Cleveland Clinic.

Chapter 15
Uncontrollable Force

1993

As the summer began, I applied for a job at a local grocery store. Since the job application did not have a section asking about medical problems, I knew I would need to inform a manager of my seizures for safety purposes and to avoid any unnecessary confusion. Upon returning my application, I was called for an interview. With a little bit of courage, I told the manager who interviewed me about my epilepsy. The nature of his response made it evident that he really appreciated me telling him. He explained that he would make every effort to find a position in the store that would not require intense physical strength and one that would allow me to take a break easily if I had a seizure. I had explained to him that being physically exhausted can trigger a seizure. Upon passing a drug test and having a physical exam, I was hired to work in the deli. That summer, I worked about thirty hours per week, slicing meat to save money for college.

Along with working part-time, I took a chemistry class that July at the community college to fulfill one of the requirements for my science minor. Working part-time at the deli and going to class during the week made for a full summer schedule. I knew very little about chemistry and figured that taking it as a six-week class in the summer would be much better than taking it during a full semester. I gained confidence in the class after receiving a passing grade on the first test, and I realized that it was not as difficult as I had imagined.

During this course, I managed to acquaint myself with a handsome young man who understood the content of the class better than I did. He and I became close companions during this

six-week course. We went on dates together and shared some of our goals. During one of our walks along the Kalamazoo River, I confided in him that I was pursing brain surgery. Telling anybody about my current pursuit took some courage. The depths of my soul and countless emotions were all poured into one personal matter that was foreign to the average person. Brain surgery seemed radical to virtually anybody, let alone a potential boyfriend. However, he was tenderhearted and concerned as I revealed to him my situation. I was glad to have a new friend with whom I could share my burdens. His friendship also made chemistry class more interesting and less difficult.

The changeover to Dilantin led to slight changes in my overall health. I started feeling a rolling sensation in my eyes on occasion, and I didn't feel as mentally sharp on Dilantin as I had on other medications. My seizure frequency had remained the same, but the intensity of my seizures had worsened. The inadequacy of the medication led to another time of turmoil.

The episode occurred on an evening during chemistry class. I had a test that night for which I had studied many hours, and I was confident I would do well. Before the test began, the teacher gave us students a ten-minute break. During the break, I went into the ladies' room along with some of the other women in the class. The next thing I knew, I was lying in the emergency room in the hospital next to the campus. A male nurse came to my side and nudged me.

"Amy, can you wake up?" There was no response right away.

"Amy, you had a grand mal seizure. You are in the emergency room because you had a bad seizure in the bathroom at the college." I slowly woke up from a sound sleep.

"Where am I?" I asked.

"You are in the emergency room. Some of your classmates found you lying on the bathroom floor in a grand mal seizure, and they called for an ambulance. . . . Do you remember any of this?" he asked. I slowly nodded my head "no." The reality of the situation started to take form in my mind as I tried to recall the event. My only recollection was the feeling of someone carrying me out on a stretcher as though I were a comet mov-

ing through space. I couldn't recall an aura or even what I was doing prior to the seizure. One aspect that I usually remembered after my seizures was having gone through the short stage of denial during an aura. That day, I had no recollection of having experienced denial. Since the seizure had come on so quickly, there was no time to go through that phase.

A nurse gave me Tylenol for my headache and took my vitals. My temperature was the only thing that was abnormal. Each minute that passed, I gained more awareness of my surroundings. I soon regained a normal level of alertness.

"Can I go now? I'll be all right. I'm missing class," I asked in an alert voice.

"You need to lie here a few more minutes until we know for sure that you are stabilized," a technician replied. *What happened to me? . . . I don't remember going into a seizure or falling. . . . And now I'm in the emergency room.*

Within a matter of fifteen to twenty minutes, I was released from the emergency room. I walked back to the campus, dragging my book bag that the ladies had placed on the stretcher. As I walked across the thick, beautiful green grass and up a hill to the buildings, I reflected upon the recent event. Being unable to recall what I was doing before the seizure really bothered me. I was very disturbed about the incident and wondered how I could have had a grand mal seizure. It didn't make sense. I had not experienced a seizure this severe since I was a senior in high school. Then it occurred to me that the change in medication was probably the cause. The different medication combined with the stress of taking a condensed summer class and waiting for preoperational testing was certainly enough to bring on a grand mal seizure. Again, the message was reinforced to me that the only hope to end this trauma was to have brain surgery. In the meantime, I had classmates to face and a chemistry test to make up.

As I approached the classroom buildings, I recalled where my class was located and went into the bathroom to recollect my thoughts and to gain courage to walk into the classroom. I knew there would be questions from the ladies who had noticed me convulsing on the floor. As I entered the classroom, the teacher was lecturing on the next chapter. Expressions of concern and

curiosity filled the room. I walked over to where I usually sat and tried to find the appropriate place in the text and lecture material. Dan, my friend, helped locate the correct chapter.

As anticipated, at the end of class, I was confronted with questions of concern from the ladies. I was subdued in my response, but I answered their questions to the best of my knowledge. One of the ladies was a nurse and expressed a deeper understanding about seizures than the others. Despite their backgrounds in life, they were all surprised that I had seizures and expressed their concerns after having found me on the floor in the bathroom. The facial expressions of my classmates were only a vague reflection of the fear and pain that lay in my heart and soul. *My life was stricken and taken captive by the uncontrollable force that resides inside me.* Again, emotional turmoil resulted from the instability and unpredictability of my life.

After class that night, I spoke with the teacher and explained the reason for my missing the test. I figured he had heard about the episode from the ladies, but I felt obligated to explain to him firsthand what had happened. He understood and allowed me to take the test right then. Thanks to many hours of studying, I managed to pass the test.

Telling Mom and Dad about the grand mal seizure brought tears and more anticipation about preoperational testing. The more struggles I endured, the more my family understood my reasons for pursuing brain surgery. We all wanted the doors to open that would lead me to a more stable and peaceful life.

All of this turmoil was a mixed blessing since I had now completed my third medication since my appointment at the clinic. None of the medications had controlled my seizures. I had finally reached the qualifications to proceed to the tests to see if I were a candidate for surgery.

In talking with my nurse the next day regarding the grand mal seizure, she told me to increase my dosages of Dilantin. The increase was an attempt to prevent the occurrence of another grand mal seizure. She also said that I would soon be on the presurgical list. Dilantin would be eliminated after preoperational testing, and I would then go back on Mysoline. The changeover would be easier to do after testing since I would be

off medication during the testing. I was content with this idea as I was grateful that presurgical testing was in the near future.

Four weeks into my chemistry course, I received a phone call from the Cleveland Clinic. My nurse informed me that I was on the presurgical list. My excitement increased as I was relieved to know that I was making progress toward my ultimate goal to have brain surgery and to become seizure-free.

Three-and-a-half weeks passed since the grand mal seizure, and no other fearful episodes had occurred. I was still amazed that I could go into a grand mal seizure so quickly and yet have no recollection of an aura or the seizure itself. The devastation of the event led me to have a dream one night that I was in a grand mal seizure. When I awoke, there was no doubt in my mind that it was only a dream, but it made me realize the impact upon my memory. Not only had I experienced grand mal seizures but the fear of having another one also filtered into my dreams. To me, that dream was more like a nightmare. The desire to have brain surgery increased with each individual event in my life, whether it was an intense seizure, side effects from medication, or a dream that reflected a dreadful life-threatening experience. Despite how grand mal seizures affected my mind, I held thankfulness in my heart for each day of life. To illustrate this point, the following scenario is an example with which nearly everyone can relate.

Thankful for Life

Anyone who has ever ridden in a car has been there—only seconds and inches from being in a car accident. After the slamming of the brakes and the squealing of rubber on the pavement, your heart is pounding and you are so thankful for not having been injured. Your heart pounds as though you were running a marathon. *Thu-thump, thu-thump, thu-thump, thu-thump, thu-thump.* Your hands shake. You rest a moment to calm your nerves. *I'm alive,* you think to yourself. *My life could have been taken back there, had the timing been any different.*

I would not have been able to make it to my destination today had I been in a car accident. You rejoice in being alive, knowing that God protected your life. The enthusiastic spirit that you had minutes ago regarding the event that you are about to attend is no longer within you. Instead, the thought of almost losing your life wrestles in your soul.

The reaction a person has after coming milliseconds from being in a car accident is a similar reaction that I had every time after I experienced a grand mal seizure. However, there are two main differences between these two situations. The first is that a person who is attempting to avoid a potential car accident consciously knows that his life is at stake, whereas when I was in a grand mal seizure, I was unable to think of the possible bodily injuries I could receive from the seizure. The second difference is that in the case of a near car accident, the car could be damaged and yet could also protect one's body from serious injuries; however, in the case of a grand mal seizure, one's body is basically the only element in danger. There is no outer layer of protection for the person who is in a grand mal seizure like there is to the person who is traveling in a car. The trauma during a grand mal seizure is happening within the person's body—a human body that cannot be replaced, unlike a car.

In both incidences, however, there is an aftershock. The thoughts after both terrifying events include the fear of having the same thing happen again and the realization that one's physical body could have received extensive injuries. In either case, your nerves are shaken up for a day or two as images of the episode replay in your mind. The quietness within your soul reflects fear that came from having your life at stake. Following this troublesome experience, you thank God for another day of living and for protecting your life from the enemy. You are very thankful for life.

Less than three weeks after the terrifying dream, I received another phone call from the clinic. My heart froze as I anticipated encouraging news. Sure enough, a bed would be available in a matter of days for twenty-four-hour EEG monitoring. I was most excited to be scheduled for preoperational testing, but I realized that I would need to take an incomplete in my chemistry class if I chose to go to Cleveland. Because of how much this medical testing meant to me, I agreed to be there despite the conflict with my class. If I did not take this opportunity, there may not be another time for testing before school started in the fall.

The next day, I explained to my teacher the opportunity I had and why I wanted so desperately to go. Because he knew of the grand mal seizure I had on campus only weeks before this, he was more sensitive to my purpose in wanting to go for medical testing. He understood and directed me to the records office to fill out a form for an incomplete for the class. I would be able to complete the course once I got back from the clinic.

Before leaving for Cleveland, I told Dan where I was going and why I wouldn't be completing the course with the class. He wished me well as we both went our separate ways. The next day, Steve drove Mom and me to Cleveland where I would spend a week in a hospital bed hooked up to wires and monitors, day and night.

CHAPTER 16

Preoperational Testing Phase 1

Once again, I approached the enormous buildings that were filled with patients hoping to be cured from diseases that seriously impacted their lives. Doctors, anesthesiologists, nurses, and parents with young children passed by as Mom, Steve and I searched for the Epilepsy Monitoring Unit (EMU). The friendly yet fast-paced atmosphere was comforting as I knew that the people there were on a mission. Each person's mission was to either *provide* or *seek* better health. This was reflected in the interactions among the staff and the patients. The atmosphere of the clinic revealed that lives were changing other peoples' lives.

I was admitted that Tuesday and anticipated being there between four and seven days. As I entered the room of the EMU, I noticed several huge monitoring screens where patients were being displayed for nurses to view. Mom, Steve, and I sat in the small room where I was assigned as we waited for the doctor's arrival. I was amazed at how well Steve was holding up. He didn't have a strong stomach for hospitals. He sat staring at his feet as he avoided looking at patients, IV units, and anything that could make him feel sick. The doctor arrived in a matter of minutes and began explaining the testing procedure.

Soon the doctor arrived, and he began to describe the testing procedure. He explained that in order for the neurologists to make a valid evaluation, my seizures needed to be recorded using an EEG and a video camera. Then he and some additional doctors would review the acquired recordings to help

determine the type of seizures I have and to decide whether or not I was a candidate for brain surgery. I would be taken off all seizure medication to increase the likelihood of having seizures while in the EMU.

As anticipated, Steve stayed only for a short time and then drove back to Michigan. Not long after the doctor left, a nurse soon came to begin the process of the EEG monitoring. Mom went to the waiting room so that I could be alone with the nurse.

"Amy, have you had EEG monitoring before?" she asked.

"No, I have not. But I've had regular EEG's many times," I replied.

"Okay, this is the same thing except you will be hooked up twenty-four hours a day for two, three, or four days until we have enough of your seizures recorded. You will have wires connected to your head all day and night. If you need to use the restroom or you need anything at all, here is the call button that you can push, and one of the nurses will come to help you. The most pain that you will experience will be in a few minutes when I connect the wires to your head. You may remember that from previous EEGs." I nodded my head in agreement.

"Some patients have a seizure right away after going off medication, and others are here for three or four days and never have a seizure. There was a patient here just the other week who came all the way from Arabia for twenty-four hour EEG monitoring. She was here for four days and never had a seizure. We discharged her, and she started seizuring after she was home. That's the chance we take with this test. Hopefully you will have seizures in the first few days. Once we have enough seizures recorded, we will put you back on medication and send you home once your levels are up. Do you have any questions at the moment?"

"No, I don't think so," I replied. I was in deep thought about the future, but I felt at peace with going through the EEG monitoring.

"Okay, you can lie down, and I will begin connecting the electrodes. The smell is awful, but it will be over before you know it," she explained.

I laid down in a comfortable position and waited as the nurse rolled the cart of wires toward my bed. Soon, the smell of

something awful filled the air. A solution was rubbed on my head, and I felt the pain of a wire scratch on my scalp. It was a familiar feeling, but the slight pain made my emotions go past their threshold. The nurse noticed the tears on my check.

"Are you okay, Amy?" she asked with concern.

"Yes. I'm all right. Keep on going. I'm fine," I replied. I wiped the tears from my cheek as I knew it was not entirely the pain from the scratching of the wire that made me cry. The first scratch of the wire represented the first official test that could lead to brain surgery. Only one scratch on the surface of my head was behind me. As excited as I was to think about the possibility of becoming seizure-free, the thought of going through brain surgery overwhelmed me. I also thought about all the other in-depth medical tests that I would soon undergo. This step was only the beginning of another long journey.

Starting at the moment when I laid down in the hospital bed that afternoon, I was taken off of all my medication. I had always wondered what it would be like to be off medication. It was such an intriguing thought to me. This was the first time in my life that I was going to be entirely off medication for several consecutive days. I had no idea what to expect. I wondered if I would seizure every hour, every few minutes, or if my seizures would be more severe. With the exception of going off all medication for one day when I was nauseous during a medication change, I had never skipped more than one dosage in one day's time. The whole idea was mind-boggling.

The day after I was admitted, the nurse explained to me that most likely my medication was completely out of my system. She said that Dilantin does not stay in the system very long and that was to my advantage for testing purposes. The sooner the medication was depleted out of my blood stream, the sooner I would have a seizure and the sooner I could be discharged.

During my testing, Mom stayed in the Omni Hotel connected to the clinic. She came to see me three to four times a day, and her face became very familiar to the nurses on staff at the epilepsy monitoring unit. Mom would walk up to the desk and ask, "How is she doing?" With those few words from my

mom, the nurses behind the counter knew exactly which monitor to look at. Sometimes when Mom came, I was asleep. But most of the time, I was awake reading or doing something to keep my mind busy. My first morning there, Mom came early to see me. I was already awake.

"How are you doing?" Mom asked.

"All right. I haven't had any seizures yet." I replied.

"You haven't! Why—that's crazy! If you were at home, this wouldn't happen." She kissed me on the cheek.

"I know. We just need to wait for more medication to go out of my system. It will happen sooner or later."

Mom stayed for a few minutes and then left to go to the clinic cafeteria for some coffee and breakfast. Meanwhile, I pushed the red button and asked for assistance to use the bathroom. The wires on my head were also connected to a portable unit that a nurse pushed along the side of me whenever I went to the bathroom. I felt like I was carrying around my life support with me. Wherever I went, the machine and wires went with me.

My lunch was delivered by the smiling lady who walked like she had a thousand patients waiting for their plastic tray of delicious food. Nevertheless, she was friendly and took time to say a cheerful "hello." As I took inventory of the food on the hospital tray, I checked to see if there was anything that I could not have. I had always done this when I was given a meal that I did not choose. Then the thought occurred to me that this was one time that I could eat anything, even if it were a food that caused me to have seizures. In fact, this was one time that I should eat those foods that I normally avoided. One of the first items on my tray that I noticed was a packet of artificial sweetener. I knew that would put me into a seizure in a matter of minutes. It seemed like the strangest thing to be doing, but I put the whole packet of artificial sweetener in my iced tea. If that didn't put me into a seizure, I would ask for more packets until I had enough artificial sweeteners in my drink to make Southern iced tea!

An hour passed, and I still had not had a seizure. I was stunned. I reviewed all the different foods that were on my mental "do not eat" list to figure out what I could eat to make

myself have a seizure. I knew that if I did not have a seizure in a matter of three or four days, I would be discharged and have to come back and go through this all over again. I wanted to complete this phase of the testing on the first try. Soon, a nurse came in to check my vital signs.

"How are you doing, Amy?"

"Pretty good."

"Is there anything you need?"

"Yes. Could you please get me several packets of artificial sweetener?" The nurse looked at me with a strange expression. "Artificial sweeteners have always made me have seizures. I don't drink diet drinks because the artificial sweeteners will put me into a seizure within a matter of ten to twenty minutes. I thought I would put some artificial sweetener in my iced tea. That should help me go into a seizure."

"Sure, I'll see about getting some for you. Would you like me to bring you some more iced tea?"

"No, that should do it."

"Your vitals are all right. I'll be back in a few minutes." I figured the conversation about the artificial sweeteners really baffled her mind. I had never heard any medical person in my entire life say anything about artificial sweeteners causing seizures. My awareness of the relationship between eating certain foods and having seizures was the basis of understanding cause-and-effect situations. There were only a few times that I had ever eaten something with an artificial sweetener, and when I did, I was bound to have a seizure.

A possible explanation for my not having a seizure after consuming artificial sweeteners is the fact that I had no seizure medication in my system at that time. Without the presence of seizure medication in my body, the artificial sweetener could not create a chemical reaction with a seizure medication. It is my conclusion that it is the interaction between anticonvulsants and artificial sweeteners that trigger seizures in people with epilepsy.

I remained free from seizures that day and throughout the night. No matter what it took, I was determined to induce seizures while I was in the EMU. Until I had a seizure, I continued listening to my CD's and reading the books I brought.

Twenty-four hours had passed since I stopped taking my medication, and I had not yet had a seizure. Mom and I could not believe it. In the past, almost every time that I had been late in taking my medicine, I had a seizure as a result of the late dosage. Now I *wanted* to have seizures for the sake of the testing process, and it would not happen.

It was a good thing we had insurance. Three days had passed since I had been admitted, and I still had not experienced a seizure. I continued putting packets upon packets of artificial sweetener in my iced tea and thought of things that stressed me out. Nothing worked. Still hooked up to expensive monitors and my hair a grease pit, I waited with anticipation to have a seizure. The nurses provided me with wonderful care and were there within a minute every time I pushed the call button. Again, Mom came to see me.

"How are you doing today? Have you had a seizure yet?"

"No such luck. It has to happen sooner or later. I think the reason I haven't had a seizure yet is because I'm not in my normal environment. I'm out of my daily routine of going to school and work. I'm not stressed out, and I'm not physically active."

"I bet you're right because this would not have happened if you were home. It just wouldn't. Well, as I told you yesterday, I need to go home and take care of some responsibilities at the office. I have to write paychecks and take care of paperwork for the doctor. I hate to leave you, but you're well cared for and I'm really not needed here. If it weren't for the excellent care that you're receiving, I probably wouldn't be leaving you, but I know you'll be all right." Mom knew she wasn't needed for my physical care but for moral support. Even so, it was difficult for Mom to leave me.

"That's fine. I can't go too far! They have me wired up—I think I'm here for a while."

"I'm going to catch the eleven o'clock bus. I checked the bus schedule, and I should be home by about seven o'clock tonight. Steve and I will drive back to get you when you're ready to be discharged. Oh, I feel bad that I have to leave you. Here you are in a hospital bed and I'm leaving you."

"It's not like I'm on my deathbed. I'm fine, Mom. You know I'm receiving great care."

"I know, but it's still hard to leave you. You're my daughter." Her leaving me brought some tears, but I expected that. Mom always wanted to be there for her kids, even after we became adults. But under the circumstances, it was all right that she left me for the weekend. There really wasn't anything for her to do aside from talking to me. The clinic had everything under control.

"I love you." She reached to give me a kiss.

"I love you too, Mom." We gave a light embrace without pulling any wires, and she left with all of her bags in hand.

This was Friday morning, and I had been on the monitoring unit for almost three days. That day passed, and I still had not had any seizures. My neurologist came to see me and to encourage me to have seizures. It was the most unusual situation I had ever encountered as a patient with seizures. I, along with all of my supporters, actually wanted me to have seizures! However, having it happen was a chore.

Sleeping with wires connected to my head brought some discomfort, but after two nights, I was able to move just right in my sleep so that I did not disturb the electrodes. On occasion, a nurse came in during the night to reconnect an electrode to my scalp. But for the most part, the wires remained intact.

The next morning I awoke to another breakfast tray on my hospital cart. The donut on my tray caught my attention. Whenever I had eaten donuts without a substantial amount of nutritional foods already in my stomach, I would have a seizure. This one time I could justify eating a donut for breakfast. This one occasion I could break all of my personal rules related to my seizures.

Before eating the donut, I called for a nurse to help me to the bathroom. When she arrived, she took my vital signs and informed me that I had a grand mal seizure in the middle of the night. She also referred to this seizure as a generalized seizure. As I ate breakfast, she explained that it was good that this happened. She said that having a grand mal seizure on tape would show the doctors much of what they needed to know. I had not remembered a thing about the seizure, but it was common for

me not to remember anything about having a grand mal seizure. I could usually remember having the psychomotor seizures in the night, but a grand mal seizure is so intense that I would have no idea that it was even happening. Being asleep before it happened made it impossible to recall any part of the seizure.

Being transported to and from the restroom was quite an ordeal. With many electrodes connected to my scalp, I had to walk slowly in order to avoid pulling any wires. The nurse stood outside the door so that she would be there for immediate assistance if I had a seizure.

Later that morning, I started feeling ill. Before lunch, I threw up and finally had a seizure. I ate lunch, but within a matter of a few hours, I threw up again. It had turned into a very rough day full of seizures and up-chuck. I was making progress in terms of my purpose of being there, but it came with being ill in a way that I had not expected. After each episode with a seizure, a nurse came to see me.

"You just had a seizure, Amy. Do you remember having it?"

"I'm aware that I had a seizure, but I don't recall anything that happened during it."

"Okay, well this gives us a good start. It would be good to have several seizures recorded on tape for the epilepsy team to review. This would give them more knowledge and evidence of the type of seizures you have. They can make a more accurate evaluation of your case the more seizures they have to observe. Is there anything I can get for you?" She took my vital signs as she spoke.

"I don't know if I dare put anything in my stomach. I may throw up again."

"You go by how you feel. I can get you some crackers, soda, iced tea, or anything else that we have in our refrigerator. If we don't have it up here, I can check with the cafeteria to see if they have what you want. But it's up to you if you want to eat something."

"I'll just take some more iced tea for now, please."

"Okay, I'll get that in just a few minutes."

As I waited patiently for the nurse to return, I got out one of my books and started reading. Between pages, I viewed the television monitor near the ceiling with my particular appear-

ance on the screen. My hair lay between the wires as the natural hair grease started to build up. I could not wash my hair until the monitoring was over. I knew I would not make it in a beauty pageant that day, but I had to laugh. I had gone from being a busy college student who had papers to write and new terms to learn, to having electrodes glued to my head and having no responsibility except to cooperate with the nurses. The latter was easy.

Although I was not battling a fatal disease such as cancer or leukemia, I had a similar mindset as someone who experiences a serious illness. I wanted to put epilepsy behind me and never again have to endure all of the pain and inconvenience that my seizures had brought to my life. I desired to live a full life without unexpected episodes that took me away from reality. During those moments when I lay in a hospital bed feeling ill and not knowing when I would have a seizure, my determination to be cured kept me in good spirits. I knew that the pain that I was experiencing at the clinic was only temporary, and the final result would far outweigh the rough days in a hospital bed. I figured a little pain could lead to a long-term gain. Just knowing that I would soon find out if I were a candidate for brain surgery was enough to make me realize that the pain was worth enduring. I hoped that one year later I would be seizure-free.

By that evening, I had three seizures and had thrown up three times. The lack of medication had obviously taken effect. I slept off-and-on throughout the day due to the increase of seizures. Mom called the clinic to check on me and was relieved to hear that I had seizured. Again, a nurse came to visit me after a seizure.

"You just had another seizure, Amy. This gives us three. I'm glad you're having seizures as often as you are. You may be able to go home by Monday or Tuesday. We'll have to get your medication level back up to a therapeutic level before we discharge you. We'll see what the doctor says. Do you need anything?"

"No, I don't. Thank you."

Later that evening, the neurologist on duty came by as he made his rounds. I got to know each of the neurologists at the clinic. All of them were very nice. During his visit, he mentioned that I would probably be given Tranzene the next day

and then they would begin me on Mysoline the following day. Tranzene was used to build up a certain chemical in my system, which would allow Mysoline to reach a normal therapeutic range much faster once it was administered.

On Monday, I started back on Mysoline, the medication with which I had experienced the best seizure control. By Tuesday afternoon, I was taken off the EEG monitoring system. It felt so good to take a shower and wash my hair. This was the first complete shower I had in a week. The task of getting the glue off my scalp, however, would take many more washings. I must have pulled glue out of my hair for at least a week after this test.

Mom and Steve arrived around noon on Tuesday. When they came in my room, I saw my mom's condition. Even though her leaving was due to her job responsibilities, my mom experienced a lot of heart anguish as she traveled home. Due to her being so distressed, she developed a herniated disk in her back during her bus trip home to Michigan. When she arrived back at the clinic on Tuesday with Steve, she was walking in the stooped position as a result of her intense back pain. I had just completed seven days of EEG monitoring in hopes of having brain surgery, and yet I was in better condition than my mother! As we left the hospital, the irony of the situation struck all of us.

Before we left, the doctor explained that he hoped to soon have me scheduled for the second and final phase of my testing. He knew about my plans to start college classes again in the fall, and he knew that the medical testing had to occur before I started school. Soon we were on our way to Michigan.

After a four-and-a-half-hour drive, we arrived back home to our four-legged friends, Katie and Molly, and a few days of mail to open. After unpacking, I got busy studying for my final exam for chemistry class. The next day, I called the college and made an appointment to take my exam.

Once I was back home, I started working again at the deli to save money for college. The money I earned over the summer paid for only about the first week's tuition bill, but it was

that "every little bit helps" philosophy that kept me working. I had informed my supervisor that I would soon be receiving another call from the clinic asking me to be there on short notice. She understood and was willing to be flexible when the time came that I had to leave for Cleveland.

The first week in August, I received a call from a lady in the scheduling department at the clinic telling me that she could schedule me for my angiogram, EEG, MRI, and psychological testing for the following week. Without hesitation, I agreed to be there. Five days later, Steve drove Mom and me back to Cleveland, Ohio for the final sessions of testing.

CHAPTER 17
Preoperational Testing Phase 2

August 9, 1993

The continuation of my preoperational testing began on a clear day in August. The long day ahead would involve several hours of psychological testing, including questions about personal matters. I was actually excited about this day in the psychiatric ward. After I began college, I had an interest in the human mind and why it works the way it does. I also desired to know what the professionals would say about my psychological state. I did not have any doubts that the results would came back positive, but I did wonder if a psychologist would pick out something particular about my personality or my cognitive ability.

The psychological testing involved anything from performing simple tasks such as pointing to a yellow circle when instructed, to looking at fifteen configurations and figuring out what the sixteenth shape should be. My fine motor skills were tested by having to push a button with one finger as many times as I could in so many seconds. The psychologist also had me fill out a personal evaluation which included questions regarding how I viewed myself, mood swings, suicide attempts, and whether or not I viewed my future as being positive. There were moments throughout the psychological testing that I wondered if I was going to *need* a psychologist by the time the testing was over! The constant drilling of questions and having to perform out of the ordinary tasks took a toll on my patience. By the end of that day, I was convinced that the real test that took place was being able to make it through the testing period

without losing my mind! If I could do that, I figured I should be considered psychologically stable.

After about six hours of psychological testing and having only one short break and a lunch break in between the morning and afternoon sessions, my mental exhaustion was very apparent. Mom was in the waiting room when I finished the tests. The psychologist greeted my mom.

"Amy went through the testing a little faster than some patients do. She has only about one more hour of testing to finish. Most patients still have three to four hours left after the first day. We can get through the remaining tests tomorrow morning. I anticipate her being completed with the testing by nine or nine-thirty tomorrow."

"Well, great! How's Amy doing?" Mom had to ask this.

"I'm doing all right. I'm mentally exhausted, but I'm hanging in there."

The psychologist responded by saying, "She did very well. I know it can be tiring, but she did very well. Get plenty of rest tonight, and I'll plan on seeing you in the morning, Amy."

"Okay. I'll see you in the morning." Mom and I walked toward the elevator and toward my next appointment.

"So, how was it? I know you say you're mentally drained, but did everything go all right?"

"Yes, it did. Some of the questions were so elementary. I guess they want to reinsure that I know the basics. Maybe there are some people who take this test who don't know what a green square is. There were more challenging questions than this, but I sure was glad to get through the basic stuff."

We made our way across several floors and down about three elevators to the main entrance area of the clinic. As usual, many nurses, doctors, and patients walked by. The amount of people at the clinic was a clear indication that the Cleveland Clinic was well known and provided excellent care for its patients.

We took a few minutes to look in the gift shop, and then we headed toward floor S51 for my EEG hookup for a PET scan. It took about fifteen minutes to be hooked up to the electrodes, and I was on my way to the PET scan test.

Besides the hooking up of the electrodes to my head, the PET scan was painless. The pictures that were taken during the

test showed the physicians the metabolic activity in my brain. In short, it measures the amount of glucose or sugar in the brain, and it also helps locate the scar tissue in the brain.

Later that day, I had a visual field exam. This test revealed my peripheral field of vision and visual pathways. Although it was useful to the doctors for the preoperational evaluation, this visual exam is also used in the case that a patient had the surgery and experienced some difficulty with vision in post-operation. The doctors could compare the before-and-after field of vision results if a problem were to arise after surgery.

After the PET scan, I had an MRI. During an MRI, the patient lies down flat on a narrow table, and then the patient is moved into a tunnel. As the table moves slowly through the tunnel, the patient's face is only inches away from the ceiling of the machine. During the test, the patient must hold completely still. Any movement will cause the final pictures taken of the brain to be blurry. One of the purposes of an MRI is to show cross sections of the brain and the depth of any unhealthy tissue.

Right after the MRI, I went to my pre-angiogram interview. The angiogram was the only test that I had the following day and was probably the most important test that I had to take. The purpose of this test was to determine the location in the brain of my speech and long-term memory. There are some serious risks involved in an angiogram; therefore, Mom and I were scheduled to meet with a nurse who would explain what I needed to be aware of prior to the test. The most important thing that she emphasized was keeping my right leg straight after surgery. She explained that in order for the wound to heel properly, the leg must be kept straight. If my leg became bent, a blood clot could form and I could die. Mom and I both knew this prior to this appointment, but hearing it again reinforced to us the seriousness of this procedure.

August 10, 1993

The next morning, I prepared for the most in-depth test of them all. During an angiogram, a wire is inserted through the groin area and up the main artery to the brain. Chemical dye is then injected into one half of the brain, causing that side of the brain to fall asleep. During this test, Phenobarbital is injected

into the awake side of the brain to keep that side calm. The surgical team checks the patient's speaking ability and long-term memory skills on the side of the brain that is awake.

At about 8:00 a.m., Mom kissed me good-bye with tears in her eyes. Mom was very concerned for me that day. Knowing the risks of the exam was frightening for both of us but moreso for her. I knew I could endure the pain and could keep every part of me still, but she had to trust my determination and judgment that I would do just that. Mom had feared for my life various times before, and once again, she was afraid of the ultimate—losing a child.

The nurse led me back to the surgical room where the angiogram would take place. Although it was a test, by definition, it was a surgical procedure because it required a wire to be inserted into my body. The nurse had me lie down on the operating table, and she read off the "do's" and "don'ts" that I need to abide by during and after the exam. I lay quietly on the table as many nurses and other medical staff congregated to the room. A pleasant female nurse came to my side.

"How's Amy today?" she asked

"I'm all right," I said with a slight smile.

"Are you scared?" she asked.

"I'm both excited and scared," I replied.

"You will be all right, Amy. Just relax. We do this test all the time. It will be over before you know it. In a few minutes, we will give you a shot in the groin area. That will be the most painful thing of the whole test. After that, you may feel a slight tingling sensation as the wire is pushed up your artery. But other than that, you will not feel a thing. You will want to go to sleep during the test, but you will need to wake up when we ask you to. We will need to ask you questions throughout the test. Your response will help us determine where your speech and memory is located," she explained.

The whole procedure sounded so complicated to me, but I trusted her words of encouragement as I waited for the test to begin. As I waited for further instruction from the nurse, I said a silent prayer. Lying on the table as still as a rock, I listened to the conversations between the nurses.

"Hey, Betty, what are you initials?" I heard a nurse ask.

"B.M.," she answered. All of the nurses burst out laughing, and so did I.

"Oh, Amy is laughing. Let's not disturb her. She's doing a great job," one of the nurses added. Here I was in a serious mindset, rightfully so, and my calm attitude was broken by an honest reply made by a nurse. I appreciated a little humor in the room that day, but I knew that it couldn't last long. Soon, I would have to get extremely serious and focus on the guidelines of the procedure.

Within a matter of minutes, more medical technicians arrived. A gentleman dressed in a white lab coat came near my side and proceeded to explain much of what I had already been told. With only a sheet covering my body, the procedure began.

"Amy, I need you to hold completely still," a nurse explained. "We are going to give you a shot in the groin area to numb the area where the wire will be inserted. You will feel a sharp pain, but that will be the most painful part of the whole test. Now just relax."

Another nurse cleaned the groin area in preparation for giving me a shot. I tried my best to think of the sandy beaches of Florida and the waves splashing my feet just as Mom had taught me to do. My personal psychology techniques helped until I felt the first poke of the needle. Every second of the knife-piercing pain seemed like eternity. I instantly wondered if any labor pains could be this painful. I did not have that experience to compare it to, but at that moment, adoption seemed like a wonderful choice.

I made fists and took deep breaths as I endured the extreme physical pain. A nurse asked if I was all right, and I nodded my head ever so slightly. Within a matter of minutes, the needle was taken out, and I couldn't feel a thing in the area that was numb.

"Amy, you're doing great. Keep up that good work. Just continue to hold very still. The doctor is about to insert the wire up your main artery. Just hold very still and listen to the doctor," a woman nurse said.

I did exactly what the nurse instructed me to do as I wondered what it was going to be like to have half of my brain asleep. The whole idea seemed so unreal. Just then, I felt the tingling sensation that the nurse had informed me about. As I

lay still, I thought about how this was the last step to providing the neurology department with all the medical facts about my case. Again, I knew that the pain that I was experiencing during this test was all for the sake of finding out if I were a candidate for brain surgery. With that hope in sight, I considered the emotional and physical pain to be worth it all.

I slowly drifted off to sleep or maybe only half my brain drifted off to sleep. Anyway, I became unconscious as the dye was injected into the right side of my brain. The next thing I knew, a voice was calling my name.

"Amy, I need you to wake up so I can ask you some questions." I fought through the heaviness of my eyelids and the tiredness that remained throughout my body. I opened my eyes to see a woman nurse with some picture cards in her hand.

"Amy, I need you to look at each picture as I show them to you. I want you to tell me what you see. What is this?" she asked. I saw a picture of a cow.

"A cow." I replied.

"Okay, what is this?" she showed me another picture.

"A house."

"And what do you see now?"

"A shirt." She went through about eight to ten pictures, all of which I identified right away.

"And one last picture. What is this?"

"A cat."

"Thank you, Amy. I will have some more questions for you in a few minutes.

During the next few moments, the doctor gave me some instructions to open and close my eyes. The latter was easy, but opening my eyes involved sleep depravation. Staying focused on the event and reminding myself of the importance of the test kept me alert. Soon I heard a nurse's voice again.

"Amy, I showed you some pictures a few minutes ago. I want you to tell me as many of those as you can remember," the nurse explained. I thought for a few seconds and then responded.

"Cat. . . . house. . . . cow. . . .shirt. . . ." I said the words with no problem of recall, and my speech was clear. But the test wasn't over. The nurse explained the next step.

"Amy, you are doing wonderful. Now we are going to let you rest so that the right side of your brain can wake up. You will rest for about twenty minutes. Once your right side is awake, the doctor will inject dye into the left side of your brain, and the same test will be repeated. Go ahead and fall asleep, and I will wake you up in about twenty minutes." I didn't have any regrets about her request. Sleep sounded like a wonderful idea.

"Amy, it's time to wake up. We are going to put your left side of your brain to sleep. Wake up," I heard a faint voice say.

The next thing I knew, I felt the dye pass through my main artery as the tingling sensation repeated. There I was, a twenty-two-year-old woman, completing the necessary tests that would indicate if I met the requirements for brain surgery. Time and patience would reveal it all. Only moments passed, and it was time to name the picture cards with the use of only the left side of my brain.

"Amy, I have another set of cards here. I want you to tell me what you see on each card," the nurse explained. I looked at the first card and saw a picture of a river. I imagined a river in my mind and then tried to say what I saw.

"Routha," I heard myself say. I was stunned to hear myself speak in such an unclear way while being able to have a clear image of a river in my mind. How strange it seemed to have my speech temporarily impaired by a chemical dye in my brain. The nurse did not show me any additional cards because of the nature of my first response. It was very clear that the center of my speech was in the left side of my brain. The nurse must have read my expression when I attempted to speak with the use of only my right brain hemisphere. I must have looked disturbed by the matter.

"That's okay, Amy," the nurse replied. "You are doing a fine job. You are unable to speak clearly because the left side of your brain is asleep and that is where your language ability is located. The test is almost over. Hang in there."

Only a matter of seconds must have passed, and I was asleep. The next thing I knew, I was being pushed down the hall as I laid flat on the roll-a-way bed. Out of curiosity, I picked up my head to look at the wound in my groin area. At the edge of my hospital gown, I could see a red spot about the

size of a dime. I remembered the nurse saying that I could die if I bend my leg and a blood clot were to form. My cooperation and self-control were so crucial to the success of my recovery from the angiogram.

With the assistance of a few nurses, I neared the room where I would reside until the next day. Although I was connected to a catheter, I was not allowed to get up to use the bathroom until around 9:00 that night. I had to lie flat in a hospital bed for approximately the next eight hours and hope that I could sleep through most of it. Sleep is what I did for about the first five hours and then I was past due to use the bathroom. The nurse provided a bed pan, but it just wasn't the same as a toilet. Failure with the more serious matter meant that I had about three hours more to wait. My only comfort was my mom's visit and our conversation to take my mind off such matters.

I didn't gain any comfort when I found out my wait to get up was longer than I thought. During one of the nurse's visits, I was informed that I had until eleven o'clock instead of nine o'clock. She expressed her understanding of my discomfort but restated that I couldn't get up. The area where the wire was inserted needed to heal more before I could stand up. Again, I reminded myself of the fatal consequences of bending my leg. The only option was to endure the temporary pain and wait until I was free to stand and walk.

Mom and I continued to talk for part of the hour until I got tired again. Before eleven o'clock, I was wide awake and waiting for the nurse to come by to get me up. The long hours of waiting were finally over. A nurse assisted me into the bathroom to make certain that I didn't bend my right leg. My leg with the wound hurt, but I used the nurse as my crutch to walk as I kept my right leg in the air.

After a sigh of relief and a slow walk to and from the bathroom, the nurse eased me back onto the bed. Mom was so concerned for me that she went back to the hotel to get some of her personal items and then she came back to my room to spend part of the night with me. The possibility that I might bend my leg in my sleep drove her to want to be close by my side. She stayed with me past midnight.

Around one-thirty in the morning, the nurse on duty told Mom that it was not necessary for her to stay in my room all night. The nurse reassured Mom that they would keep a close watch on me and she encouraged her to go back to the hotel and get some rest. She looked toward me with an apprehensive look as though she was told that it was all right to leave her very sick child. It wasn't that Mom didn't have trust in the nursing staff because she did. A mother's love for her children is like no other. Mom desired to be by my side during those crucial hours of recovery.

"Amy, are you going to be all right if I go back to the hotel?" she asked.

"Yes, I will. My leg still hurts, and I'm not going to move it. The nurses will come by in the middle of the night to make sure I'm in a good position," I explained.

"I'm just concerned for you. But I know the nurses will take wonderful care of you. Okay. If you think you will be all right, then I will go back to my room. But I know that the nurses would let me sleep here if you wanted me to. There's an empty bed right here."

"No, that's okay. I'm in good care, Mom. I will probably sleep most of the night anyway. I can push the call button if I need anything," I reassured her. I saw the hesitation in her face.

"Okay, I'll go back to my room then. I love you." She kissed me on the cheek and gave me a hug. For a moment, I placed myself in her position and imagined how it must feel to leave your own child in a hospital bed for the night, knowing that one wrong move could be fatal. Mom left the room with sleepy eyes and heavy thoughts about the firm precautions of my recovery. As I drifted off to sleep, I knew that God was watching me through the night and into the morning.

At 7:20 a.m., I awoke from a sound sleep with my leg in the same position as I had it prior to falling asleep the night before. To my side was a hospital tray with a carton of cereal, a pint of milk, and a donut. Not long after I started eating, Mom walked into my room.

"How are you doing? It looks like your appetite is good," she remarked.

"I'm doing fine. I slept well last night. I don't think I moved a whole lot." She reached over and gave a kiss. "The nurse came by and gave me some pain reliever in the middle of the night. Other than that, I don't remember a thing."

"Your next appointment is at 10:30 a.m. I can help you take a shower and get dressed. I'm sure you won't be able to do that on your own. I'll ask the nurse if they wouldn't mind me helping you."

For the first time in about twenty years, mom helped me with my daily washing. Most of her assistance was simply providing ways for me to keep my balance while guarding my wound. I was allowed to bend my leg at that point; however, it was necessary to keep the wound dry. Mom's assistance helped lessen the pain in my leg and helped me keep my balance. Before I left my room, a nurse gave me a list of precautions to follow for the next two weeks as my leg continued to heal.

My next appointment was with the epilepsy psychologist. Mom walked as I hobbled to the S51 floor where my neurologist's office was located. Upon arriving at the office, I reported to the main desk and sat down. Within a matter of minutes, a nicely dressed lady came out to greet me. She introduced herself and shook my hand. As she walked me back to her office, she explained that she was a psychologist for patients who pursue brain surgery. She came across as a person who was there to talk about whatever I wanted to talk about. We sat in her office and proceeded with about a forty-five minute meeting.

"Amy, I am here to assist you in any way that I can. I am the epilepsy psychologist, which means that I help people like you who are going through the steps to have brain surgery. Brain surgery is a serious thing to think about. It takes a lot of courage to do what you want to do. I know you must be excited about the thought of becoming seizure-free. How are you dealing with all of this?"

"I am both excited and scared. I have had seizures basically all my life. I have wanted to be cured since I was a child.

It has been my lifelong dream to be free from seizures and the side effects of medication. I am so excited to know that there may be a cure for my seizures."

"Do you work? Are you in school?"

"I am a senior in college. I am going into teaching. I have worked since I was fourteen. My first job was a paper route, and since then, I have worked in restaurants, and I am currently in the student work program on campus. My parents have always taken me to my job and to school. It has been an inconvenience to not be able to drive, but I manage. I am a goal-oriented person. I never wanted my seizures to hinder my life beyond not being able to drive. For the most part, I live a pretty normal life."

"It sounds like you have done a lot with your life. That's great. Not all people with epilepsy are as active as you. It's wonderful that your parents are as supportive as they are. What do your parents think of the idea of your having brain surgery?"

"They are behind me one hundred percent. They are scared, but they understand why I want to pursue this. They have walked the path with me along the years. They know the struggles I have endured, and they know that I want to be able to drive. Although they do have concerns, they are very supportive."

During our meeting, I expressed my concerns and asked some questions regarding surgery. After three days of testing, there was finally a person to talk to about my inner fears and concerns. I had been provided a professional friend to whom I could pour out my innermost thoughts and burdens. That afternoon in the psychologist's office, I cried as I spoke freely of my experiences with seizures and the emotional battles I had been through. I told her about the struggles of growing up on many medications and how it affected my educational experience. My ongoing desire to become seizure-free was very clear. Through the tears, I sensed her compassion and personal understanding of my circumstance.

"Amy, do you have any questions about surgery? I will answer your questions the best I can. If I cannot answer your question, I will have a doctor answer it." I paused for a moment. My mind raced in many directions, but one question surfaced in my mind more than any other.

"What are the possibilities that a patient would die during this surgery?" I asked.

"The chances of death are basically none. There has been only one death in the last twenty-years and that was a case in which everyone involved knew that the patient may not make it. It was a severe case. The clinic has a team of doctors and nurses who will review your case and will know by evaluating the test results if you are a candidate. They will be able to determine if there are any specific risks in your case. If you fall into the high-risk category, most likely you will not be a candidate. But if the tests show that your seizure disorder is in one focused area and it is not near your language area in the brain, then you would probably be a candidate for surgery. The neurology team that determines candidacy for brain surgery reviews every aspect of a person's life. They consider the medical tests, the psychological status of the patient, and the patient's goals and overall quality of life. Since you are in college and you are pursuing a teaching career, you have something positive going for yourself, and the medical team will take that into consideration. Also, if the psychological tests show that you are emotionally stable, that will be a good step toward becoming a candidate for surgery. However, most of the weight is in the results of the medical tests that you just underwent. The epilepsy team of doctors will not categorize you as a candidate for surgery if they have evidence that you are at a high risk of damaging a healthy part of your brain, such as the language area. They will not allow a patient to go through the surgery if they don't meet certain medical criteria." She explained all of these details like she had explained it thousands of times before.

"Do many people who go through this surgery experience a change in personality or behavior?"

"No, there hasn't been any record of personality changes. However, there are a few patients who experience memory loss. Another risk involved in this surgery is the possible temporary loss of part of your vision. Some postoperative patients experience a loss of vision in one corner of their visual field and then regain it over time. Everybody is different. I hope that answers your questions," she replied.

"Yes, it does."

"I see that you just completed the WADA test. You were walking with a limp as we came down the hall. How have you been handling all of these tests that you have taken?"

"The tests have been mentally exhausting, but they have gone all right. I had been through MRI's, EEG's and PET scans before, so those tests were nothing new. But this was the first time I went through an angiogram and psychological testing. The angiogram was stressful for both my mom and me. I'm still in a little bit of pain, especially when I walk. But I guess that's to be expected. I'm glad that the tests are completed. Overall, I didn't mind going through it. But it's nothing I would want to do on a routine basis either," I explained with a smile.

"I understand. It takes a lot out of a person to have several tests over the course of several days. And you're away from home and out of your daily routine. You seem to be coping well with everything though. I know you have been through a lot in your life and even this week. And you have a lot to think about while you wait for the results of the testing. But Amy, you have a lot to be grateful for. You have goals, and you're pursing a college degree. Not just anybody with epilepsy goes to college. Some people with epilepsy don't hold jobs due to the severity of their seizures. But in your case, you are able and willing to make something of yourself. I think it's fantastic that you are going to college and you're not letting your seizures discourage you from obtaining a college degree."

"Thank you. I never wanted my seizures to prohibit me from gaining a higher education. There are some challenging circumstances to deal with, but I know that fulfilling my responsibilities is important, and I keep going. Sometimes I sit in class feeling exhausted, but I make myself pay attention. I can usually snap out of being tired after a seizure."

I appreciated so much the clinic making this debriefing period part of my visit there. I too realized the importance of my emotional status through the medical testing and even through the waiting period that lay ahead. Waiting to hear the results was going to be the hardest part of all. The psychologist continued explaining issues related to the surgery.

"If you have this surgery, the surgeon will remove only the part that is damaged. Part of knowing if you're a candidate for surgery is finding out where the language and memory are located in your brain. Once the doctors know where your major functions are located and they know where the scar tissue is located in relation to your language and memory, the doctors can make an assessment regarding your candidacy for surgery. They will not do surgery if they find that your language is close to the scar tissue or that they would have to remove healthy tissue in order to get to the scar tissue. This surgery is performed about two or three times a week. The surgeon has done this surgery for five years now, and he is a wonderful surgeon."

I sat in her modern office listening to the many details that she explained about the surgery and the risks involved. It all seemed overwhelming, but I knew I needed to hear the pros and cons of the surgery. I was so relieved to know that another human being heard the deep fears and burdens that I was carrying with me through this time. I could open up more to her simply because she was an unbiased person in relation to my life. One principle that was reinforced through this meeting was the importance of having someone who will just listen in times of doubt and hope. The psychologist didn't change my medical condition or make any unreasonable statements about my future. She just listened and gave me encouragement at a time in my life when I needed it the most.

This was my last appointment for the day and concluded my preoperational testing. Steve arrived at the main gate of the clinic later that afternoon to pick us up. Still with a hobble in my walk, I got in the car and rode back home to Battle Creek where I would prepare for my last year of undergraduate classes.

After the completion of the preoperational testing, I went off Dilantin and was put back on Mysoline. Based on my prior experience with Mysoline, I expected to have better seizure control and be at a lower risk of having another grand mal seizure. However, the combination of the chemical change occurring in my system and the anticipation of waiting for the results of the tests increased my seizure frequency during the

next month. One weekend, I slept four to six hours during the day and slept through the night as well, due to the increase of seizures. There was one day that I had six seizures due to my system adapting to the chemical change and gradual increase of medication. Again, there was a heaviness in my knees, which created a strange sensation when I walked.

By the time the fall semester started the last week of August, some of the side effects of the medication change had diminished, and I was feeling alert throughout the day. My medication level was expected to be back in a normal range within a matter of a few weeks. Seizure frequency was close to normal and, once again, I was looking forward to tackling the challenges of college life.

As I moved my personal belongings to my dorm, my thoughts were directed primarily toward the possibility of having brain surgery. There was not one day that passed that I didn't wonder if I would be on the operating table in less than a year. While I waited with anticipation, I also realized that if I were not a candidate for surgery, I would live the rest of my life with seizures. If surgery was not a possibility, facing that reality may mean having another stumbling block to overcome. *Seizures for life with no possible cure.* Every time the phone rang in my dorm, I wondered if it was the clinic.

That semester, I had education courses under the direction of my college advisor. I was acquainted with her from previous semesters, but had not told her about my seizures. I knew that this was the appropriate time to inform her since I was going to be in one of her classes. As she and I discussed my class schedule, I searched for the right words to say to tell her about my situation.

"There is something I must tell you," I paused. "I have seizures. I have had them all my life. I don't want you to get scared if I have one in class. You might never see me in a seizure, but if you do, the best thing to do is nothing." I explained the nature of my seizures and how I typically felt after having one.

"Are you on medication?" she asked with sincerity. Her question opened up another facet of my seizures.

"Yes. I am on Mysoline. No medication has ever controlled my seizures." I hesitated to tell her that I was pursing brain surgery. *How would that sound to my college advisor?* I thought.

"And not to scare you any more, but I am pursuing brain surgery. I recently went to the Cleveland Clinic for a medical evaluation. I am now waiting to hear from the clinic about the results of my medical tests." I was nervous about this conversation in that people typically think of *brain surgery* as such a serious matter. My advisor nodded her head, listening with intensity.

"Would you be interested in reading some material that I have on epilepsy? I can bring some pamphlets in for you to read."

"Sure. I would love to." she replied.

"Okay, I will get those to you in the next couple of days."

I left her office feeling relieved that someone else was aware of the burden that I was dealing with in my life. I knew that what I told my advisor must have been a shock to her, but I also knew that it was not reasonable that I go through the remainder of my college classes keeping such a deep issue a secret. I needed a network of people who would listen and be supportive during a time in my life when I was experiencing so many different emotions. I was in a most unusual situation. The matter was not a common one such as divorce or abuse or financial problems. But rather *brain surgery . . . someone might open my head . . . my life could be improved or impaired.* I could not keep this complex circumstance to myself like I did in my high school years, even if telling others made them curious about me.

As I walked back to my dorm, I scuffed through the colorful oak leaves on the ground. Enormous oak trees over a hundred years old were seen throughout the campus. I took a breath of the autumn air as I wondered what burdens other college students had and how their concerns compared to mine. My experience on the secular college campus showed me that the main concern shared among several students was when and where the next party was. That thought was not even in the realm of my mind. I had more serious things to be concerned with. My quality of life was at stake for reasons that few people

could understand or were even concerned about. I was aware that if I took one drink, my condition could worsen. I could have a grand mal seizure if I took just one drink. Because of my seizure disorder, I could not comprehend why any human being would want to deliberately degrade his quality of life and could find pleasure in waking up from unconsciousness. What was so cool to many college students was only a knife-piercing reminder to me of the humility that I had experienced throughout my entire life. Coming out of a seizure and trying to clear up the confusion was a weekly and sometimes a daily struggle. To me, there was no pleasure in such an event. My situation made me cringe at the actions of those who wasted their brain on seemingly pleasurable things that only degraded their God-given lives. I tried to put my deep thoughts aside as I reached my dorm and prepared for my studies.

Later that semester, I overheard a conversation in class about a sorority girl who had a grand mal seizure after taking a drink at a party. One of her society sisters explained that her arms and legs were shaking intensely and that her eyes rolled back in her head. She was taken away in an ambulance. I shook my head as I learned of this situation. My personal view about why I should not drink was further confirmed.

CHAPTER 18
The Answer

"He healeth the broken in heart, and bindeth up their wounds."
Psalm 147:3

The Tornado Zone—The view of a resident

Imagine yourself having to live in an area that, for some reason, has several tornadoes every month. There is no option to move because you were placed in this particular house and city since childhood with very little indication that you will ever be able to relocate. In fact, it is impossible to leave the city where you reside. Whether you are at the store, the school, or at home, you are always at risk of being struck by a tornado. You are aware that a tornado can strike on any day, any time, day or night. Oh, these are minor tornadoes that cause only minimal damage, if any at all. The newspaper in the paper box might get ripped, or the wind from the tornado may blow the leaves onto the porch. On occasion, a limb from a tree takes a beating, but no major damage usually occurs. Still, you are fearful of tornadoes, those storms that disturb your place of occupancy and your mental sanity.

Because you live in a tornado zone, you learn how to protect yourself from those dreadful storms. You set out to build stronger walls on your house, you sleep on the side of the house that is least likely to take the strong winds, and you record each tornado that occurs in hopes of determining when a tornado is most likely to strike. You also attempt to figure out if there is anything you do that triggers these tornadoes. Much of your life revolves

around the possibility of being hit by a tornado. Although you dislike tornadoes, you have learned how to adapt to these unpleasant and frequent storms.

Then a devastating moment occurs. You wake up one morning in a different place than where you fell asleep. There is a man standing near you who informs you that a major tornado hit in the middle of the night and did lots of damage to the part of the house where you were sleeping. He adds that you were fortunate that someone was awake in the house and was able to take you to the hospital where any bodily injuries could be treated. You notice that the close loved one who brought you to safety is standing nearby with tears of fear in her eyes. You have a thought that is reflected in the mind of your relative. *My life was in danger, and I didn't even know it. Is another tornado going to strike in the near future? Only moments ago, I was near death.* Although the tornado may not have been that serious, the thought of a near-death experience forms in your mind. Your bright and enthusiastic spirit for life is broken by the shock of learning about the episode and how your life was recently threatened. Still, you remain living in a tornado zone every day of your life, or until an unexpected opportunity drops on your front doorstep that allows you to move to another corner of the world. Only hope carries you through another day of living—hope that one day you will live far away from this tornado zone. But there is also that voice inside you that says, *I will live in this area for the rest of my life.* Nevertheless, the desire to relocate remains.

So you grow up and venture into a career, in spite of the fact that even on the job you can be struck by tornadoes. Sometimes the whirlwind storm leaves your hair ruffled and your body tired from the extreme force. Even so, hope remains as you try to live a normal life.

Again, time passes and the tornadoes continue to strike. No matter what you do, there is no stopping the storms. They are bound to strike. And then, one day, you are presented with an amazing offer. This is something you expected would never happen. Your landlord informs

you that he has an opportunity for you to apply to move out of the tornado zone. Without hesitation, you agree to apply for this new living arrangement. There is a possibility that you could actually live in a city that is very unlikely to get struck by tornadoes. You are ecstatic!!!

After much effort to get the application filled out properly, all you can do is wait for the final word. There is one overbearing thought that lies in your mind. *If I am not qualified to relocate, I will live in this tornado zone for the rest of my life. This is my only chance to permanently get away from the storms.* Your instinct tells you that you are going to qualify to relocate, but you still have to wait for the official word from your landlord.

A month later, there is a knock at your door. You hope that it's your landlord. Sure enough, it's him. "Good afternoon. I stopped by to tell you that my managers reviewed your application, and you are very qualified to relocate." An awesome feeling of peace flows over your mind. Your lifetime dream to move where tornadoes rarely or never strike is about to come true.

"Thank you, sir. This is wonderful news. Oh, I am so glad . . . oh, . . . you don't know how much this means to me. I have waited my entire life to relocate. How soon can I move?"

"There are some others who are ahead of you, but once all of them have moved, we will call you to let you know when the date will be that you can move."

After your landlord leaves, you are left speechless. Your childhood dream is about to be fulfilled. Soon, you will no longer be struck by tornadoes, and you will no longer have to protect yourself every day from the destruction of the terrifying storms. Hope turns to reality, and reality turns to joy. The storms will soon be only memories in your past.

August 27, 1993

The day was Friday, and the first week of classes for the fall semester was completed. I went back to my dorm to pack my clothes in preparation for the weekend at home. The phone rang.

"Hello."

"Hello, may I speak with Amy?"

"This is Amy."

"Hi, this is Wendy from the Cleveland Clinic." My heart rate increased as I realized the purpose for the call. *Please . . . may this be the answer I've been hoping for.*

"I wanted to catch you before the weekend." All other thoughts were put aside. *My quality of life rests on this answer.* "The Epilepsy Team of doctors and nurses have reviewed the results of the tests that you underwent, and everybody on the team agreed that you are an excellent candidate for brain surgery." I had a quiet sigh of relief as I listened with intensity. "You are now on the list to be scheduled for next summer. There are several people who have priority over your case, and I cannot promise when we will call you with a surgery date. Every time someone on the list is scheduled for surgery or is crossed off the list, your name moves closer to the top. But I have noted that you want your surgery next summer, and I can assure you that you will be scheduled for that time period."

"That's okay. I'm so happy. This is wonderful."

"I understand. You have been through a lot, and you want to put this behind you. I'm not in your shoes, but I can understand how you must feel. Having brain surgery will give you an opportunity to become seizure-free. The success rate is high. About 70 to 80% of the patients who go through this surgery become seizure-free. About 10 to 20% of surgery patients have a decrease in the amount of seizures they experience. I know you must be excited. Do you have any questions?"

"Yes, what are the chances that once surgery is started, the surgeon will find more problems than anticipated?" I asked.

"That won't happen. The results from all the tests that we have done show us precisely where the scar tissue is located and what parts of the brain are near the scar tissue. The surgeon can see what part to remove by looking at the MRI. The tests show us everything we need to know. The team of doctors and nurses that discussed your case all agreed that you are one of the best cases we have seen."

I was stunned at her response. "You mean there are no flaws across the board regarding the evaluation of my case?"

"That's right. The results of the medical team's discussion showed that you are one of the best candidates for this type of surgery. We don't see many cases like yours. Some people fall in the good range for candidacy, and others fall in the low-risk range. But you are at the top of the excellent range. We couldn't ask for a better candidate."

The reality of the fabulous news left me speechless. A few black clouds were lifted off my shoulders. *Soon the light will shine.*

"Do you have any other questions?" she asked.

"No, I don't think so."

"Just call me if you think of any other questions. I want you to have answers to any questions or concerns that you have. That's what I'm here for."

"Thank you. I appreciate your help."

"You take care, Amy."

"Okay, good-bye."

After hanging up the phone, I sat in silence on my beige rug in my dorm. I bowed in prayer and thanked the good Lord for sending me an amazing blessing about a matter that I had searched to resolve my entire life. Only God and I saw the deep significance of what the nurse told me, and only He and I saw my relief in my soul at those crossroads in my life. I had prayed and waited at least fifteen years to hear this answer. I knew that the news I had just received was from Him and that it was His way of saying *"I am in this. . . . I have control. . . . I will never leave you nor forsake you. . . . You called on me, and I answered your prayer. . . . Fear not, for I am God. . . . Nothing is impossible with God."*

The opportunity to have brain surgery really did not come as any surprise. My instinct about the matter prior to the phone call from my nurse was that I was a candidate. I had that inner assurance that said, *this is an answer to my childhood dream.* It just made sense. A comment made by the doctor during my testing gave me an indication that I was going to meet the qualifications to have surgery. I remembered him saying that the area of my scar tissue was in the most operative section of the brain. Hearing his assessment gave me encouragement that *one day* I might be seizure-free.

My inner excitement about having brain surgery was unexplainable. The relief and joy I had was of the same nature as that of a man who has been fighting in a war for over twenty years and who finds out that he will soon be flying home to his family. A soldier may say to himself, *maybe one day I will be able to see my family . . . one day . . . that's if the enemy does not take my life first.* Fulfilling the dream of going home alive and being able to see the family without battling for your life is an awesome feeling. As for me, I had battled over twenty-years with seizures and side effects of medications. Finally, I had received the news that my seizures may soon end. Deep in my heart, I believed I would be cured. A vision of resolution and victory over my epilepsy shone in my soul.

The next special moment that lay ahead was telling Mom and Dad the news. They too had spent many years searching for a cure to my seizures. I anticipated the weekend to be filled with a mixture of emotions including tears, excitement, and further questions. The journey continued as I believed I would soon reach my destination.

Mom was still at work when Dad and I arrived at the house that night. I waited in suspense to inform both of them of the fabulous news. I wanted to tell both of them at the same time. I was in my bedroom when I heard Mom and Dad conversing. I went to greet her in the usual way. She had an unusual expression on her face. Dad got the first word in.

"Amy, do you have something to tell us?" I looked at both of them, trying to read their reaction. Mom interrupted.

"Your nurse from the Cleveland Clinic called me at work today because she couldn't reach you at your dorm. She wanted to contact one of us before the weekend, so she called my office. She told me that you are an excellent candidate for surgery." The tears in her eyes said it all.

"She called me too. I was waiting to tell both of you at once," I said with a slight smile. Mom and I embraced as we shared some of the same thoughts.

"I'm happy for you, Amy, but . . . you're my daughter . . . I don't want anything to happen to you . . ."

"Mom, everything will be all right. This is w. waited for my entire life."

"I know it is, Amy. You have been through a lot to ᵬ this," Mom expressed. "But you know you don't have to have the surgery. No one would be disappointed in you if you chose not to go through with the surgery."

"I know, Mom. But I know this is the right thing to do. This is the only way I can possibly become seizure-free. The process is the hardest thing to accept. Brain surgery sounds so serious, and it is. But I cannot allow this opportunity to pass me by. It's my only hope to be cured." I tried to give Mom and Dad the encouragement they needed during this moment of hearing the news that brought many thoughts and emotions. They too needed emotional support during this time of trial.

"I am on a waiting list for the surgery. The clinic will call me when my name is at the top of the list and when they have a date scheduled. That may not be until next spring, but the nurse assured me that I would be scheduled for next summer. Now all we can do is wait for the call."

"How long is the recovery period?" Dad asked.

"About six weeks. The surgery needs to be scheduled as early as possible in the summer so that I will be ready to student teach in the fall. The people at the clinic are very understanding, and I'm sure they will be able to schedule my surgery so as to allow me enough time to recover before the fall semester."

In celebration of my being a candidate for surgery, Dad took Mom and I out for seafood supper. The focus of our conversation that night was my parents' work and brain surgery. My inner reaction to the opportunity that lay ahead included deep thoughts that I would carry with me for many months to come. As my parents were grappling with personal acceptance of my decision to have surgery, my spirit was still awed but grateful that I would soon put to rest the mystery and battle of my life. I longed to put down the weapons and armor that protected me from the vicious enemy. Like a man preparing to go home from a twenty-years war, I was astounded that I may soon live life in peace, untouched by spontaneous attacks that affected my emotional and physical well-being.

As I continued my studies at college, I searched for the right words to say to my peers and professors regarding the opportunity to have brain surgery. I wanted to assure others that this step was the right step for me to take. Yet, I was hesitant to let others know about my surgery because I did not want to receive depressing comments from those who did not understand all the details. I had no reason to take on a negative attitude about having surgery, and I did not want to *begin* taking a depressing outlook. As far as I was concerned, having brain surgery meant gaining a new life. However, due to the serious connotations that are associated with the phrase *brain surgery* and the lack of understanding among the general public with regards to epilepsy brain surgery, I thought it was in my best interest to limit the number of people I told. I needed a small network of supportive people, not an army of soldiers who had never fought a single war.

In the midst of thinking about how different my life was from that of other people's and mentally preparing myself for surgery, I wrote a poem. There were times when my innermost feelings could only be revealed through poetry because there were so many thoughts and emotions that were combined to make me who I was and who I came to be. On September 29, 1993, the anniversary date of my convulsion in 1971, I wrote this poem entitled "The Sight of the Blind."

> A child with no eyes senses darkness on all days,
> No shapes—no colors—or sunshine rays.
> He knows other people by voice and ear,
> For he knows not by sight but what he hears.
> He finds his way by touch as he walks,
> As he laughs and smiles and hears others talk.
> Family and friends are glad they're not he,
> For how could they live if they could not see.
> Their lives would be different in ways they don't
> know,
> Their jobs—their knowledge—independence would go.
> Yet a blind man can think and live a full life,

He holds beliefs and sometimes a wife.
Once asked was he for a bit of advice,
In complete darkness, he listened so nice.
With an expression of joy that filled his eyes,
He moved with sincerity to give his reply.
As he spoke from the heart on a brisk night,
He said, "You're seeing the darkness, and not the light."

The news that I was a candidate for surgery brought separate spiritual trials for my parents and me. Dad and Mom were seeing my circumstance through the eyes of parents while I was seeing this as a trial that would bring an improvement in my medical condition as well as in my personal and spiritual growth. I figured that the primary image that filled my parents' mind was their daughter's brain being exposed to human hands while whispers of death were unspoken. *What if* echoed in all of our minds.

For the first time in my life, I felt the need to give emotional support to my parents. I realized their concerns and how this opportunity for me to be cured brought both excitement and fear to all of us. Although I was the one who was going to have brain surgery, I knew I had to be considerate of my family during this time as well. My parents, sister, and brother, and extended family certainly had heavy thoughts as we waited for the day of surgery to arrive. Similar questions and concerns were expressed throughout the family.

Time on weekends was spent at home talking about aspects of brain surgery and the events that would soon take place. Mom and I embraced for minutes at a time after talking about the procedure and the possible results of the surgery. Every time that I observed the concerns that my parents had for me, I had wished I could plant my peace in their minds. I had often wondered about the depth of their fears and wondered what it was like to be the parents of a child pursuing brain surgery. In a similar manner, they expressed concern for my emotions, and they asked how I was feeling about placing my life in the hands of a brain surgeon. My answer was usually a simple one as I revealed only

encouraging thoughts. My inner peace was one that I could not attribute to anything except the power of God.

Although I had already made the decision to have the surgery, my trials with changing medicine were not over. Late that fall, the Federal Drug Administration approved another seizure medication, the first one in eight years. The approval of Felbatol created much excitement across the country in the field of neurology and among seizure patients. The excitement was similar to that of a fisherman catching a fish after sitting in a boat for ten hours with no bites. In the minds of various doctors and patients, their catch had come in. The approval of a new anticonvulsant brought hope for a cure for patients with seizures who had not been controlled by other seizure medications.

My nurse from the clinic called me in November and asked me if I was interested in trying one more medication. She said that Felbatol had been tried in Europe and had worked in controlling some patients' seizures. She explained that if it didn't work, I would probably remain on it until surgery. With some hesitation, I agreed to make the changeover during Christmas break when I would be at home and not in school. Changing medications had become such a common event in my life; therefore, I was easy to persuade to try a new medication. As for Mom, she had a bit of hope in her voice when I told her I would soon switch medications.

"Maybe this will control your seizures. You just don't know, Amy." The undertone was one of hope that I would be cured some way other than through brain surgery. I knew that possibility was far from reality.

The time for final exams soon arrived, and the semester came to a close. My seizure frequency increased the week of finals due to the high stress that came with studying long hours. Finals ended on Thursday, and I started the changeover to Felbatol on Saturday. Surprisingly, I experienced very few seizures during the medication change. The fact that I was on break from school had a lot to do with the minimum amount of seizures. As I wound down from another semester, snow and festive music were all around, and the aroma of homemade cookies soothed my mind. The holiday season was here.

The Answer

As part of Christmas Eve, Mom, Steve, extended family members and I met at a church across town for a candlelight Christmas Eve service. Christmas music came from the organ as we walked in the church. Each person was handed a white candle for the service. The church pews became full with people young and old as the tune to "Away in a Manger" was heard throughout the church. Wreaths and tinsel glistened as the images of peace and good tidings filled the hearts of many. After opening prayer and the welcoming, the first candle was lit, and the others were lit from the first. With the lights dimmed, only a small flame from each candle gave light to the room. The entire congregation sang "Silent Night" as part of the spiritual celebration of the birth of Christ.

As I looked down at the burning candle that I held in my hands, I reflected upon the sequence of events that had transpired that year and the blessings I had received. The turbulence in my medical condition had brought both fear and doubts, and the results of the medical tests had brought an answer to my childhood prayer. The candle continued to burn as the wax dripped down to the cardboard ring. Peace filled my heart as I considered the possibilities in my future. I realized that this was possibly the last Christmas Eve that I would be afflicted by seizures. In less than a year, I would be on the operating table. Like the flame melting the wax, soon part of my life would melt away. It was my hope that the part of me that had caused so much anguish and questions of the heart would soon be only memories from my youth. *Then Silent Night will play every night, and into the day, and each night and day to follow.* Inspirational words of the season were sung in unison that Christmas Eve that added meaning to the Christmas season and also reflected my hope of new life. I tried to hold back the tears as voices raised throughout the church singing . . .

> *Silent night, holy night! All is calm, all is bright,*
> *Round young virgin Mother and Child.*
> *Holy Infant, so tender and mild,*
> *Sleep in heavenly peace. . . . Sleep in heavenly peace.*

Chapter 19

Storms

"Wait on the Lord: be of good courage, and he shall strengthen thine heart: wait, I say, on the Lord."
Psalm 27:14

January, 1994

After I was taken off Mysoline and placed on Felbatol, I started experiencing nausea and more seizures due to the chemical change in my system. Shortly after New Year's Day, severe side effects arose that caused me to be bedridden. Starting on a Thursday, I was nauseous and was awake until 4:00 a.m. After I finally fell asleep, I had dreams that were nowhere close to my ordinary dreams. The worse side effect came that Friday night when I woke up with hot flashes accompanied by nausea. I was unable to stand up for more than a minute without feeling extremely nauseated and having to lie back down. The only possible cause was the medication. The symptoms were flu-like but magnified to the fourth power.

The most frightening symptom was my increased heart rate. My heart raced as if I were running a marathon as I lay waiting for the internal pain throughout my body to cease. I had never in my life felt my heart beat so rapidly. I took a drink of water as I lay in bed wondering how long the pain would last. *I'm on a new drug.... What do doctors know about this drug? College starts in a week,* I thought to myself. I had no idea if I would be in any condition to return to school. *This is my last semester of classes before graduation.* The physical pain made me fear for my very life.

Hot flashes and nausea persisted through Saturday when Mom called the clinic and talked to the doctor who was on call for the neurology department. He ordered that I stop the medication immediately to deplete some of the medication from my system, and then start it back up on Monday at a much lower dose.

I stayed in bed all day Saturday waiting for a change to occur in my internal system. All I could do was wait. There was nothing else that I nor anyone could do. On Sunday, my health started to improve. On Monday, I started the medication again as directed by the doctor. By Monday afternoon, I began regaining my strength and started to see hope in being able to go back to school. Even if I was not completely back to normal by the time school started, I knew I would be there for classes. I had to be. I was not going to let the side effects of a new medication stop me from completing my education. I had made it too far to give up because of a difficulty with a medication change. The following week I had several seizures as a result of the medicine change and from the stress of thinking about starting classes the following week. The weekend before classes started, I felt healthy again as I prepared for my last undergraduate semester at college.

As I packed my bags and moved back to campus, my mind was overwhelmed with all that had happened in the previous month and all that lay ahead. I knew that the next six months were probably going to be the most intense six months of my life. Along with the overwhelming thought of surgery, my class schedule included three methods classes, which were ones that were going to be most valuable to my teaching. Many visits to elementary schools were required along with several papers and tests.

While anticipating a date for surgery to be set in the near future, I still had questions that needed to be answered. There were so many things that had to be ironed out and dealt with during that semester. As I thought about my situation, I knew that this combination of circumstances would happen only once in my life. *A first time college graduate . . . brain surgery . . . a new life!* (At least, I hoped that this was the only time I would ever have brain surgery!) The more I thought about hav-

ing brain surgery, the more I anticipated that there may not be many more days of enduring the darkness and confusion that resulted from having seizures. In a matter of months, my life would be changed. Despite the mixed emotions that I was experiencing, I was excited about this opportunity. As I relied on God during this time of trial, I became very acquainted with a particular verse of the Bible. I read the "Twenty-third Psalm" several times a week as the words seemed to be written specifically for me. There were parts of this verse that echoed in my heart as I prepared for the transformation.

> Though I walk through the valley of death, I will fear no evil . . .
> you anoint my head with oil; my cup overflows. Surely goodness
> and mercy will follow me all the days of my life.

As I meditated on having brain surgery, I wondered that if I *did* end up being cured, whether or not I would be able to remember years later the sensations of having seizures. I wondered if I would be able to put into words the experience of having a seizure. I knew that no words could replace the actual experience of having a seizure, but I wanted, in some way, to capture the experience in word form.

On January 30, I lay on my bed in my dorm and wrote a poem about the experience of having a seizure that reflects much of the thoughts and images before, during, and after a seizure. If words can explain a seizure, this poem does just that.

The Storm

Rays shine on me when I awaken in morn,
As I begin the day with a promise of light.
My forecast is filled with laughter and dreams,
With plans I have made and friends so close.
The light, the breeze, a beautiful day,
The image of true life—this is me!
WAIT! I think I heard thunder in the distance.
Oh my . . . RUMBLE . . . BLUR . . . light? . . .
SHAKE . . . LIGHTNING . . . uh?
DARKNESS .
 Mi freind, . . . iz tha . . . u?

Light is coming, yes, light is coming . . .
The awakening occurs with powerful rays;
It shines on my face in all my dismay.
As sights of beauty and life reappear,
The image of darkness is haunting my mind.
But once again I reach for my dreams,
As the flame of desire continues to burn.
The light—the darkness—who is in charge?
The rays!—the laughter—A storm is in me.

In order to have an accurate record of these events in my life, I kept a three-ring binder in order to record each seizure and significant factor pertaining to my health. Beginning with the time that I started going to the Cleveland Clinic, I wrote down information about the telephone conversations that I had with the staff at the clinic, any side effects I experienced from seizure medications, and various attributing factors that triggered my seizures. Along with my hope to become seizure-free, I had an inner longing to share what was tucked inside my heart. *One day I will write my personal story of having epilepsy and going through brain surgery. I will need a journal to refer back to when I write my story for the world to hear.*

February 7, 1994

In preparation for teaching, I was required to spend a few hours each week in an elementary classroom. One Monday evening, I rode with my advisor to an elementary school for a meeting that was designed for my classmates and me to meet the teachers we would be working under. The meeting was at 5:00 p.m., which was dinner time on campus. I knew that if I ate too late, I was likely to have a seizure. However, I did not have any substantial food in my dorm, and there was no time to go to the store to get something before I had to leave. Therefore, I left for the meeting without eating dinner. The meeting went fine, although I was nervous that I would soon be in a seizure. I knew myself all too well. A normal eating schedule was prudent to limiting the amount of seizures. Despite the risk

of my having a seizure, I made it through the evening without having one. Leftover fish was waiting for me once I got back to the cafeteria on campus. I was grateful to eat, regardless of how long the fish had been sitting in the warmer.

When I awoke the next morning, I remembered having a seizure in the middle of the night. Despite the recent seizure, I felt well-rested for another day of classes. After I ate a bowl of cereal, I grabbed my clothes that I had set out the night before and walked down the hall to the bathroom to take a shower. All alone, I stood at the sink brushing my teeth when I felt an aura begin. Before the seizure took full control, I went into the shower stall to be alone. I didn't want another student walking in on me while I was in a seizure. Darkness and tense muscles engulfed my being. Time passed, but how much time, I did not know.

As I regained awareness, I saw my left arm extended in front of my body. I watched my arm shake involuntarily like I had never seen before. Never in my life had I experienced consciousness during part of a seizure. I knew right away that this was no ordinary seizure. This had to be a grand mal seizure for my arm to be shaking so intensely. I feared for my well-being as well as my mental and emotional strength. Fear gripped my mind. *Would I still be my usual self throughout the day?* I sat in silence on the bathroom floor of the shower stall as the reality of my condition settled into my mind. Surgery wasn't far away, and that was my only hope to escape the turmoil of my life. *But what about today. It is the beginning of another day of classes . . . but what day is it?* Tuesday came to mind.

I went out to the sink area and looked in the mirror. There were no broken blood vessels or any scratches or bruises. I was relieved to know that there were no outward signs that something unusual had happened. *How would have I answered that one? Not many people would understand anyway.* The emotional shock of the event lay heavily on my mind as I hoped I would not have a grand mal seizure in class. I knew I would not be able to bear the humility of such a event. I figured I would be looked upon as one who "freaks out." I had heard such degrading terms before. I then went back into the shower stall to continue my morning routine. As I stood in the shower, tears combined with the hot water that hit my face. I feared having to

go through that day just as a soldier going into battle fears that he might get shot down by his enemy.

After my shower, I went back to my room and checked my schedule to reassure myself that the day really was Tuesday. Sure enough, it was. I remembered I had a class the night before, and Monday was the only evening that I had a night class. That morning I had a teaching methods class and a piano class.

While I pondered my responsibilities for that day, two conflicting voices fought against one another. One said, *I would rather just go to bed and protect myself from having a grand mal seizure in front of my peers.* The other voice said, *I can't give up. I must not let the devastating and fearful moments of my life prevent me from going on. I must be strong, even if it's hard.* This mental battle was a familiar one, but I had not struggled with these two conflicting thoughts so strongly as I did that day. This seizure reminded me of the time I had a grand mal seizure my senior year in high school and my mom thought she was witnessing my last breath. Now I was a senior in college, and I had experienced two grand mal seizures in the past year.

In addition to the inadequacy of my medication, I knew that one of the main causes of my grand mal seizures was my fast-paced life. The typical stress that goes along with working and going to college had begun to affect the intensity of my seizures. Knowing this truth, I didn't want to live my entire life enduring grand mal seizures and living in fear as I entered another day. *The only hope is surgery.*

While I contemplated what I should do, the thought crossed my mind, *What if I have a seizure while crossing the road?* Although it was a small town, there were cars going down Main Street on a consistent basis. After a few moments of thinking about my options, I finished my hair and make-up and headed out the door to my methods class.

The unpredictability of my life was one of the most difficult things to deal with. My life was subject to sudden episodes that interrupted my daily routine and sometimes caused my mood to change from enthusiastic to being extremely quiet and withdrawn. I could go from being energetic and involved in activities to being exhausted and having to sleep for a few hours to

revive my body and mind. Knowing that I could have a grand mal seizure at any time of the day brought fear in itself. Nevertheless, I considered my responsibilities important to fulfill.

 I sat quietly in my methods class in a somber mood, reflecting on the prior episode. I took notes as I always did and tried my best to focus on the topic of discussion. I was relieved that no one said anything to me and no one suspected that something was wrong. I just wanted so much to keep this incident to myself. As I listened to the professor speak on matters related to teaching reading, I hoped that I could go through the day without another serious episode. As I had experienced before, a quiet spirit within me said, *I want to live. I mean, really live. I want to experience life to the fullest and learn new things. Soon the light will shine continuously.*

 After my methods class, I went to the Conservatory building for piano class. I was struggling to retain a good attitude toward my classes and not to appear upset about anything. The whole incident was so traumatic for me that I could not fathom how someone who was unfamiliar with seizures could understand what I had been through. I went into the classroom where students could begin some warm-ups on the available organs and started playing the major scales that I had practiced many times before. Soon songs flowed out of the organ as I waited for the teacher to come over to hear me play. Within a matter of ten minutes, it was my turn to play for the professor.

 "Hi Amy. How are you doing today?" she asked with a smile and a warmth about her.

 "All right," I said softly with a hint of a smile.

 "Oh, do you need a hug? Here." She wrapped an arm around my shoulders.

 "Thank you," I replied with the same tone of voice. At that point, part of me wanted to explain what had happened, but the whole event was still so recent, and I remained fearful of what the rest of the day would bring. It seemed too complex to explain to anyone. After we exchanged a few words, I started playing "Michael Rowed the Boat Ashore" and tried to put aside the fear and emptiness that filled my heart. After piano class, I went back to my dorm and called the clinic to inform my nurse about my seizure.

"I felt the aura come on, and I went into the shower stall. When I started coming out of it, I saw my left arm extended out from my body, and it was shaking involuntarily. I had no control of my left arm. Never in my life have I been conscious while I was still in a seizure."

"It sounds like it was a grand mal seizure. Psychomotor seizures can turn into generalized seizures. You are still on Felbatol, right?"

"Yes, that's right."

"We may have to switch you back to Mysoline. I will check with your doctor and see what he wants you to do. I'll get back with you as soon as I talk with the doctor."

"Do you think that being on Felbatol caused me to have a grand mal seizure?"

"That is a possibility. It could be a combination of factors, such as stress and the medication. But considering you have not adjusted well to Felbatol and you have had a grand mal seizure since the changeover, there is a great indication that the medication is not effective in your case. Felbatol is a new drug, and we are still learning about it. Hang in there, Amy. You are on the surgery list, and someone will call you probably in April or May. Do you have any other questions?"

"No," I said with a sigh.

"Okay, I'll talk with the doctor and let you know what he wants you to do."

Hang in there, I thought. *My life was at stake, and I'm told to hang in there.*

I remained quiet and cautious throughout the day, for I was unsure that my life would remain in the normal state that people usually saw me in. Another day passed, and I was still waiting to hear back from the clinic. Going through *another* medication change was not appealing, and there really was not time to make the change. The thought of enduring the side effects of a medication change during the semester did not seem reasonable but neither did the onset of a grand mal seizure. Both brought pain and turmoil into my life, but figuring out which one I would rather endure was another dilemma. Later that day, the phone rang. It was my nurse from the clinic.

"Hi Amy. I spoke with your doctor, and he wants to switch you back onto Mysoline until surgery. Felbatol is obviously not suitable for you, and we know that Mysoline has been the most successful in controlling your seizures in the past. He recommended that you take 1250 mg the first day."

She continued to explain the schedule for decreasing Felbatol and reintroducing Mysoline. The whole idea of switching did not settle well with me, but I was caught between two evils. If I stayed on Felbatol, I could easily have another grand mal seizure. I also had to realize that Felbatol was new on the market and that all of the side effects had not yet been discovered. On the other hand, making the switch to Mysoline meant going through a chemical change in my system and experiencing more seizures for days or possibly weeks.

Mom picked up the new prescription of Mysoline from the pharmacy that Thursday. I went home on Friday, primarily for the sake of being with my family during the medication change. If I had severe side effects during the changeover, someone would be able to assist me. I was not looking forward to the weekend, but I was caught between a rock and a hard place. Speaking of rocks, I knew I would soon feel rocks in my knees once I started Mysoline. But that was the least of my concerns. Making it through the weekend so that I could return to campus on Monday was my greatest concern.

Saturday morning, I took my first dose of Mysoline. The high dosage seemed unusual, but I knew that there were different ways of going about a medication change. I just had to trust the clinic that it was the right thing to do. Within an hour of taking the first dose, I felt a spacy sensation in my head and a strange feeling in my eyes. I expected some side effects right away, but the ones I was experiencing seemed to come on stronger than usual. Mom fixed me a sandwich for lunch and some iced tea. Lunch looked good, but I was not that hungry. Soon after eating, I started to feel nauseated and dizzy. I remembered the weekend that I had right before the semester started. All I could do was hope that this would not be a repeat of that weekend.

Not much time passed, and I saw my lunch again. Mom came in to my bedroom when she heard me vomit. After she cleaned it up, she sat on the side of my bed and rubbed my head.

"How are you feeling now?" Mom asked.

"I feel nauseated and dizzy. I'm having hot flashes. Do I feel warm?"

"Maybe a little bit," she said.

"I think the nauseousness is coming from the chemical change. The medication is a shock to my system. Mysoline is mixing with Felbatol, and the two probably don't mix well. Will you call the clinic to see if this is normal?"

"I sure will. You have classes on Monday. You won't be able to go back if you're in this condition. Is there anything that I can get for you before I call?"

"No."

"Okay, I'll go call the clinic."

Mom left the room and went into the kitchen to phone the doctor. I waited and listened to hear the conversation.

"Amy just started Mysoline this morning. She feels nauseated, and she says she is having hot flashes. She ate lunch, but she threw it up. We both think that the beginning dose is way too high. Amy is a college student. She has classes on Monday. I know she has homework this weekend, but she can't even do that. She is bedridden!"

I heard a long pause. As I waited to hear a response from Mom, I felt my heart pound like it had about a month ago when I was still adjusting to Felbatol. This time, it seemed more severe. I laid in silence in my room and heard my heart pound like I was listening to it through a stethoscope. I could only imagine what was going on in my body at that time. I knew there had to be a major chemical war going on underneath my skin. All the evidence led me to believe that my body was not accepting the rapid changeover. It was as though my physical heart was screaming out for its very life. To turn my thoughts toward something else, I turned on my stereo. Just then, Mom came back from talking to the nurse.

"I just talked to your nurse. She understood and said she needs to talk to the doctor to approve it through him, but that she thinks we need to stop the medication entirely and begin it

again at a lower dosage. She is going to call me back in a few minutes. How are you feeling?" She sat down on the side of the bed.

"The same. My heart is still pounding hard," I replied.

She put her hand on my heart to feel it. "Oh, yeah. It *does* feel like it is pounding harder than usual."

A mother's expression is always transparent. As she sat on the side of my bed, I saw her expression of pain as she knew that I was hurting. Times like these brought up memories of the past for both of us. I thought of the time that I had a drug reaction in junior high and I looked like I got punched in the mouth. I dreaded going to school because I did not want to be teased by my peers. Once again, there was nothing anybody could do to alleviate the problem right away. I'm sure this situation brought back painful memories for my mom for what happened to me at the hospital when I was an infant. Nevertheless, we both knew that we had to contend with the present situation and put the past aside. Just then, the phone rang.

"I bet that's the clinic," Mom said as she got up to answer the phone.

I lay quietly wondering when the internal pain would subside. I had a lesson plan to write, and I could not even stand up without feeling dizzy. *How am I going to have my work done by Monday? Why did I listen to the nurse? I should have stayed on Felbatol and taken the chance of having another grand mal seizure! . . . When is this turmoil going to end?*

"Your nurse said that the doctor wants us to stop the Mysoline and start the Felbatol back up tomorrow. She seemed to think that by tomorrow you should start to feel better. Are you feeling any better?"

"No," I answered. Again, she sat on the side of my bed to comfort me. After she left, I started to cry. I was tired of having my life uprooted by the side effects of medication and having to put daily responsibilities aside while I coped with physical pain. I feared that my condition and future circumstances would hinder my studies and my graduating. The unusual battle I was experiencing was going to require continuous determination and a lot of emotional strength. How soon I became

well again would influence my mental attitude toward life and my level of achievement in my studies in the weeks to come.

The next day, I started back on Felbatol in the morning. By evening, I was feeling better but not completely back to normal either. I started on my homework, but altered my original idea for a lesson because of the lack of time. Mom suggested that I stay home another day and go back to campus on Tuesday. I didn't believe in staying home unless I was on my deathbed or unless I had a major problem that kept me near a bathroom. I gave her my traditional line, "I'll be all right," and I packed my bags for campus. Marvin was there that night to pick me up.

By Monday night, I felt almost back to normal. Unexpectedly, I didn't have any seizures the first day of being back on Felbatol. It was unusual that I had gone through a chemical change and didn't experience an increase in seizures. Throughout the week, however, I continued having the usual amount of seizures. After a long and painful weekend, I was grateful to be back on campus and able to fulfill my responsibilities.

My advisor asked me on Monday if I had the lesson completed that I had told her I was going to do. I explained that I was sick that weekend and was unable to do much homework but that I had thought of another idea for a lesson. On Tuesday, I went to the kindergarten classroom that I was assigned and taught the lesson I had prepared. The children filled my heart with joy as I anticipated a future in the field of teaching.

As my student work scholarship that semester, I was the office supervisor for the performing arts department. I worked an average of six hours a week answering the phone and doing office work. The college set up this work program to help students pay off their tuition bill, but it only skimmed the top of the total tuition. Being a private college with only about seven hundred and fifty students, the cost to go there was outrageous. But having the small town atmosphere and my being able to meet with professors on a short notice made it worth the extra cost.

Through this office job, I became acquainted with all the professors in the fine arts department. One of my favorite teachers was the band director. He always had a smile on his

face and often had a humorous line to say that brightened my day. One day after I got all of my office work done, I walked down to his office to chat for a few minutes. We always had good intellectual conversations. The band director was one of the people whom I had informed about having brain surgery. Like many other people, the whole idea took him by surprise. He often remarked about me having to lose my long hair. He expressed that he just couldn't imagine me bald.

While I sat talking to him about having brain surgery, I noticed a sign on his desk. It read: *Sometimes the Lord calms the storm; sometimes He lets the storm rage and calms His child.* How true that seemed. The storm in my life sometimes raged, and other times He gave me peace to contend with the storm. At that point in my life, I knew I was in a storm I would never forget.

I greatly appreciated our conversations. He showed an interest in my life and what I was going through. He too was part of the support network of people that I had created during this time of preparing for surgery. Just going to college was a good enough reason to have friendships with people who were older than me. I was a college student trying to make it out into the world, but I knew that older meant wiser. I appreciated professors who took the time to talk with me on a personal level and would listen to what I was going through. I knew I couldn't go through this time in my life on my own. Although in my quiet time it seemed as though I was alone, the support that others showed me eased some of the concerns that lay heavily on my mind. Anyway, I figured that allowing certain people to know of my situation beforehand would be less of a shock to them afterwards than if I appeared on campus after surgery with a bald head and a scar, having not told anyone about my surgery in advance. Without giving forewarning to my friends and professors, I would have a lot to explain!

Through praying about surgery over a two-year time, I gained the assurance that the Lord was going to cure me. My intuition concerning the outcome of surgery told me that I was going to be able to live an active and healthy life, free from the

burden of seizures. Although I still had the overwhelming emotions to cope with, I was totally in favor of having the surgery and was able to accept the risks involved. I viewed the surgery as a win-win situation. Although I didn't believe I was going to die, I still considered all possible outcomes. My analogy was that if I made it through the surgery, I would experience better health than before surgery. I would either have fewer seizures, or I would be cured. And *if* the good Lord chose to take my life on the operating table, I would live eternally with Him. That, my friend, was how I gained peace of mind as I waited for my surgery date to arrive.

There were numerous people who were hoping and praying for my surgery to be a success. One evening, my mom told me that a prayer warrior in Brazil was praying for me. While my dad was in Brazil on business, the word about my situation had reached a Brazilian lady who was known for praying. She promised to pray for me. Where there was God, there was peace. With such God-given peace, there was the desire to press on toward an event that may answer my childhood prayer.

In the middle of my personal endeavor, the four-and-a-half-year friendship with Marvin came to an end. He had become possessive of me over the previous months, and our relationship had been more of a headache than a healthy friendship. As I prepared for two important events in my life—graduation and brain surgery—I needed only positive relationships that brought support and encouragement to my life. However, our friendship was far from that. We were two different people heading in two separate directions.

CHAPTER 20

*P*reparation

April 4, 1994

One Monday following my afternoon class, I went back to my dorm room and dropped my books on my bed. The phone rang.

"Hello."

"Hi Amy. This is Mom. The Clinic just called me." I knew what this was about. "They couldn't reach you in your dorm, so they called my office." I heard a quiver in Mom's voice. "The clinic came up with a date for surgery." My heart rejoiced, but at the same time, I read my mother's thoughts. "Your surgery is scheduled for May 18th. The nurse will be calling you to tell you more about the surgery and the appointments prior to surgery."

"It's all right Mom. . . . It's all in God's hands."

"I know it is, Amy," she said ever so softly. "I'll be all right. There's a lot to think about between now and the time of surgery. . . . I just need time to have all of this set in. It seems so unreal." I expressed some similar thoughts, but no words could deeply express what I was going through.

"I love you, Mom"

"I love you too, Amy." We exchanged a few more words and then ended our phone conversation. I sat in awe in knowing that a surgery date had been established, and I felt at peace with the whole situation.

Along with planning for the big day, I also had to be concerned with finishing one class that was required for graduation. The college had agreed to allow me to go through commencement exercises as long as I took my last class that summer. I understood the importance of completing my graduation requirements prior to surgery. I didn't want to count on my

analytical skills right after surgery, nor did I need any undue stress during recovery.

Within a matter of days, Mom called the local college to find out when the class I needed was offered. The news came that the class was offered the same time as my surgery. My patience and faith were tested once more as I was obligated to call and reschedule my surgery date. I was so eager to have surgery that I was willing to get up and go at any moment if I were called. But I also wanted to complete my bachelors degree in education. Waiting another month or more for surgery would seem like an eternity at this point. But I knew that I had to fulfill one more requirement in order to begin student teaching in the fall. Through talking with the community college, I learned that the class I needed was cancelled but that I could still take the ornithology class as an independent study course starting the week after commencement. Another surgery date would still need to be rescheduled.

April 7, 1994

I wrote a response letter to the woman who had sent me pictures and a letter regarding her experience with the same surgery. I thanked her for her words of encouragement and expressed to her my excitement and fear of the operation. That same day, I received a phone call from the Clinic.

"Hello," I answered.

"Hello, is Amy there?" said a voice at the other end.

"This is Amy," I replied.

"Amy, this is Joanne from the Cleveland Clinic. Do you have a minute?" she asked.

"Yes, I do. Go ahead."

"I'm calling to go over with you some of the matters related to surgery. I want to make sure that you are informed about the procedure and that all of your questions are answered." I sat down with a pen and paper in hand.

"The night before surgery, you are not allowed to eat anything past midnight. And you are not allowed to eat or drink the next morning. You need to begin fasting at midnight the night before surgery." She continued going over additional important information. "Get a good night's rest the night before surgery.

And if for any reason you have a cold or any type of infection the morning of surgery, we will have to cancel your surgery. Continue taking your seizure medication prior to surgery. You will be given a heavier dose of medication after surgery. Don't be concerned if your medication dose is different after surgery. We usually give Dilantin to patients in recovery to prevent them from having a seizure when the likelihood of a seizure is greater. If you do have a seizure right after surgery, this is normal. Some patients have a seizure after surgery and never have another one again. Another thing is that you are not to wear any perfumes or deodorants the day of surgery. You can take a bath that morning but don't use any lotions or deodorant. Your body must be free from all soap residues and lotions. Maria is working on scheduling your surgery date, and you should hear from her soon. That is all that I have. Do you have any questions? I will answer any questions that you have," the nurse said so kindly. I was amazed at how the medical staff extended themselves to my cares and burdens.

"Yes. I have made out a list of questions that I thought of throughout the past weeks." I held the list that contained such personal and deep questions. "How long will I be in the Clinic after surgery?" I asked.

"You can plan on five to seven days. Some patients stay longer then others but plan on up to a week. Once you are able to keep food down and you are stabilized, you will be ready for discharge."

I continued with my questions. "How much of my hair will need to be shaved for surgery?"

"We can shave just the section that will be operated on, or you may choose to have your whole head shaved. That's up to you. For cosmetic purposes, you may want to have your whole head shaved. That's what a lot of our patients do."

"Okay, when will my head be shaved?" I asked.

"The anesthesiologist will shave it after you are asleep," the nurse replied.

I continued with more significant questions. "What are the limitations during recovery?"

"You will need to lay low at home for the first two weeks. You will want to take a nap each day during the first week of

recovery. It is common to feel nauseated during the first week because of the anesthesia. By the second or third week, you should feel up to going out of the house and going out in public. By the sixth week, you should be back to normal. There is also a weight limit during recovery. You won't want to lift any heavy objects because your skull will still be healing. The main key is to take it easy and don't do any strenuous activities."

"Will I be hooked up to an IV during surgery?" I continued.

"Yes," the nurse explained. "You will receive an IV prior to surgery to increase the amount of nutrients in your body. It will remain in your arm throughout surgery and until you are able to keep food down."

"My next question is, what becomes of the area where the scar tissue is removed?" I wondered if I would have an air pocket in my head for the rest of my life.

"That area will be filled with fluid," she replied.

More serious questions remained on my list. "About how much skull will be removed?"

"It will be close to three inches wide and three inches long. Your hair will grow back over the scar, and it won't be seen after your hair grows back." she replied.

"What is the size of the scar tissue that will be removed?"

"I cannot give you exact measurements, but it's about the size of a quarter."

"Is memory loss common after surgery?" I asked.

"It is very rare," she answered.

"How soon after surgery will I be able to see my family?"

"You can see two family members in intensive care for two minutes. Once you are in recovery, you can see any two people at a time for a two-minute period. Then you can see them for longer periods of time once you are in the epilepsy monitoring unit."

"I have a few more questions on my list," I added.

"That's all right. I'm glad that you are asking questions now. You need to know what to expect," she replied.

"Will the surgeon take tissue from another part of the body to use in putting my skull back together? I know some surgeries require this."

"No. Your skull will be put back together with a man-made material, and you will have staples in your head for the first week after surgery. You won't even feel the staples."

"Oh, okay." I didn't know what to think about staples in my head.

"I have a funny question. Can you save the tissue that is removed so I can take it home?" I asked with a smile.

"No, for safety purposes, we must discard the scar tissue. The other reason is that the tissue being removed will come out in dust. It will not be a chunk. The scar tissue will resemble crumbs." We concluded our conversation on that bit of interesting information as I reflected upon all she told me. *Part of my brain will come out looking like dust.*

April 8, 1994

On Friday of that week, I made the call that I dreaded to make. I called the Clinic to cancel my surgery date and to ask for another date any time after the end of May.

"It's not a problem, Amy. Thank you for calling us right away. We have lots of people on the waiting list for this surgery. I will check the schedule to find out the next possible date."

"Is it still possible to have my surgery scheduled for this summer?" I asked.

"Oh, yes," the nurse replied. "I will put you at the top of the list. And because you have arrangements for the fall, I will make sure you get scheduled as soon as possible."

"Thank you. I really appreciate your understanding and willingness to work around my schedule." I was so relieved to hear the nature of her response.

"I will get back with you as soon as I figure out a date that all the doctors, anesthesiologist, nurses, and surgeon are available for surgery. Several peoples' schedules need to be open for the day of surgery. I will get back with you next week sometime."

After I hung up the phone, I took a deep breath and nodded my head. I was amazed as to how all of this was coming together. I was overwhelmed with all I had to accomplish prior to the day of surgery. I still had four weeks of class work to complete and final exams. Graduation ceremony would follow, and then I would learn about the characteristics of birds in my

last class toward my degree. All of this was combined with the excitement and fear of having brain surgery. The stress that came with such pressures increased the frequency of seizures, and this caused me to be exhausted during parts of the day. Despite being tired from having more seizures, I experienced insomnia, often lying awake until about 3:00 a.m., and then arising at 6:30 a.m. for an 8:00 a.m. class.

With anxiety racing fiercely through my mind, I was thankful to see another week of classes pass and the weekend arrive. I was one week closer to the completion of my lifelong dream to become seizure-free. The Lord knew how to balance my study load and the intense emotions I was experiencing. I was blessed with having less homework one week, but my psychological state was like a roller coaster. As I started working on some assignments that were due in the weeks ahead, my thoughts were more on the life-changing matters than on the significance of my studies. Both were very important to me, but the uniqueness of my situation weighed heavily on my mind. My life was subject to change, and my was faith and courage were being put to the test. I was like a man placed on a deserted island who had no source other than God to find a way to civilization. Moments of fear and loneliness occurred as I felt like I was fighting the fight on my own. There was no human shoulder to cry on who had experienced the same fight as I was battling. My only source of strength to carry on was in God. Some moments when I would think about having brain surgery, I would be excited and hopeful. Other moments I was fearful of the process and outcome. Serious questions were part of my thoughts almost every day. *Is God going to end my life on the operating table? What if the surgeon takes out too much brain tissue and I'm worse off after surgery then I am now? Will the surgery leave me as a vegetable for the rest of my life . . . unable to speak and live a normal life? . . . Is God going to cure me of the illness that has been a lifetime struggle for my family and me? Will I remember after surgery everything that I learned in college? How is this surgery going to change my life?*

Even after contemplating such complex questions, I knew in my heart that I had not become an excellent candidate for surgery merely by chance. Still, questions of my destiny lin-

gered in my mind as I sat in my dorm room staring at the chipped paint on the wall that must have been there for the past few decades. Everything around me seemed so insignificant. With all of this in mind, I got up and called Dad to see when he was going to be there to pick me up for the weekend.

I arrived home to Katie who wagged her tail and told me a story as a greeting. Molly the cat came by to acknowledge my presence and went about her business. I checked the counter for my mail, and I saw a pink envelope addressed to me. The return address had the lady's name on it who had gone through the same surgery as I was about to go through. As if there were a million dollars inside, I opened it and went into my bedroom to read it.

Pictures fell out as I opened the letter that was written on decorative stationery. I stared at the two pictures of a young woman with a curved scar on the side of her head and her head shaved bald. One photo was of her in the hospital bed only two days after surgery, and the other was of her twelve days after surgery with her hair less than a centimeter long. *Soon I will look like this,* I thought to myself. The intense emotions of fear and "what if's" slowly dissipated as the reality of my future sunk in. I was only encouraged and inspired to see the pictures and to read her letter. *She made it through, and so can I.*

April 13, 1994.

The signs of spring were very apparent as buds of lilacs were blossoming, and the occasional rainfall created a refreshing smell in the air. New life was seen in the flowering buds of Daffodils throughout lower Michigan. I took a deep breath of the spring air before entering the dormitory. The phone rang within a few minutes of my returning to the dorm.

"Hi, Amy. This is Maria from the Cleveland Clinic. I checked the schedule, and the next possible date for surgery is June 17th. Is this date all right with you?

"Yes it is," I said with excitement and relief.

"Okay," Maria continued. "You will need to report to the Clinic on June 15th and 16th for preoperational appointments and tests. An MRI will be done on the 16th which will give the

surgeon a map of your brain to follow for the surgery. I realize your family has quite a drive to get here. You and your family may want to arrive in Cleveland the evening before your tests, or you could come down early in the morning of your appointments. That's up to you. But you will need to be here a few hours before your first appointment. I will be sending you an itinerary with the times and dates of your appointments."

The nurse continued going over issues related to the surgery and specific events that I could expect. I had heard most of it before, but I listened eagerly for confirmation of what I already knew to be true and with hopes of learning something new. After I hung up, again I took a deep breath as I meditated on what lay ahead. *Final exams, graduation, a summer class, and brain surgery.*

May 8, 1994

An important day finally arrived—I was graduating from college. My family was planning for commencement as I was trying to calm my nerves. I had a seizure late in the morning due to the emotional stress of the day. The seizure made me drowsy, but I knew I had to fight off the heavy feeling of tiredness in order to participate in the important event ahead. There was no time to rest, and I wanted to fix my hair especially nice. I drank some caffeine to boost my energy level and went about my responsibilities.

With the aid of caffeine and the heart's desire of wanting that day to be a special one for my immediate family, I strove to sustain the graduate spirit. As I sat at my vanity dresser styling my hair, I reflected on all I had endured over the past five years and the long nights of studying to receive *A's* and *B's*. I wondered how different my schooling would have been had I not had epilepsy. Would I have chosen a different college? . . . a different occupation? . . . Would my studies have come easier than they did? . . . But then I realized it didn't matter. There was no way of knowing the true answer to any of these questions. I was graduating from college the way I was, and I was taking with me all the positive and negative experiences that life had brought me. Had I lived without such an affliction, I would not have been the same person. What really

mattered was that I had accepted my circumstance and chose to live one day at time. I put those thoughts aside as I finished curling my hair. If I thought much longer about such a complex matter, I might have found myself in another seizure.

Standing on the college campus, I pinned a pink corsage on my mom's dress in honor of Mothers' Day and my graduating from college. Later, my family and I stood underneath an oak tree to have our picture taken. As I stood waiting for the picture to be taken, an aura took over my smile and the joy of the moment.

... a rush of heat swept through my body ...
... a swirl of light moved around me ...
... distorted noises passed within the light ...
... my limbs were ridged within the confusion ...

I awoke to the presence of my family dressed in their best attire and the bright sunshine that made the day especially nice.

"Are you okay?" Steve asked.

"I'm okay," I replied in an exhausted voice.

My family and I got back into sequence for a family portrait. A friend of mine who was taking our picture may have seen me in this state before, but I was not sure. I was more concerned that he was concerned.

As I approached the church for the Baccalaureate ceremony, Dad snapped the camera multiple times. The church bell rang, and my graduating class proceeded into the church. As I looked forward, I saw a woman classmate a few people ahead of me who had gone through epilepsy brain surgery a few years prior to this time. She and I were never close friends, but we had spoken about the matter once before. Her surgery had not been successful, but I was too optimistic to believe that I was going to fall into the same category. We were two different people in similar yet different circumstances.

After the Baccalaureate service that lasted only about twenty minutes, the class prepared for commencement. With my black cap and gown, I went to the library along with my classmates and found my place in line for the program.

Some of my classmates who had gone through the same teaching program as I did were in front of and behind me. We talked about our education classes that we had together and expressed some of the fears we had about student teaching. The ladies helped one another by putting bobbypins in each other's hair and by placing the mortar board correctly. Standing in the graduation processional line was our last time together before we would begin our student teaching and make it out into the world. The events of that day brought back memories of my high school graduation, but this time we were supposed to be ready for the real world.

My anxiety increased, and I was sweating in the hot summer weather. Conditions were great for an outdoor graduation ceremony *and* for the onset of a seizure. As I stood in line with my fellow classmates waiting for the signal to begin the procession, once again the internal heat shot through my limbs and darkness resumed.

When I regained awareness, I noticed that the lady next to me saw what had happened. She said nothing, but I read the look on her face very clearly. As I resituated myself in line, I hoped I would retain the joy of this special day. The line started to move toward the courtyard as the band played the processional march and the professors led the way. The sun shone on the small and quaint college town that was filled with family, friends, and professors. With thoughts of the special day at hand, I thanked God for leading me to this day of success and for the opportunity that lay ahead.

Steve, Amy, and Angie are shown here during the summer of 1972.

Amy at two years of age

Amy in kindergarten

Amy in sixth grade

Amy on her graduation day, receiving her B.A. in Elementary Education in May of 1994

Steve and Brenda Crane, parents of Amy

Marjorie Beamish, friend for more than twenty years

Aunt Gladys

CHAPTER 21

Approaching the Day

May 25, 1994

A few weeks after commencement, I began my Ornithology class. One day I was dismissed from my bird class earlier than I had expected. Since I had to wait for Mom to arrive, I went to the library to look for some books on neurosurgery. As I awaited for June 17th to arrive, I desired to know more about brain surgery without my having to become a brain surgeon. To my disappointment, there was no reading material on the type of epilepsy surgery that I was going to have. Some of the information in the table of contents included *ketogenic diet, causes of epilepsy,* and *types of seizures.* My eyes glanced over the all-so-familiar titles as the wonders of brain surgery ran through my mind. The reoccurrence of a seizure during an increased time of stress held true. As I continued searching for new information, my body was taken in by the uncontrollable force that I was fighting to put behind me. The books around me disappeared from sight, and light was combined with fog. My limbs were bound by rigidness and involuntary movement. Through a narrow path of light that became wider, I regained full awareness once again.

I must have squatted down during the early phase of the time lapse. As a consequence of my involuntary actions, a page in a book was wrinkled. I looked at my watch and noticed that it was time to meet Mom. I smoothed out the page and placed the book back on the shelf. I walked out of the library feeling as if I hadn't slept in days and discouraged by the lack of information on epilepsy brain surgery. As expected, Mom was waiting in the big blue Cadillac at our designated meeting place. I opened the car door and dropped into the seat like a rag doll.

"Hi Amy," Mom said. She looked at me with a serious expression.

"Did you have a seizure?" she asked.

"Yeah," I replied in a tired voice. My eyes were heavy, and I wasn't my cheerful self. Mom had seen these characteristics so many times that she really didn't need to ask if I had a seizure.

"Well, you can take a nap when we get home. Do you want something to eat before we go home, or do you just want to go straight home?" Mom asked.

"I just want to go home. I'm tired," I replied.

As we walked into the house, I put my book bag on the floor in the hallway. With little energy left, I headed to the bathroom to take out my contact lenses. Within a minute of lying down, I was asleep and did not awaken for at least a few hours.

When I awoke, I felt revived and ready to complete my responsibilities. After I ate dinner, I began my homework of bird watching and listening for different songs made by birds. As the class progressed, I realized that taking this class had a humorous side to it. I was bird watching, of all things! Throughout the time of this course, I chuckled at the fact that I was studying birds and how some people view this task as something that only weird scientists do. Regardless of others' views, I was studying birds for two weeks and then I was having brain surgery. Bird watching actually served a purpose during those last few weeks prior to surgery. Sitting out in the wilderness gave me an opportunity to focus my thoughts on something other than the special day ahead. The time spent listening to the different chirps of birds and observing specific characteristics of birds was actually encouraging during a time in my life when I needed some personal quiet time. (Even if it were with the birds!)

Although I was taking a class during this time, my life had slowed down tremendously after graduation. During that last month-and-a-half before surgery, I had more time to think about the upcoming surgery and to wonder what it was going to be like to go through the process. There were moments during that last month that I felt overwhelmed by what lay ahead. I

had never in my life been so emotionally involved with a major event that was about to take place. I found it to be the strangest thing to be planning for a life-changing event that I was happy about and yet to have a streak of fear mixed in with the happiness. During those weeks when I had evenings to relax and time to reflect, loneliness again settled into my heart, soul, and mind. *I am the only one going through this. . . . I am the main one who needs to be strong. . . . No one understands the emotions I have. . . . I am about to put a part of life behind me. . . . a part of me that I have wanted to get rid of since I was eight years old. . . . And now I'm going to do it. . . . the opportunity is there to do it. . . . I must be strong. . . . I will be the only one on the operating table. . . . just me.*

One evening as I thought about having surgery, I knew that only God could hear my thoughts and that it was impossible for another human to be right there experiencing the same emotions as I had. As I lay on my bed, crying from the depth of my heart and longing for someone to listen to me express my every thought, I decided to write my thoughts into a poem. Writing was a way of releasing my thoughts when no other human being was there for me to share my thoughts with at that time. With tears in my eyes and a poetic mind, I wrote this poem.

The Unheard Heart

> The beat is steady and sustains my life,
> As it lives in pain with thoughts of strife.
> The pain is not seen, but it feels so deep,
> As the rate increases and the heart just weeps.
> It reaches out to say "I'm here,"
> Finding a distance in those so near.
> Just a friend, just an ear and such . . .
> Maybe a hug . . . Is this too much?
> As a rapid beat lives in such pain,
> A lonely heart questions, Am I insane?
> The beat is steady and still in one part,
> While streaks of pain shoot through the unheard heart.

<div style="text-align: right">May 27, 1994</div>

That evening, Angie was at the house to see the family. I had been in my room for over an hour when she knocked on the door and came in.

"What are you doing, Amy?" She saw the redness of my eyes as she sat down on my bed.

"What's wrong?" she asked.

I didn't say anything at first. I started to cry harder knowing that there was someone who wanted to hear what was on my mind. I knew it wouldn't change the circumstance, but talking about things with my sister was better than keeping such deep thoughts to myself.

"I'm feeling overwhelmed about having surgery. I'm not thinking about backing out—it's just that I'm the only one going through it. I want to have surgery. I want to be cured of my seizures. But the whole idea of having brain surgery brings a lot of mixed emotions. Waiting is the hardest part."

"I understand," Angie replied. "I mean I'm not in your shoes, but I can see how you must feel. I can't imagine going through what you're about to go through and even what you have already been through. I admire you for your desire to go through the surgery. But I know you must have a lot to think about. You're going to let someone else operate on your brain! I've had my tonsils out and I thought that was painful, but that's nothing compared to brain surgery. It can't be easy waiting for these last few weeks to pass before surgery. But you know all of us are behind you. We are happy for you that there is an opportunity for you to be cured. I love you . . . and so does the family . . . we want the best for you."

"I know. . . ," I said in a whisper.

"If you ever need someone to talk to, you can give me a call," Angie added. "I don't get to Mom and Dad's that often, but you can call me anytime. Is there anything else you want to talk about?" I nodded my head "no."

"Thank you for listening," I replied.

"That's okay. I just wondered what you were doing. I knew you were in here for a while. I was just talking with Mom in the living room and wondered where you were. Do you want your door closed?" she asked.

"Yeah."

After Angie left my bedroom, I was relieved that someone in the family knew what I was going through. Again, I knew no one could truly understand my emotions. I knew it was best that Dad and Mom didn't know about my emotional state because they may try to talk me out of having surgery. I didn't want them to read more into my thoughts than what was really there. I knew that what I was experiencing was only natural for what lay ahead. I was not reacting in any unusual way to the situation. It was as if I was going through a grieving stage as a result of knowing my life was about to change, hopefully for the better.

May 29, 1994

The day was Sunday, less than three weeks before surgery. The day was mixed with darkness and light, fear and hope. Since Mom wasn't feeling well and since Dad went to see his mom who was in poor health, I called Ruth to ask for a ride to church.

The message that pastor preached was on sacrifice and how sacrifice can hurt, but that the fulfillment of a given task is worth it in the end. As for me, I knew that I would soon sacrifice my long hair and the damaged part of my brain where my seizure disorder was located. The hair would grow back, and hopefully, all of the scar tissue would be removed so that I would never have a seizure again. *Faith . . . trust . . . determination . . . a burning desire to overcome . . . peace filled my soul.*

At the end of the service, I went up to the altar during the altar call. All alone but in the presence of God, I leaned on the wooden altar in prayer. The circumstances seemed overwhelming. *Just God and me.* Human loneliness settled in as the peace of God flowed through my every thought.

A few minutes later, I felt someone put his hand on my back and sensed that the person was behind me. It was Ruth. She was fully aware of my surgery. As she touched me, I cried harder as I envisioned myself on the operating table. Ruth had known me since Marjorie and I were in the first grade. She had seen me in seizures throughout my childhood and had a heart as big as the ocean blue. We prayed together as the hymns played and then made our way back to our seats.

"When is your surgery?" she asked.

"June 17th," I replied as I wiped my face with a tissue.

We exchanged only those words. Along with countless other people who cared deeply for me, Ruth had that expression of awe regarding the surgery I was going to have. The silence between us said it all. All we could do—and the most we could do—was to hope and trust in God. As the service ended, I hoped that the sacrifice I was going to make was going to be worth it all.

June 2, 1994

Following another day of ornithology class, I experienced a seizure as a result of being overheated on this warm spring day. After returning home, I sat in my living room. In the distance I heard my mom conversing on the phone with her sister Betty. As one would expect, they were talking about my surgery. I heard silence and then my mom's quivering voice.

"No, . . . I cried in the beginning, but now I'm just happy for her. I know that she's in the Lord's hands." Again, I realized the pain that my disorder had brought my mom and the mixed emotions she was experiencing as we neared the day that I would place my life in the hands of a brain surgeon. I was glad to see Mom reaching out to her sister for support during this time of waiting. In one way, my family and I all had a part in the battle. I was the one in the actual battle attempting to defeat the enemy while my family was on the sidelines, watching the war in action. As with a war, the only refuge my family had was to pray for victory and to reach out to close family for support.

June 5, 1994

As I saw the sunrise over the horizon, I anticipated hearing another encouraging message in the Sunday morning service. My parents and I sat in the small sanctuary as I wondered about the exact wording of Mom and Dad's prayers and how they were coping with my situation at this point. As I listened to the

pastor's message, I felt the onset of an aura that turned into a seizure. This was one of few seizures I ever had in church. For a split second, I wondered if anyone would notice. But there was no turning back the event of darkness and mental isolation that I was about to experience. Surgery was in twelve *long* days.

That evening, Ruth Roberts gave me a ride to go to the Sunday evening service. As I coped with so many thoughts, I desired to spend time alone in prayer—just God and me. Realizing that I would be going into the operating room without a loved one by my side, I drew closer to the only One who knew my deepest concerns. No other human knew my true emotions—only God—the One who was by my side and in whose hands my life rested. At the end of the service, Pastor had the congregation clasp hands in small groups to pray. The bond between us was one of encouragement.

June 6, 1994

As Mom drove me home from my bird class, I had a seizure. I gripped my half full cup of iced tea as my surroundings disappeared. Shortly afterwards, I awoke to find my clothes were soaked from tea and my cup was out of my hand. Mom explained to me what had happened. She said that I threw my cup of iced tea across the front seat. I was rather confused about the incident and didn't recall having done so. However, since my books and clothes were wet, that in itself was clear evidence of the event. I had become frightened during the seizure and had given a harsh movement with my arm to get rid of what I "knew" was in my hand. Even though I was not fully aware of my surroundings during the seizure, I vaguely realized that my cup remained in my hand.

June 7, 1994

Ten days before surgery I received a call from the lady with whom I had been corresponding. It was only the night before that Mom was encouraged through a telephone conversation

with this lady's mother. Mom had asked the mother if her daughter could call me and tell me about her surgery.

"It's been almost four months since my surgery, and I haven't had a seizure. I feel great," she explained. She went on to inform me about some details regarding her surgery and the pitifulness of hair loss.

"The surgeon was very nice. He will talk with you as long as you want. And I went home five days after surgery. I couldn't believe how soon I was able to go home. It also felt strange to not have hair. After about a week, I started wearing hats." I listened closely to everything she said. I felt so encouraged to be talking with someone who had recently gone through the exact surgery that I was going to have. She continued on with details about the surgery.

"Right after surgery, I was extremely thirsty. They told me that I couldn't have anything to eat, but that I could have an ice cube to suck on. I was also told that I would begin vomiting if I ate anything. You can expect to have a dry mouth after surgery. It's the anesthesia that will make you thirsty. Oh, and the anesthesiologist was cute. I remember that part." We both laughed.

We ended our telephone conversation with exchanges of warm words of encouragement. I had formed a common bond with another human being who had walked along the same path as me. She had experienced some of the same trials as I had. Her victory over seizures occurred only months before. Her operation was performed by the same surgeon that I was going to have. Besides the fact that her seizure disorder was on the left side and mine was on the right, our cases were very much alike. My knowing that her surgery was, at that point in time a success, gave me more comfort as my surgery date approached.

June 10, 1994

My surgery date was one week away, and it seemed so unreal that soon I would be lying on the operating table with my brain exposed to human eyes. As I dealt with such deep emotions and the realities of the next week, I decided it would be best if I met with my pastor for spiritual and emotional sup-

port. I had met with him several times prior to this to discuss my surgery and factors related to epilepsy. Although I knew I had dealt well with everything up to this point, I also knew I needed to express my fears and thoughts to someone outside the family. At a time when there was a possibility for me to be cured of my seizures and the nature of my emotions were difficult to pinpoint, I truly needed someone to just listen. Pastor Phil had always showed me his willingness to listen, and he had a way of calming the storm of fear when there seemed to be no let up. One day after class, Pastor Phil arrived at my house for our meeting. After a subtle, yet friendly greeting, we sat down in the living room for a talk that would last at least a few hours.

"I don't know how to explain how I have been feeling recently. My emotions are so different than ever before," I explained.

"I've been praying for you. What has it been like the past few weeks? Are you starting to feel the pressure?"

"Yeah, during the past few weeks especially, I've felt a sense of loneliness." Tears began to fall. "I guess it's hard because I'm the only one who is going through this. I mean I realize that several other people have had the same surgery, but I'm the only one in my family who is going through with this. I know that others are affected emotionally by it, but not to the degree that I am."

"I understand" he said, shaking his head with a sincere look on his face.

"I've been praying heavily about this for the last six months to a year. I trust that I wouldn't be going through with this if it wasn't His will. But it's part of human nature to want someone who is close to physically go through the same thing. But that can't happen in this case. . . . It's just me."

"I understand," he replied. Pastor was sometimes a man of few words when the content was deep.

"I don't want you to think that I'm thinking about backing out because I'm not. I just have a lot to think about. Waiting is the hardest part."

"I can see that. I have been through some difficult things, but never something like this. I couldn't imagine what it's like

to go through what you're going through. You are the first person I have met who was pursuing brain surgery, but all things considered, you are handling everything wonderfully. I am amazed how well you have coped with your circumstance."

Pastor's willingness to come and talk with me meant the world to me. I had finally found a minister whom I felt comfortable telling my problems to and who gave me a sense of spiritual support when we were finished talking. He was distant enough from my family and my disorder that he was able to give an unbiased opinion. He was also able to recognize some of the most obvious and deepest emotional struggles I was experiencing. I had finally come to the conclusion that it was those who had less experience with seizures and hadn't known me all my life who were able to give me the most comfort during the darkest moments. To talk to my family about my present psychological state and the possible negative outcomes of surgery would seem to give my family the message that I was doubting my decision. Or even worse, doubting God. I was nowhere near that point, and I didn't want my family to draw the wrong conclusion. It only seemed right to spare my family the confusion and to cope with such trials of faith away from those whom I loved so much.

Before the end of our meeting, Pastor expressed an interest in being at the clinic the day of my surgery. I had wanted to ask him to come, but I did not want to impose. I gave him a map to the clinic and expressed my appreciation for his willingness to be with my family in the waiting room during surgery.

Chapter 22

Binding Love

The last two days before leaving for Cleveland, my family went through the typical chaotic routine of last-minute shopping, making important phone calls, doing the laundry, and cleaning the car. Months earlier my parents had also made the decision to sell the house in order to build a home on a piece of wooded property. The added responsibility of selling the house only made preparation for the trip that much more intense. Every thought and action was focused upon making the drive to Cleveland and gathering the items needed for before and after surgery. I purchased some thank-you cards to give to my family and pastor after the surgery. I didn't want to forget about expressing my thanks to those who were planning on being there for my important day. I also went to the library and checked out some books to read during my stay in the clinic while I was recovering. I planned to the maximum with the hope that I would be able to fulfill all that I could while I rested in a hospital bed.

After Mom and I spent hours cleaning the family car, both inside and out, then it was Dad's turn to do some tune-ups under the hood. He used his mechanical skills to figure out what was wrong with part of the engine. A couple of hours later, Mom and I worked diligently on household chores, while Dad worked on the car. Mom went out to see how Dad was doing; soon she came back with a concerned expression.

"Amy, your dad doesn't know if he will be able to fix the car right away, so he needs our prayers. He wants us to take the Cadillac to Cleveland, but he says he doesn't have the right tool to fix it. He will have to wait until Monday to rent the machine

that he needs. But don't you worry. He said that we will rent a car if it isn't fixed by the time we have to go."

The next day was Sunday. My parents and I went to church as though it were an important spiritual holiday. Seriousness was the only mood felt as we made our way to church. Similar thoughts were on our minds. This was our last Sunday in church before my surgery. Some of the most fervent prayers would be continued this morning.

As we entered the church, Pastor greeted us with a handshake and a look of deep concern and support. My parents and I sat near the front as we usually did. This day of worship was more important than anyone knew. I could not know for sure what was going through the minds of my Mom and Dad, but it didn't seem too hard to figure out.

During altar call, my Dad stepped toward the altar, and Mom and I followed. A chorus played on the piano. With Dad on my left and Mom on my right, I dropped on my knees between them. I placed an arm on each of their backs as we prayed in silence. No words were heard except for those spoken to the One listening above.

> *Dear Lord, thank you for answering my deepest prayer and bringing me this far. . . . I ask that you will guide the hands of the surgeon during my surgery, and may your will be done in this situation. . . . Please be with my family during the surgery and give them a peace of mind. . . . And if any tragedy happens during surgery, please be with my family to help them to deal with such occurrences. . . . Just give my family peace during the events that occur that day. I pray that you will give me the strength I need to follow through with what you have laid before me. . . . I love you and trust you. . . . Thank you Lord for being with my family through this. . . . Thank you for the love and support that they have shown me. . . . Please give my family the courage that they need to get through the waiting during my surgery. . . . Amen.*

The music continued as I ended my prayer. Mom and Dad were still praying. The tears in their eyes told their whole

prayer. I had never seen my mom and dad pray so intensely as they did that morning in church. The future of their youngest daughter lay in the hands of God. My parents had witnessed me having many seizures, and during some of my seizures they had thought that I was near death. The possibility of me becoming seizure-free was exciting for them, but the process that I had to go through to become cured frightened us all. *Brain surgery . . . the removal of brain tissue . . . an incision into the skull . . .* All of these thoughts echoed in our minds as we walked back to our seats.

Out of fear of how people would respond, I had asked my pastor not to tell many people about my surgery. I didn't want to answer a lot of questions, and I didn't want to run the risk of someone thinking I was making a radical decision. There was so much that I would have to explain that I didn't think it was worth letting everyone know. I already had the support of my family, my pastor, and my best friend's family whom I had known since grade-school. My receiving binding love from my family and a close friend was enough for me. Simplicity was on my side.

As we left church that day, Pastor shook my hand and asked a few last minute questions such as when we planned on leaving for the clinic. He reassured me that he would be there for the surgery. I walked out of the church building wondering when the next time would be that I would step foot in my church and what condition I would be in when I did.

That day I continued packing for the big event. From sweat pants to reading material, I packed more than I probably needed for being in a hospital bed for five to seven days. The woman inside of me shone through as I packed everything from library books to several colors of knit pants. Loose fitting shirts to go over my head were a top priority in the packing mission.

That evening, Mom and I went to the race track to watch my brother race his beauty of an enduro car. I sat on the hard benches with blankets and a Coke to drink. Diehard racefans cheered for their favorite race car as the black debris flew toward the bleachers.

While the rumbling sounded and the drivers pressed on to receive the grand prize, my mind was in a race all of its own. It

was a race far away from the one that would bring some crazy race-car driver thousands of dollars. I was in a race that required determination, faith, and dreams—a race that is run by only a few. There were no opponents in my race except the devil who could discourage me. *No competition required . . . just a willingness to place my life in the hands of God and man. The only risks involved were the impairment of speech, vision, and memory. One way or the other, my life would be changed. The ultimate prize would be reaching the checkered flag, not first or last, but simply reaching the finish line. Unlike race cars, if something breaks during brain surgery, there's no fixing it.*

June 15, 1994

The next day was my last day to pack before leaving the following morning. The car was still immobile, and Dad remained in his tense mood as he tried to fix it before we were to leave for Cleveland. He still did not have the tool that he needed to make the necessary repairs. The possibility of renting a car was our only hope. That evening, the phone rang.

"Hello."

"Hi, Amy. This is Marj. I just called to wish you well and let you know I'm praying for you. Are you heading out tomorrow?"

"Yes, I am. The car is broken, and it doesn't sound like my dad can fix it tonight. So we may be renting a car in the morning. But one way or another, Mom, Dad, and I are leaving tomorrow morning."

"That's awful about the car. I hope it works out all right with transportation to get there. Are you all packed?"

"Pretty much. I will need to pack a few items in the morning. Other than that, I'm all packed."

"Well, how are you feeling about everything now? Have you had second thoughts about having surgery?" she asked with concern.

"No, I know it's the right thing for me to do. I have been both fearful and excited over the last four weeks, but I have not thought about backing out. I have been fearful of the unknown and yet excited about the possible results. I just hope that when I wake up, my mind is there. I wonder if I will still be myself—the Amy that everybody knows. You know, what if I wake up

thinking I went for a walk in the park, or I yell at the surgeon or something strange like that. What if I wake up liking country music." We both laughed. Marjorie knew of my high dislike of country music.

"I have been thinking about you a lot and wish you the best. I'll be praying for you." I heard her voice change. "I love you, Amy."

"I love you too."

We said our good-byes on a serious note. Marjorie and I had been good friends since first grade. She had seen me through a lot of my trials and had helped me in school during those years that I had a hard time catching on right away. We had shared so much over the years. From playing school to attending church together, we were almost like sisters.

Chapter 23
Final Tasks

The next morning, I put my feet on the floor like an army man rising for duty. All I had to do before we left was take a bath, get dressed, and pack those final items. All that Dad had to do was figure out our means of transportation! He called a few car rental companies, and none of them could get a car for us within the hour. He finally reached a car rental place at the Kalamazoo Airport that had one that could be rented. Being the only sure option, he agreed to take it. We had already packed Dad's Monte Carlo so that we would be ready to drive to the rental car. Dad didn't want to drive his car to Cleveland because of some mechanical problems that he knew existed. Being the man of the family and the one responsible for getting the three of us there, Dad wanted to know that we were taking a reliable form of transportation.

Within a matter of ten minutes after Dad found a rental car, we headed to Kalamazoo. I was scrunched up in the back seat with all of our suitcases. Once we got the rental car, we all seemed to relax a little bit more. Soon we were on the road to Cleveland, Ohio where I hoped my life would be changed for the better.

Despite the hassle we went through to get on the road, we had an enjoyable time traveling to Cleveland. We had already made four trips to the Cleveland Clinic for appointments, but this trip was different. The purpose of this trip was like no other.

As we approached the city of Cleveland and the skyscrapers that were all too familiar, I marveled at what lay ahead in the days to come. *Cleveland, Ohio . . . This is where my life will be changed. . . . where a miracle will be performed . . . that I once thought may never happen. . . . I want to live to tell.*

We arrived at the Omni Hotel in time to unload the car and freshen up before my appointment at 2:00 p.m. An MRI was the only test I had that day. The other appointments were scheduled for the following day. Although several tests had been run many months prior, the surgeon needed a recent MRI because this one would be his guide for the operation.

Mom and I entered the part of the clinic with the purple sign above that read "Magnetic Resonance Center." We waited for only a matter of minutes and then my name was called. The clinic staff members were always so flexible and willing to take me early if the time allowed them to do so. A nice male technician walked me back to the room where I would have my MRI.

"I see that you are going to have brain surgery on Friday. Dr. Comair is one of the best surgeons around. He's a nice man. You'll like him." The MRI technician was aware of why I was there and the significance of this MRI. Although I was already confident about the surgery, I was encouraged to hear a medical professional in the clinic speak some words of confidence about my surgeon. I had not yet met the surgeon, but my appointment with him was in about twenty-four hours. I couldn't wait to talk in person with the man who was going to operate on my brain.

The next day was full of appointments. Starting at 8:00 a.m., I had an EEG, followed by my appointment with the surgeon. After the EEG, I had just a few moments to style my hair before meeting the surgeon. Running my fingers over my scalp, I felt the glue that was used to attach the electrodes to my head. I picked out some of the glue from my hair and used a curling iron to make it look like I hadn't just crawled out of bed. I was sure that the surgeon had seen worse, but I wanted to look presentable for this appointment.

Dad, Mom, and I waited on floor S-80 for my name to be called. Soon my surgeon called my name. After he introduced himself as Dr. Comair, I asked him if I could meet with him without my parents being present. He acknowledged my request as my parents started to stand up.

"I will meet with Amy first, and then I'll call you folks back," he explained to my parents. I knew they wanted to meet with him too and discuss any questions that they might have.

But I just wanted time alone with the surgeon. I wanted to hear what he had to say and to be able to ask questions without any extra pressure or having nervous parents in the room.

"I'm Dr. Comair," he said in a Lebanon accent. "I will be your surgeon tomorrow. There are some things that I would like to go over with you and then you can ask all the questions you want." Hearing his first few comments gave me the impression that he was very down-to-earth and one who had an awareness of what I may be going through.

"Let me tell you a little about myself and my experience as a brain surgeon. I perform this surgery two to three times a week and have done this surgery for five years. About 80% of the people who undergo the procedure end up virtually free of seizures. Although the risks are low, there is the risk of losing part of your vision, or your speech can be impaired. Very few patients experience any of these effects, but I must make you aware of them."

I could not believe that I was conversing with the man who was going to operate on my brain. What an amazing feeling that was to finally meet the man who knew how to remove the part of my brain that had caused my seizures all these years. The success rate was also encouraging.

"I want you to look at me straightforward." He looked back and forth at my left and right temporals. "Your right temporal is sunken in more than your left. That is due to your right temporal lobe being damaged. Your right hippocampus has shriveled up over the years like a grape turning into a raisin." He used his hand and made a slow fist to demonstrate this concept. "As a result of the right temporal lobe being damaged, the outermost part of your temporal lobe is sunken in more than the left." He explained this in such a way that made me realize the in-depth knowledge of the brain that this man held. I had never in my life heard or even noticed that my right temporal near my eyes was not the same as my left. I was amazed that there was a physical feature about me that related to my seizure disorder.

"Now about the procedure. You will be under complete anesthesia for the surgery. The anesthesiologist will place a gas mask over your mouth and nose, and he will ask you to take a deep breath. Within a few minutes, you will start to feel sleepy,

and you will drift off to sleep. You will not feel anything during the operation. You will be hooked up to several monitors that will monitor your breathing and the amount of anesthesia in your system. You will see several people in the operation room before you go to sleep. They will be there throughout the surgery to help monitor the machines and your IV. After you are asleep, the right side of your skull will be cut in the shape of a horseshoe. After the skull plate is off, I will insert a tool approximately three inches into the brain to the hippocampus. The hippocampus is a long-term memory bank. Everybody has one hippocampus on the right and one hippocampus on the left. The hippocampus resembles a piece of broccoli with a stem and a crown. I am going to remove the crown of the hippocampus. The tests revealed that 85% of your right hippocampus is damaged. Since the hippocampus on the right side of your brain has been damaged and has only caused problems, the hippocampus on the left side of your brain has done all the work of storing information. The left side has had to make up for the lack of memory storage on the right side."

"Do you mean that I have no long-term memory on the right side of my brain?"

"That is correct. The hippocampus on the right side has only caused problems and has not been able to hold information. By removing the scar tissue, the left side will be able to function better." He continued his explanation of the procedure. "To begin the surgery, I will go through the healthy tissue with a skinny device until I reach the hippocampus. Then I will scrape the scar tissue so that it will flake off like crumbs or dust. Then I will insert another device through the healthy tissue and vacuum up the scar tissue. After the removal of the scar tissue, I will put the skull back on with the aid of man-made material. The actual removal of the scar tissue takes only about fifteen minutes. From the time between opening and closing the skull, the operation will take about five hours. The prep work and the closing up of the skull takes the most time. Once the skull is closed up, I will wake you up and ask you your name in order to check your responsiveness. You will have lots of swelling after surgery due to the trauma that the brain will go through during surgery. You will be given Tylenol with

codeine for the first several days after surgery to help relieve the swelling and the headache. From the operating room you will go to intensive care. From intensive care you will go to recovery, and then eventually you will be taken to the epilepsy monitoring unit. Now, I know this is a lot of information to take in. What questions do you have?"

I paused for a moment, absorbing everything that was said. "Will you be taking out any healthy tissue?"

"No. Your scar tissue is located in such an area that it is not necessary to remove any healthy tissue. A tool will be inserted through healthy tissue to get to the scar tissue, but I will not take out any healthy tissue. The healthy tissue that the tool goes through will be swollen afterwards from the trauma, but there will be no permanent damage to the healthy tissue."

"Is there a chance that I will have a loss of memory after surgery?"

"Some patients experience a memory loss right after surgery, but in the cases that I have had, there has been only temporary loss of memory. Since your memory is on the left side and I will be operating on the right side, I will not be taking any functional memory." He paused for a second and then asked me if I had any other questions.

"If you do not have any other questions, I will invite your parents in to talk to them."

"That's fine," I replied.

"Okay, I'll be right back."

He then left the room to get my parents. I had only a matter of moments to reflect on our conversation before Mom and Dad arrived. *I have only one functional long-term memory bank. I never knew that it was a memory bank that was damaged. I wonder what Dad and Mom are going to think about the content of the surgeon's explanation of my case.* Just then, the surgeon and my parents walked into the examination room.

"Have a seat," he said in a cheerful voice.

"I'm Steve Crane, and this is my wife Brenda," Dad said as he shook Dr. Comair's hand.

"Nice meeting both of you," the surgeon said in his Lebanon accent.

"Nice meeting you," Mom replied with a smile, but holding back the tears.

"I have explained the surgery to Amy, but I would like you folks to be informed of the procedure as well."

Again, he explained the details of the surgery and what condition they could expect me to be in after the surgery. When the surgeon began explaining that the part of my brain that was damaged was the long-term memory bank, I saw their expression of curiosity turn to expressions of amazement. The problems I had experienced in my childhood started making sense.

After lunch, I still had four appointments to attend. Each individual meeting was an interview to discuss what I could expect before and after the surgery. The medical staff also wanted to insure that I was aware of what I needed to do to prepare for surgery. The admitting interview was the most interesting one of them all. Mom and I sat across from the nurse who was sitting at a desk as she asked me numerous questions.

"Have you had any alcohol or tobacco products in the past six weeks?"

"No."

"Have you recently thought about taking your life?"

"No."

"Do you have reason to believe that you are pregnant?"

"No." I looked at Mom, and she looked at me.

"Well, I was waiting to hear this one! No, I'm just joking," Mom said in a humorous tone. The nurse started to laugh along with us. It did seem a little odd to be asked that question with my mother in the room.

"I know you have been told some of this already, but I must review these guidelines with you anyway. You are to not eat anything past midnight tonight. Also, get plenty of rest tonight. If for some reason you come down with any type of infection by morning, even if it's a head cold, we will have to cancel your surgery. You can take a sponge bath in the morning, but you are not to use any soaps, lotions, deodorants, or perfumes. Your surgery is scheduled for 11:30 a.m., and you should plan on being there at least a half hour before then." After the nurse

asked her final questions, Mom and I made our way back to the hotel to meet up with Dad.

The final preoperational testing was completed. Only time itself and the procedure were the barriers between the old and new life. That evening, Dad, Mom, and I sat on a balcony overlooking Lake Erie and watched the ships pull in and out of the harbor. As much as my mind would allow, I relaxed in a chair with my feet up and enjoyed the view of the old and new ships passing by and the sea gulls that flew overhead. My mind was still stunned by the thought that this may be my last evening with epilepsy, a disorder that had brought so much pain and struggle to my life. It was as if I were preparing for a funeral for a part of me that I had longed to bury. Silence was the best therapy, along with being with the two people who had seen me through almost twenty-three-years of experiencing seizures and the ongoing side effects of medication. The few words that were spoken that warm summer evening were about the scenery, including the uniqueness of each ship. As for me and my life, I had waited a long time for my ship to come in.

Later that evening, more family began to arrive. Angie came with her nine-month-old daughter Amanda. My Grandma, having recently remarried, arrived with her husband George. Steve would be driving down later that night and planned on arriving in the early hours of morning. Pastor would also arrive early the next morning.

The sun was setting as I walked around the block of the Cleveland Clinic with Grandma, George, and Mom. As we strolled through the historical town of Cleveland, we discussed the certain characteristics of the authentic old churches. Grandma told us stories about the different churches our ancestors attended and the ages of other church buildings back home. I joined in with the conversations by adding my own humor. At a moment when my thoughts were heavy and I had a very important event the following day, I kept a witty spirit and involved my family in my humor. Maintaining a balance between the deep situations in life and moments of laughter was my way of coping with the emotional weight I had carried for over a decade.

During our walk, we made a point of finding the building where we would all gather the following day for my surgery. The building was massive, silver in appearance. As I gazed at the enormous and modern-looking building, I stood in amazement at the realization of my having brain surgery the next day. In less than twenty-four hours, my life would not be the same. My family and my pastor would be in the family waiting room, anticipating the results of the operation. We ended our evening walk while there was still daylight. We returned to the hotel together, except for George who took a detour to the store.

Late that evening, the whole gang ate in the hotel restaurant before my fasting began at midnight. As I waited for my meal and engaged in conversation with my family, the details of my surgery raced through my mind. The next day a drill would pierce through my skull. As I anticipated experience excruciating pain as a result of the incision, I knew that the pain would be only temporary and that throughout the remainder of my life I would reap the benefits of having the procedure. With six of my family members around the table, I knew that all of them would be there the next day during the surgery and that they would see me in the recovery room after I awoke. The time with my family meant the world to me. As I looked around the table, I realized the unity that existed in my family and the love they had for me. *They are here for me.*

In the hotel room, I kicked back and enjoyed more conversation and laughter with my family. Grandma, George, and I played cards while my dad lay on the bed and watched a game on television. Angie stayed in her room while Amanda slept. The evening was filled with jokes and stories that made tears come to my eyes from laughing so hard. The significance of our visit in Cleveland seemed to be pushed aside during the varied tales about chickens, foxes, and how things used to be.

Before I drifted off to sleep that night, I had my devotions and prayed to God to thank Him for this wonderful opportunity of possibly putting the biggest mystery in my life behind me. I thanked God for all that He had brought me through and for the moral support of my family and pastor. And finally, I asked that He guide the surgeon's mind and hands and that He give my family peace of mind in the waiting room. *And if anything goes*

wrong during my surgery, give them the strength they need to cope with the outcome. The evening before my surgery, I was more concerned about my family than I was about getting through the surgery. My family had helped me through adversity my entire life. I wanted the results of my surgery to lessen, not increase, the concerns that my family had carried throughout my growing up years.

CHAPTER 24

The Transformation

June 17, 1994

I awoke the next morning feeling rested and eager to prepare myself for the big day ahead. Suspense and intense emotions overflowed. As I prepared for the transformation, again darkness appeared as the stress brought on a seizure. *Soon the light will shine continuously.*

While I was getting ready, the phone rang. It was Angie informing us that a nurse at the clinic had called her room asking that I report to T.C.I. as soon as possible. The surgery before mine had been canceled, so the clinic needed to fill that bed. Within a matter of seconds, the nurse called my room and reiterated the importance of my getting there right away. She said that the bed was ready and if it was not used right away, they would have to redo the prep work before my surgery at 11:30 a.m. By going early, I would save the staff some work, and I could get my own surgery underway sooner than anticipated. Without hesitation, I agreed to be there as soon as I could. Again, I experienced a seizure as a result of anxiety and excitement. After I regained my rational mind, I realized I might have just lived through my last seizure. What an awesome thought that was!

Dad, Mom, and I rushed around to inform the family of the change in plans. The three of us then hurried out the door to our destination. On our way, we stopped at the information desk of the clinic to let the receptionist know that we were expecting our pastor to arrive soon and that he needed to be informed that I was called to surgery early. We wanted to be sure that pastor would know where we were. With very few minutes to spare, we stopped at the clinic chapel for a moment

of prayer. After about three minutes, our eyes met, and we gathered our personal belongings and left.

We went up elevators and through many corridors that seemed never-ending. It took at least fifteen minutes to get to T.C.I. The speed of our walk revealed the importance of the day as I carried my bag of medical information along with some reading and writing materials for my recovery period. Finally, we arrived at H10 in the T.C.I. department and checked in at the desk. The receptionist was glad to see us.

"Thank you for coming early, Amy. We had to cancel our first patient's surgery due to an infection that developed overnight. The bed is all prepared, so we thought you might as well take it. You can have a seat."

"Thank you," I replied.

A sense of heaviness as well as calmness filled the air as my parents and I waited for my name to be called. Mom showed affection and love toward me during our last moments together before surgery. We were hoping that Angie, Steve, Grandma, George, and Pastor would make it to T.C.I. before I was taken into the operating room. The unexpected change in plans threw everybody for a loop that morning. Pastor had planned on arriving at the clinic at the time we had told him earlier. Since we did not know what hotel he was in, we were unable to contact him to inform him that my surgery time had changed.

"Amy, you and your parents can come on back," a nurse said.

We gathered my personal items and followed the nurse. The emotions within us intensified. The nurse started asking me questions as we entered the room.

"Have you eaten anything since midnight last night?"

"No," I replied.

"Do you have a cold or any infection?"

"No."

She continued her list of questions and then asked if any of us had any questions. My parents asked questions that were discussed the previous day, but it gave them a sense of security to hear the in-depth information a second time.

The nurse asked me to undress and put on a hospital gown. My family waited in the other room as I made the necessary adjustments. I laid my clothes on the bed as though they were

something sacred. Then I put on the plain aqua-colored hospital gown that I would wear in the depths of unconsciousness while part of my brain would be removed and during the moment I would awake from surgery. Soon my life—my body—would lie flat on the operating table and would be placed in the hands of highly-trained medical professionals. Completely unconscious, I would not have a say in anything that occurred in the operation room. However, faith and trust in God would get me through. The nurse then asked me if I was dressed before she pulled open the curtain.

Dad noticed I did not have a bag to put my clothes in. As another nurse opened a drawer to a hospital dresser, Dad observed the bags in the bottom drawer.

"Hey, could Amy have one of those Cleveland Clinic tote bags for her clothes?" he asked.

"Oh, sure," a nurse replied.

"After all, she is going through brain surgery! She at least deserves a souvenir that has the clinic's name on it," he added. We all chuckled at the nature of his comment.

Within fifteen minutes, Pastor, Grandma, George, Steve, Angie, and Amanda arrived. The expression of my family's faces revealed their state of mind. We said our hellos with both happiness and seriousness. We spent a few moments together before the final departure. Angie placed her daughter Amanda on my bed, and I cuddled with her. As I held my nine-month-old niece, I looked into her brown eyes and saw a life that was so simple and yet so precious. I said to myself, *Life seems so simple, doesn't it?* I held a life full of joy and smiles . . . a life that was only beginning . . . one that had not yet been altered by a major affliction. *A simple life.*

The family stood in almost complete silence for a few seconds as I enjoyed the blessing of being with Amanda. A few casual comments were made as we waited for a nurse to give us the sign that it was time. A long ten minutes passed, and then a nurse arrived.

"We are ready for Amy. Someone from T.C.I. will be here shortly," he said.

"Thank you," Dad replied. "We'll stay here until they arrive to get Amy."

"That's fine," the nurse replied reassuringly.

The moment of saying good-bye and departing was almost here. The expressions of concern were written all over my loved-ones' faces. Angie picked up Amanda from the bed.

"Pastor, will you pray, please?" Mom asked. The family bowed, and Pastor prayed for the success of the surgery and for precision on the part of the surgeon. The moment had arrived. My family had to leave me. The only and most important thing they could do was to pray for success as they waited in the family waiting room. Each family member and Pastor came to me to give me a hug and to exchange words of encouragement and love. The expression on each person's face said it all. Steve gave me a hug in the brotherly manner I expected. With a tear in his eye, he wished me well. Angie gave me a hug and told me that she loved me. The line got shorter as a tone of seriousness remained. The same response came from Grandma and George. Only hugs, kisses, and words were left. The waiting for a word from the surgeon would be the longest part. And then came the moment to say good-bye to the two people who had shed tears over my struggles and who had tried everything within their means to find a cure for my seizures. They had witnessed everything that I had gone through with having epilepsy. From being toxic on seizure medication to being exhausted after having seizures several times in one day—they had seen it all.

"I love you, Amy." With a quiver in her voice, Mom gave me a hug that expressed all her love for me. "I love you too, Mom. It's all right. It's all in God's hands. I love you." After a long embrace, Mom let go as if she were letting go for the last time. Then Dad gave me a hug, and with a tear in his eye, he told me that he loved me. My parents departed as they looked back at me with tears of fear and happiness. I was left in the T.C.I. room surrounded by intravenous equipment, rollaway beds, and the awesome emotional feeling of knowing that the Lord had brought me to this special day. An annoying beep filled the room as I waited patiently for a nurse to arrive to take me to my destination. In a matter of minutes, a male nurse came and greeted me.

"Hi there. Are you Amy?" he asked.

"Yes, I am," I replied in a serious voice.

"How are you doing?" he asked in a caring tone.

"I'm doing all right."

"Glad to hear it. I'm going to be taking you to the operating room. You can lie on this bed here." I climbed up on the tall bed, still in amazement at what I was about to go through and the importance of this day. He started to push the bed, and we were on our way to the cold operating room that I had yet to see. On our way, we talked and he told me details about the operating room in order to lessen my anxiety.

"Amy, have you ever had surgery?"

"No, I haven't."

"Well, there's nothing to worry about. We do this surgery all the time. I'm sure you're both excited and nervous, but believe me, there is nothing to worry about. Where are you from?" he asked.

"I'm from Battle Creek, Michigan."

"About how far of a drive is Cleveland from your home?"

"About four-and-a-half hours."

He continued to talk to me as he transported me to the OR. "Now, it's going to be cold in the OR. Another nurse will give you a heated blanket to keep you warm."

"Why is the operating room cold?" I asked.

"An operating room needs to be kept at a cool temperature to prevent bacterial growth. We need our hands and the surgical instruments to be free from all disease and bacteria to ensure a clean environment for surgery. Do you have any other questions?"

"When will I be able to see my family again?" I asked.

"After the surgery, you can see your parents in intensive care for two minutes. We don't allow prolonged visits immediately after surgery because the first few hours after surgery are a very crucial time of recovery. If you do have a seizure after surgery, it's most likely going to happen immediately following surgery. Some patients have a seizure right after surgery, but then they don't have another seizure ever again. You are going to have a headache, and all you will want to do is sleep. Once you're in recovery, you can see two family members at a time. Do you have any other questions?"

"No."

As I was rolled down the hallway of the very busy clinic, I lay in peace and reflected on the days of the past. I remembered the multiple seizures in one day, the mental dullness from the heavy medication, and the inconvenience of not driving. There I was, by the grace of God, heading toward a life of possibly overcoming the biggest mystery of my life . . . by means of brain surgery . . . one life . . . living one moment in time. As I reflected on my life and my present situation, the thought occurred to me . . . *Every individual is living one moment in time. . . . each moment is a unique moment. . . . life is precious.*

After a long ride down several corridors, we arrived at an enormous door with a sign on it and the engraved number 31. "This is the operating room, Amy. In a minute, I want you to roll over from the bed you're on now to the bed that you will be on for the operation. I want to remind you that the room is cold."

A bed was rolled out and pushed up close to the bed I was on. I climbed over to the bed of my destination. At that point, a nurse came by and placed a heated blanket over me. Only a few moments passed, and the door was opened. A cool breeze of air from the OR swept over my face. I intensely observed the room where my skull would be cut and human minds and hands would be used to remove the precise part of my brain that had caused so much pain over the years. I saw unfamiliar medical devices and a few medical professionals dressed in hospital masks and slippers. Their appearance brought a smile to my face as I had not witnessed firsthand the authenticity of OR attire. Each nurse appeared as though they were dressed for a pajama party. The male nurse along with a woman nurse followed me in to the operating room.

"How are you doing, Amy?" she asked with sincerity. "You are going to be all right." I recognized her right away. She was the lady who came to give me encouragement during my stay in the EMU during my preoperational testing. After I entered the OR, she held my hand as my mother had many times before.

"I'm fine. . . . I'm both scared and excited," I replied.

"It's okay, Amy. I know this is an important day for you because you've been waiting for it a long time. But before you

know it, surgery will be over, and you will see your family. You will be just fine."

She continued holding my hand during the first few minutes of my being in the OR, and she left after several medical staff members arrived. Her words of encouragement were uplifting and reflected the high quality of care that I had received and anticipated receiving throughout my stay at the clinic. As I looked around the OR, I saw several nurses and medical technicians preparing for surgery. A few medical staff members were busy putting vascular equipment on my legs, while others inserted intravenous needles in my arms for a source of nourishment during and after surgery. Only seconds passed and a male nurse came to my side to ask me some last-minute questions. He introduced himself and repeated to me what the other male nurse had told me about the gas mask. He asked basic questions to be sure of my rational state of mind, and possibly to make sure that I was the right patient.

"What is your full name?" he asked.

"Amy Elizabeth Crane."

"What are you about to have done?"

"I'm having brain surgery for my epileptic seizures." I smiled at the simplicity of the questions and was reminded of the many times when other people asked me simple questions after I had a seizure so that they would know that I had not lost my mind. He also told me that my hair on the right side would be shaved after I was asleep. He started to walk away.

"Sir?"

"Yes, Amy."

"I want my whole head shaved," I said. He gave me a smile and confirmed my decision.

"Okay, I will let the anesthesiologist know that you want your entire head shaved. Thanks for letting me know. Are there any questions that you have?" he asked.

"No. I think I have asked them all," I replied.

"In a few minutes I will put the mask over your mouth and nose. You will need to take in a deep breath and just relax."

"Okay."

I knew that in only a matter of minutes, I would be completely unconscious like I had never been before. As I lay quietly,

I recalled my childhood when I memorized the "Twenty-third Psalm." The same verse that I had learned as a child had become a source of strength during my young adult life when my quality of life was at stake. While many people were engaging in the preparation for my surgery, I said this verse to myself. Each word touched the depths of my heart.

> "The Lord is my shepherd, I shall not be in want.
> He makes me lie down in green pastures, he restores
> my soul.
> He guides me in paths of righteousness for his name's
> sake.
> Even though I walk through the valley of the shadow
> of death,
> I will fear no evil, for you are with me;
> Your rod and your staff, they comfort me.
> You prepare a table before me in the presence of my
> enemies.
> You anoint my head with oil; my cup overflows.
> Surely goodness and love will follow me all the days
> of my life, and I will dwell in the house of the
> Lord forever.

Thank you, Lord. . . . I love you," I whispered.

Dr. Comair, the surgeon, came to my side and gave me some final words of encouragement. Then the anesthesiologist arrived.

"It's time to give you the anesthesia. After you take a deep breath, you will be asleep within a matter of minutes. Are you ready?"

"Uh huh," I replied. The anesthesiologist placed a device over my mouth and nose.

"Okay, take a deep breath."

There was a unique sensation that I experienced as I breathed in the anesthesia. I tasted a flavor of fumes that I had never experienced before. With a few seconds, I felt a rush go through my body. It was as though I was feeling the anesthesia flow through every one of my veins and through every square inch of my body. I even felt the anesthesia affecting my feet. Within that new breath, I saw my old life pass before me. I had

such peace throughout this entire time. Not one tear came from my eyes as I anticipated falling asleep and awakening to a new light. As I felt myself fade away, my life remained in the hands of God and man.

Retrospect:

After I went to sleep, I was not completely alert again until after the surgery. There was only one moment while I was under anesthesia that I heard the voices of nurses and doctors in the operating room. To this day, I do not know if I heard voices during the procedure or if it was afterwards. I vaguely remember a female nurse giving a firm command to someone else in the operating room. I seemed to recall the nurse saying, "Increase the IV. She's waking up." Again, I am not completely sure about the timing of this episode, or even if I heard the nurse correctly. But when I heard a woman's voice in a very commanding tone, I thought for sure I was waking up when I was not supposed to. The slight alertness that I had during this time may have been attributed to my desire to know exactly what the surgeon was doing to my brain.

CHAPTER 25
The Great Awakening

A human voice was the first sound that I became aware of after surgery. A sense of heaviness persisted over my entire body as I heard a man's voice speaking to me. An unfamiliar object was in my mouth and extended outward, making me unable to close my jaw.

"Amy, the surgery is over." I'm sure other words were spoken, but complete exhaustion prevented me from hearing the other voices in the OR. Only moments after I become aware of the tracheotomy tube in my mouth, a male nurse carefully removed it so that I experienced very minimal discomfort. Again, I heard the same voice.

"Amy, you need to start waking up now. Your surgery is over. You did very well." Consciousness came very slowly, but the few words that I heard were understood. Again and again, a man attempted to wake me up.

"Amy, you need to wake up enough so that I can ask you some questions." He put his hand on my side and moved me ever so gently. With my eyes closed, I became aware of the fact that I was being asked to wake up. I opened my eyes long enough to see equipment and wires all around me.

"Amy, can you tell me your full name?" There was a short pause.

"Amy . . . Elizabeth . . . Crane."

"Good. Now can you spell your full name?"

"Capital A-m-y space . . . capital E-l-i-z-a-b-e-t-h space . . . capital C-r-a-n-e."

"Great. Can you tell me where you are?"

"The Cleveland Clinic in Cleveland, Ohio."

"And what event just took place?" My eyes remained closed as I responded to his questions.

"I had brain surgery for my epileptic seizures. And if you want to get technical, you removed the hippocampus on the right side of my brain." I thought I heard a chuckle from the surgeon, or maybe even a few words of shock. The level of my alertness so soon after surgery surprised me, and I'm sure my in-depth response shocked every medical technician in the operating room.

During that awakening moment when anesthesia remained in my system and I was at a high risk of having a grand mal seizure, I rejoiced in the light that surrounded my life. I rejoiced in the light that represented a promise of continuous light without the onset of darkness and affliction. Even though my head was in much pain, I thanked the Lord for another breath and for coming through the surgery successfully. It must have been only moments later when a woman nurse began asking me more questions. By then, I was out of the operating room.

"Amy, can you tell me who is the president of the United States?" No response.

"Amy, I know it's hard, but you need to wake up for just a minute. Can you tell me who is the president of the United States?" I thought for a moment.

"Hillary." The nurse laughed. I had remembered my pre-planned response for this question. I did not know if the nurse knew what to think of my response, so I thought I should clear up any confusion. I lifted my head just a little bit.

"By the way . . . Bill Clinton is the president of the United States, just in case you're wondering," I said in a tired yet joyful tone. I didn't want the nurse to think that I had lost all of my marbles during surgery. I wondered if she took me seriously. After all, this was a serious question with regards to the doctors and nurses knowing if my memory was working properly. However, my ability to remember my response was very important to me. The main reason I planned that response was to see if I could remember a specific thought after surgery that I had before my surgery. I knew that if I remembered my personal joke, then I could be sure that my memory had remained the same as it was prior to surgery. It was my private joke and

test. Despite how tired I was and the throbbing pain in my head, a slight smile came over my face as I realized my long-term memory still remained. Surgery had not disturbed my rational mind, and my jovial sense of humor was untouched. Since much of the anesthesia was still in my system, I drifted back to sleep in a matter of seconds.

My next awareness of light was in the intensive care unit. My head was still engulfed by the most intense headache possible to man. Nutrients through the intravenous needles were my only form of nourishment, as needles with attached tubes were connected to my hand and arm. Many medical personnel came to ask me my name and to check my vital signs. In a matter of moments, I would be reunited with my family.

"Amy, wake up. There are some special people here to see you," I heard a voice say.

"Amy, wake up." I felt a nudge. "Your parents are here to see you."

I slowly opened up my eyes to see two of the people I longed to see again. There they were at the end of my bed. Their expressions were ones of joy and relief as I spoke my first words to them since surgery.

"Hi, Amy," I heard from the end of the bed. "Oh, she looks wonderful," Mom said as she held on to Dad. Nothing but suspense was between them.

"Hi," I said in a faint and tired voice. Silence remained as my parents observed my appearance and overall well-being. They walked to my bedside, and Mom held my hand very gently.

"I love you, Amy," Mom said with tears in her eyes.

"We are so glad to see you. . . . We can't stay long. This may seem like a strange question, but how are you feeling?" Mom asked.

"I have a major headache," I whispered. Mom continued to hold my hand. This was the moment that all of us had waited for. Not to see me without my hair—but to know that the surgery was completed and that I was still myself.

"I'm so happy for you. Oh, I can't believe it," Mom said between a smile and a tear.

They spent only a few moments in silence looking at me. At that point, they knew more about my appearance then I did.

It wasn't until the following day that I got a glimpse of my newly-acquired look.

A nurse then motioned that their two minutes of visiting time was over. It was the clinic's policy that a brain surgery patient was not to have lengthy visits immediately following surgery. Too much excitement could trigger a seizure.

"I love you, Amy," Mom said again before leaving my bedside. Mom backed away so that Dad could come near me. He kissed me on the hand and told me that he loved me.

Our reuniting was a special moment of relief and happiness for everybody. Although we did not know if I were cured, the main event was over. Everybody was relieved to know that I was out of surgery and I was responsive. Any and all doubt of me making it through the surgery had been lifted from everyone's mind. Only weeks of recovery and limited activity separated me from a new life.

In a matter of seconds after my parents left the room, I returned to sleep. I remember nurses continuously coming in to check my vital signs and asking me simple questions to reinsure my rational state of mind.

Between questions and vital checks, I was able to see my family and pastor. By then, my overall alertness had improved, and I was able to carry on a conversation. Angie and Pastor were the next visitors. Again, I was awakened by familiar voices.

"Hi, Amy. Pastor Phil and I are here to see you," I heard Angie's voice. I opened my eyes.

"Hi," I replied with a slight smile. Again, I read their expressions. They were encouraged to see me alert, but they didn't know what to say about my radical change in appearance.

"You have a lot less hair then the last time I saw you," Pastor said.

"Yeah, it's my new fashion statement," I replied, in a humorous tone. They both laughed and were surprised at my response. In fact, I surprised myself.

"How are you feeling?" Angie asked.

"I have a headache like you wouldn't believe."

"I bet. It sounds like the surgery went very well. Your surgeon came out to see us after the surgery. He said that the surgery couldn't have gone better. In fact, he said that you were

one of the best patients he has ever operated on. He had nothing but encouraging words to say." A sense of peace came over me as I realized that the many prayers prior to my surgery had made all the difference in how well the operation went. God had answered prayers.

Although I was in no position to carry on a long conversation, I took in much of what was said. Again I rejoiced in the light that surrounded my life. A spirit of newness filled the room. Pastor and Angie stayed their allotted two minutes, and then they left the room.

Once again, I fell asleep. Within minutes, Grandma and George arrived. They too had an expression of awe that I would have liked to have captured on video camera.

Steve was the only one of my family who didn't come in to see me. His experience with fainting in a hospital when he went to see Aunt Gladys seemed to alter his tolerance level for hospital smells and the presence of blood. The waiting room was about as much as he could handle. Seeing a brain surgery patient after surgery was out of the question.

Either minutes or hours later—I couldn't recall—I was awakened by a male nurse. My level of tiredness remained about the same as when I was awakened immediately after surgery. It was all I could do to open my eyes and focus on what was being said.

"Amy, how are you doing?. . . Can you wake up so I can ask you some questions?" He attempted to wake me several times. "Amy, you are doing great. You did very well during surgery, and the surgery went just as planned. There were no complications whatsoever. You were so good during surgery. All the people in the operating room were very impressed with how everything went. Some of the nurses said that they haven't seen anyone get through this surgery as well as you did. . . . Can you wake up for me?"

The content of his conversation caught my attention, and I tried to fight through the toxic sensation of the anesthesia. As I opened my eyes about halfway, I saw the gentleman nurse standing by my bedside. My eyes were swollen as I struggled to keep them open. A white lab jacket and the fancy embroidery with the clinic's name filled my view.

"Amy, can you tell me what room you're in?" the man asked. I thought for a second and replied, "Intensive care."

"No, that was the last room you were in. You were moved a little while ago. You are now in recovery."

"I didn't know I was moved," I replied.

"Oh, I'm sorry. You were first in intensive care, and now you're in recovery. That's okay. You are doing great." What seemed like seconds later, I was asked the same question. This time I got it right, which assured the nurse that I was thinking rationally.

Since I had progressed to the recovery room, I was allowed to have visitors again. Again, Mom and Dad came in to see me. I awoke to the greeting of the voice of a nurse. Their smiles and tears revealed their joy and thankfulness to be able to witness me alive and coherent.

"We couldn't stay long last time we saw you," Mom explained. "We were allowed to see you for only two minutes." I wanted to see them more too, but I also understood why there was a time limit for visitors.

"We're so proud of you. The surgeon said that everything went very well." Mom came to my

bedside and held my hand. I could read the total relief on her face. She held on to my hand like never before. She fought back the tears as she observed my condition.

"I love you . . ." she said. "Oh, I'm so happy for you. I knew you would be okay." She continued to hold my hand as she expressed her amazement over my health. She told me again that she loved me and she backed away to let my dad see me.

"Steve didn't come in to see you because he didn't think he could handle seeing all the wires and needles. He is going to be leaving soon, and he wanted me to let you know he wishes you a good recovery," Dad explained. I gently nodded my head acknowledging his message.

During Mom's and Dad's visit to see me in the intensive care unit, the news came over the television that O.J. Simpson was being chased down an interstate in a white Ford Bronco. That was the first I had heard of the case, and Dad filled me in on what had supposedly happened. What no one knew at the time was that O.J.'s trial had only begun, and mine was nearing the end. With a white bandage over my head and a thankful

heart for life, I couldn't understand why anybody would take another person's life. As many Americans were glued to their televisions and radios to hear the latest on the O.J. Simpson case, I lay in a hospital bed with an intravenous needle in my hand and anticipation of living a new life. *I want to really live.*

In a matter of moments, our precious time together had to end. The nurse explained that it wouldn't be until I was in the epilepsy monitoring unit that I would be able to have visitors for longer periods of time. Once again, a nurse came in to check on me. In the depth of my sleep, I felt a nudge and heard the sound of a male voice. He asked me my name and the other familiar questions as he recorded my vital signs.

The headache and the swelling of my cheeks persisted as I was carted to the epilepsy monitoring unit where I stayed until I was discharged from the clinic. The epilepsy monitoring unit was the unit I had stayed in one year prior to surgery during my twenty-four-hour EEG monitoring. Once again, I returned to the H floor where I was acquainted with many fine nurses.

A nurse rolled me from the portable bed to the bed in the room. With the IV remaining in my arm and hand, I was arranged in a reasonably comfortable position in my room.

"Amy, I know you are tired, but can you listen for just a few minutes?"

"Uh huh."

"Because of the heavy anesthesia in your system, you are not allowed to eat or drink anything at least until late tonight. However, because the anesthesia will make you thirsty, you are allowed to suck on an ice cube. You will most likely throw-up if you eat anything. The best thing for you to do now is to get some rest. We need to wait until more of the anesthesia is out of your system before you eat. If you are hungry tonight, you can have some soda crackers and ginger ale. You can let one of the nurses know tonight if you are hungry. In the meantime, you will remain connected to the intravenous tube for nourishment. You will be taken off the IV once you are able to keep food in your stomach. That may not be until Sunday. By tomorrow, I hope to have you going for short walks up and down the

hall. If you need to use the bathroom, just push the red button, and a nurse will assist you. Do you have any questions?"

"What do I look like?" I asked with sincerity.

"You have a white bandage on your head, and the right side of your face is swollen. You look normal for having just gone through brain surgery," she replied.

"Do you know where my mom and dad are?"

"Yes, they went back to the hotel to get something to eat. They said that they would be back to see you after they ate. They will be allowed to spend more time with you in here. I will be back in a few minutes with some Tylenol with codeine."

The nurses came in to check on me about every half hour to an hour. With every visit they took my vital signs and usually verified that I knew my name. My parents arrived in my room later that evening.

At 2:00 a.m. Saturday, I ate the soda crackers and ginger ale that the nurse had promised me. However, to be discreet, a cardboard bucket became a very practical item. The fluid from the intravenous tubes remained my only source of nourishment throughout the night.

Chapter 26
A New Light

"The people that walked in darkness have seen a great light: they that dwell in the land of the shadow of death, upon them hath the light shined."
Isaiah 9:9

Saturday, June 18, 1994

I awoke the next morning to the radiant sun. Only the window blinds separated me from the rays of light outside. *The sun rose again, and so will I.* As I lay in awe about having made it through the night without having a seizure, once again I rejoiced in the light that surrounded my life. An enormous headache remained as a quiet spirit within me hoped for continuous light without the presence of darkness and pain. Within a few minutes of my awakening, a nurse arrived.

"Good morning, Amy. How are you feeling?" she asked.

"All right. I have a major headache though," I replied.

"Here's some Tylenol with codeine. You should try to eat something for breakfast. It may not settle well with you because the anesthesia is still in your system, but just eat what you can. We will keep you hooked up to the IV for nourishment, but you should eat something," she explained. I didn't say anything unless I was asked a question. I felt exhausted, and my energy level was very low. The nurse checked the IV needle that was in the back of my hand. I looked toward the doorway and saw my parents walk in, holding one another's arm.

"How is she doing?" Mom asked the nurse.

"She's doing great. She made it through the night without having any seizures, which is encouraging." Dad and Mom

came closer to see me. With an expression of deep concern and yet amazement, they asked how I was doing. I was just as happy to see them as they were to see me.

"My head is pounding," I said in a soft voice.

"How did you sleep last night?" Mom asked, searching for words to say.

"All right. I slept most of the night. Nurses came to check on me quite a bit." Mom bent over to gently kiss me on the cheek. Her thoughts of joy and relief were transparent. The nurse continued telling my parents details about my status.

"She still needs to lay low and not have too much excitement. The swelling in her face is normal and that will go down more each day. The swelling is from the trauma of going through surgery. The procedure that Amy had causes internal and external swelling. The brain goes through trauma during surgery. The trauma can be worse than a head injury from an automobile accident. The brain needs time to heal. The swelling that you see is part of the healing process."

"Have you eaten yet?" Mom asked. I nodded my head no.

"Do you feel like eating?"

"I'll try."

The process of eating was a chore in itself. I lacked energy, and I wasn't quite sure if the cantaloupe and juice would stay down. Mom fed me small bites since I lacked energy, and I was able to open my mouth only a tiny bit. The entire right side of my head felt tight, and my mouth was difficult to open. The combination of the man-made material that was used to put my skull back in place and the swelling on my face created this condition. Within less than an hour after eating, I found myself over a bucket.

Starting at about 10:00 a.m., I was blessed with one delivery of flowers after another. A dozen pink roses from my Aunt Betty and Uncle Bob sat next to multiple flower arrangements from other family members and friends. Each time I saw a nurse deliver another bouquet of flowers, a slight smile came to my face. It got to the point that I needed another bouquet of flowers like I needed another hole in my head!

Later that day, I looked in the mirror to observe my newly-acquired appearance. My family had seen me, but I was the

only one who had not seen how my appearance had changed. During one of my times out of bed, I walked over to the mirror to take a look at myself. The look came as a surprise to me. I had a cotton bandage wrapped around the top of my head, which I could not feel. I looked like a wounded soldier out of combat or an Egyptian mummy having a bad day. I stood in awe as I stared at myself in the mirror, looking at the change in my appearance. I didn't look forward to going through the boy-stage in hairstyles.

Dad and Mom came to see me throughout the day, bringing me cards, more flowers, and giving me hugs and kisses for encouragement. One of the gifts they gave me was a stuffed monkey that was dressed as a nurse. Mom handed me the monkey and said, "When you're all alone, you will always have a nurse by your side." Dad and Mom smiled, and so did I. Laughing was not the best thing for me to do at that point.

Throughout the remainder of the day, I napped several times and kept food down for only a matter of minutes. A nurse came in about every hour to check my vital signs and to see if there was anything I needed. I wanted to tell a nurse that I was alive and that there was no need to check my vital signs, but I didn't. I knew they had reason to check my life signs every hour, and their actions were in my best interest. Plus, I wanted to stay on their good side for obvious reasons.

The next day was Fathers' Day. As I continued recovering from brain surgery, my dad lay on my hospital bed as he watched a stock car race on television and as I stretched out my legs in a nearby chair. I also gave him a Fathers' Day card I had prepared in advance. The unusual setting and events that were present that Fathers' Day will always be remembered.

June 21, 1994

Four days had passed since surgery, and I was now able to keep food down for more than twenty-four hours. My alertness and sense of humor remained untouched. A nurse read a list of all of my restrictions for my recovery period as I prepared to be discharged from the clinic. I was given a hat that had the

"Cleveland Clinic" inscription and a washcloth with ice to apply to my head for the ride home. Dad and Mom loaded the car with the flowers, leaving a space in the back seat for me.

On that first day of summer, I walked out of the clinic with a horseshoe-shaped scar on the side of my head and so much to be thankful for. Rays of light shone all around me as well as in my soul. Whether I was cured or simply healthier than before remained the only mystery. Despite not knowing the total results of the surgery, I rejoiced in the light while I was not experiencing the tunnel of darkness that I had known so well.

As Dad drove the three of us out of Cleveland, my head throbbed as we went over the potholes in the streets. I knew within a matter of minutes of being on the road that it was going to be a rough ride home. Every bump, great and small, made my head pound like a hammer. I asked Dad to avoid as many bumps as possible. Traveling had never been so hard on me as it was that day.

Around supper time, we stopped to eat at a fast-food restaurant. We decided to eat while traveling since I needed to get home to rest. I soon found out that the combination of high speed and food did not settle well with my mind and stomach. About three bites later, Dad pulled into the next exit so I could eat without the presence of motion. The anesthesia had not yet worn off, and I easily became nauseated.

The rest stop was my first time to walk into a public place looking like a soldier out of combat. As I walked toward the building with staples and a scar on the side of my head, Mom held my arm to support me. I sensed the looks from people in all directions. At that point, I wasn't wearing my hat. My scar was sensitive, and anything that touched it was irritating. The odd expressions on the faces of complete strangers did not come as a surprise. But their expressions made me aware of the many looks and questions that lay ahead.

As we pulled up to our dirt road, I felt a sense of happiness and comfort to be back at home. I was home where all of my childhood memories were formed and where I had spent a lifetime with the hope of one day becoming seizure-free. A "For Sale" sign stood in the yard as my parents wanted to sell the house before moving into the house they were building. Within

a matter of minutes of being home, the realtor showed up unexpectedly with some prospective buyers. I answered the door and explained that I was the woman whom he had met before. I explained why I looked the way I did, although the realtor had previously been informed of my situation. The couple, on the other hand, stood in awe as they observed the unique mark on my head. We talked for a few minutes as I updated the realtor on the events that took place in recent days. Just then, Mom entered the hallway.

Being as shocked as I was, Mom expressed that she was not informed that the house was going to be shown. The realtor explained that he had left a message at the emergency phone number that we gave him and that a family member was supposed to call us to inform us of their visit. Regardless of the unexpected visit and the suitcases that remained in the hall from our trip, the realtor took this couple through our house.

June 22, 1994

During the first full day back at home, I started to feel the same way I did the first twenty-four hours after surgery. I kept a wastepaper basket close to the sofa where I lay most of the day. I felt nauseated and threw-up everything I ate. Observing my condition, Mom expressed concern that I shouldn't have been discharged from the clinic as soon as I was. To limit my physical activity, Mom spoon-fed me miniature bits of fruit and other soft foods.

I continued taking Tylenol with codeine for my headache and took one or two naps per day. In the midst of my nauseous feelings, another bouquet of flowers were delivered at the house. The amount of flowers I received that week almost matched the amount of flowers I had received over the years from various male acquaintances. As roses, carnations, and various flowers filled the house, family and friends called to see how my recovery was going. A smile came over my face each time I heard Mom say, "No, she has not had any seizures since surgery." One time when the phone rang, it was my nurse from the Cleveland Clinic calling to check on me. The follow-up from the clinic was encouraging to all of us.

Despite the vomiting and pain from the incision, I gained the peace that this pain was only temporary and that it was the last major physical pain that I would have to face for long time. The discomfort that I was experiencing was the grand finale' to a life of emotional and physical affliction that I once thought would be with me my entire life. The old life full of anguish and instability seemed to be coming to a close. *The light remained; yes, the light remained.*

As I lay in pain on the living room sofa with my monkey nurse by my side, I was amazed at how well I made it through the surgery. All of my faculties were there, and yes, I knew who was the president of the United States. I knew my name, and all of my thoughts were rational. As I continued reflecting on the recent days, I thought about all of the fears I had prior to surgery and how none of them came true. I didn't spout off at the surgeon, and I didn't think I had gone for a walk in the park. Although a physical part of my brain had been removed, my mind was still there! Because of my physical condition at that time, I didn't smile outwardly very often. However, if God had taken a picture of my heart during those first few days at home, He would have photographed the biggest smile ever created. And He would have smiled back too.

The next day I was still nauseated, but my health was improving. Pastor Phil and his wife Sally came to the house after I woke up from a nap. I remained calm, but I enjoyed their conversation and appreciated their visit. I was still getting used to people looking at my dark peach fuzz on my head with a horseshoe-shaped scar on one side. I knew I looked drastically different, but that came with the territory.

The following day I went to a local doctor to get my staples removed. I anticipated experiencing pain when the staples were removed, but there was no option. I had thirty-one staples in my head that had to come out. The doctor who took them out was a little surprised at the nature of my situation. He mentioned that he had never removed staples on a patient who had brain surgery, but he assured me that it was not a problem for him. Surprisingly, I didn't experience any significant pain when the doctor removed the staples. Within a matter of a few minutes, I was staple-free and was on my way to garage sales

around town. My first long outing in public since surgery was enjoyable, but I sure did attract the attention of many people who had no idea what I had been through. I was sure that many people thought I had been in an automobile accident, while others may have thought I had a brain tumor. As I noticed people staring at me, I just smiled back and went around finding bargains. Only one person had enough nerve to ask me the reason for the scar. Nevertheless, Mom and I went from sale to sale that day in late June as I hoped the hot summer heat would not trigger an internal heat rush as it had so many times before.

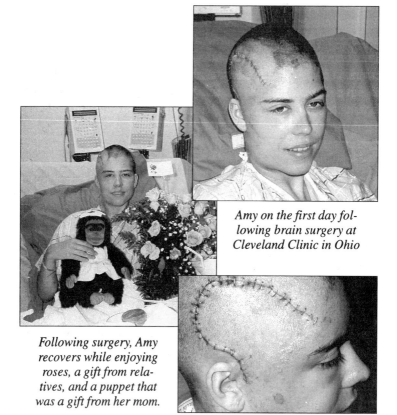

Amy on the first day following brain surgery at Cleveland Clinic in Ohio

Following surgery, Amy recovers while enjoying roses, a gift from relatives, and a puppet that was a gift from her mom.

For the first seven days after surgery, Amy had thirty-one staples at the horseshoe-shaped incision.

Chapter 27

Aftermath

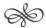

Prison Cell

Imagine yourself being locked in a cold prison cell for twenty years, though having not committed a crime. You are granted the privilege of walking in the courtyard and seeing people pass by on the other side of the gate, but you have yet to experience life in the typical world. As a prisoner, you spend most of your time behind bars, longing to know what lies beyond the courtyard. The prison cell and courtyard are the only surroundings that you have ever known.

In the midst of your sitting on a small stool in the prison cell, you remember why you are there. You were placed in this prison cell when you were an infant as a result of an uncontrollable circumstance that occurred. Although you did nothing to deserve this way of life, you are there because there is sin in the world. Because you have spent your entire life there, the prison cell has become home to you, inspite of how cold and inconvenient the place seems. The prison cell has become part of you and has influenced your thoughts. Having just a pillow and a cot to sleep on, you become very familiar with this environment. You awake each morning expecting to see steel bars only inches away from one another and a prison guard who walks by to say "good morning."

Then one day the steel bars are released, an event you thought would never occur. You enter the world that has always been known to those people who walk outside the courtyard. You are so excited at finally being allowed to experience life in the typical world, and yet you

are also afraid to experience life outside the prison cell—the only place of occupancy that you have ever known. As you pass by the local circus that seems so inviting to attend, you hesitate. You stand on the sidewalk realizing that you have never been to a circus, or experienced the thrill of riding on a roller coaster, or eaten cotton candy while sitting on a park bench. Memories of having extreme limitations in the prison cell rise to the surface your mind. *I have been isolated from life for so long,* you think to yourself. *This world is so unfamiliar to me. I wonder if I can go back to the prison cell.* But there is no going back behind steel bars. You were released from prison for the rest of your life. The place that you have always known as "home" is no longer your home. Now you must learn, for the first time in your life, how to adapt to typical life experiences and circumstances—away from the cold and inconvenient prison cell.

As you encounter new experiences each day, your personal thoughts seem to be beyond human understanding. You realize that you no longer live in the familiar prison cell that brought you a lot of emotional pain, but that you also have limited knowledge of the world that now surrounds you. A different type of emotional turmoil enters your life. You cry for hours each day, longing for another human being to understand the complexity of your emotions. Even when you attend the most common event, such as a social gathering, you want to be alone and cry. You must come to accept that you no longer live surrounded by cold steel bars. You don't want to die, but you are afraid to live.

Over the course of the following week, my headache slowly diminished, and I started to stay awake for longer periods of time. Ten days after surgery was the first time that I went without taking a nap during the day. Still with a scar showing on the right side of my head and hair as short as an army man, I went with Mom to a beauty salon to look at wigs. I figured there was no harm in trying to make myself look some-

what normal for a young woman. Of course, I fit right in with one of the nineties-hair-styles that could be found in Hollywood and even on the streets.

That evening, Mom and Dad went out to the new house to work as we waited with anticipation for the sale of our home. I went with them out to the site where the house was being built to see how the house had changed since I last saw it. Dad pounded hammers and nails, while Mom varnished the window frames. I sat on the unfinished deck looking over the wooded acres that surrounded the house. The only noises that were heard were the sounds of construction, the birds chirping, and cars on the highway.

As I sat observing the nature that was all around, an empty sensation came over me. It was not an aura or any sign of a seizure. I felt the peace within my heart disappear. Like a flash of lightning striking a living tree, my joy turned to sorrow as I started to cry. I had no idea what had caused the sudden change of emotions, and neither did I know what to do. I did not know if I should go and cry on Mom's shoulder, or cope with this unusual experience on my own. Emptiness filled my being as my inner peace dissolved. *Loss. . . . grief. . . . sorrow.* My heart filled with an anguish that was unfamiliar. Within a few moments of crying, my thoughts became clearer.

The thought occurred to me that a major part of my life was gone. Although epilepsy was something in my life that had brought inner struggles as well as unexpected incidents involving confusion, it had been much of my life. Epilepsy had helped form *me*. It had been a part of my life since before I could remember. My seizure disorder went with me wherever I went. It had shaped my thinking, my academic experience, and had influenced my decisions when faced with certain social pressures. For the first time in my life, I had reason to believe that my epilepsy no longer existed.

It was this tenth day after surgery that this thought occurred to me: *I was the same person, but I no longer had the continuous battle between light and darkness. . . . health and sickness . . . alertness and confusion.* I believed that I had acquired a new life separated from the anguish and humility of having seizures. Despite the strong desire that I had prior to surgery to be cured,

the reality of it all had not completely sunk in until that evening. My focus up until that point was having surgery along with the medical recovery from a serious operation. The emotional part that lay in the depths of my soul had been placed aside while I coped with the physical and more obvious aspects of the recovery process. The emotional pain that I had that evening was like that of losing a loved one. Like losing a parent or a sibling, a part of me was gone. Fighting for complete mental awareness through a single day had been part of my life ever since I could remember. I reflected on the reality of my life. *I'm finally home from battle. . . . My medical war is over. . . . What will I battle against now? . . . What is it like to not have to fight between darkness and light every single day? . . .Who am I?*

After reality settled in, I went to the car to find a napkin to wipe away the tears. I then returned to the porch to recollect my thoughts. After reflecting on the cause for my emotions, I determined that I did not want Mom and Dad to find out about my emotional instability. I wanted to cope with my feelings on my own just as I had most of my life. Anyway, I had received so much support from my family before and after surgery, and they were so happy about how well I had come through surgery that I did not want to burst anybody's bubble. The psychology involved was one that only I could understand since I was the one who had been through all of the experiences that amounted to this feeling of loss. To have a family member, or anyone for that matter, understand all of the emotions involved seemed impossible. I figured that if I tried to explain this to someone, they might respond by saying something like, *All your life you have wanted to be cured, and now you are feeling sorrowful after being blessed with a new life?* Just as I had felt several times in my youth, I again concluded that no one would completely understand.

As the sun started to set, Mom and I went back to our home. By that time, I had regained control of my emotions and appeared my normal self. I kept my thoughts to myself as I wondered if another episode was bound to occur.

After two weeks of recovery, Mom was supposed to go back to the office, but she was hesitant to leave me alone. I could see the tears in her eyes when she thought about leaving

me alone. She feared that I would go into a seizure when she was not there, and no one would be there to help me. After hours of contemplating going into work, she brought her work home and did her typing in the kitchen. After a trying yet rewarding two weeks of recovery, the radiant light remained.

July 4, 1994

On Independence Day, only sixteen days after surgery, I sat in Steve's yard under the starry sky watching the fireworks display. The colorful fireworks filled the sky as loud sounds echoed throughout Battle Creek. The *Battle Hymn of the Republic* was heard throughout the airport and the surrounding neighborhoods. As our nation celebrated the freedom that we were granted over two hundred years ago, I celebrated the beginning of a new life. The fact that I had gone over two weeks without a seizure was a clear indication that I could go six months or even a lifetime free from the bondage of seizures. The enormous red, white, and blue designs sparkled in the night sky as I sat in awe thinking about the traumatic and joyful events that had occurred in my life. The heartache that I experienced as a child and the events that occurred in my adult life had led me to a new life I had longed to obtain. Each explosion of fireworks in the dark night sky represented a trial that I believed would never return to my life again. One explosion was for the unexpected onset of seizures, one for the side effects of medication, one for the many hours I slept after having seizures, and still others for the emotional struggle I went through as a teenager not being able to drive.

As Americans honored the men who lost their lives in wars for our country, I reflected on the personal war in my life that had recently come to an end. The abrupt explosions of bombs hadn't been felt in over two weeks. For the first time in my life, there were no trembles in my veins or attacks from the enemy that could endanger my life. The inner tremblings and near death occurrences in the war were only memories. I had escaped the war—the war in *my* life. From war to peace, from darkness to light, I saw victory in my life as the flag rose over a land of peace and freedom.

That fourth of July, I personalized the term *freedom*. Freedom meant being seizure-free. . . . freedom from sudden exhaustion after the seizures . . . and freedom from frightening episodes that brought thoughts of death to the minds of my loved ones. *The battle was fought, blood and tears were shed, and only a scar and memories remained.*

July 6, 1994

Almost three weeks had passed since the renewal of my life. As I sat in the bathtub one evening, a sensation came over me like nothing I had experienced before. Like I had done many times in my life, I stopped what I was doing and waited for the sensation to pass or to develop into a seizure. I knew that this was no ordinary aura. The sensation in my head, mind, and body felt like someone was taking over my emotions and entire body. I thought my soul and spirit were being controlled by some other force. *What is happening to me? It can't be.* I had never had this type of unusual sensation or aura before. It was like no other.

The unique sensation eventually passed, leaving only questions and doubts of the success of the surgery. During the remainder of the evening, I experienced this sensation two other times. I dreaded the idea that one of these sensations might turn into a seizure. But because this particular sensation had a different nature to it than the ones I had prior to surgery, I had reason to believe it was not truly an aura. I wanted to believe that it was related to the healing taking place in my brain, and not an onset of seizure activity. But I knew that only time would tell as I hoped and prayed for continuous radiant light.

That same week, Ruth Roberts took me out to lunch to celebrate getting through the surgery all right. She too, had seen me grow up with epilepsy and was there over the years to hear Mom's concerns about my condition. Over Mexican food, I told her about my surgery and how I still had not had a seizure since surgery. After several questioning looks from the waitress, Ruth explained to the waitress what I had recently been through. She also expressed amazement regarding my situation.

After lunch, we walked through the mall for an afternoon of shopping. Ruth wanted to buy me something to show her moral support and happiness for the success of the surgery. Again, strangers passed by doing double takes at my scar and short hair. I smiled knowing that one day they could learn of my story through reading my book that I would one day write. No one made a point to ask me what had happened to me, but the looks I received said it all. Had anyone asked, there would have been too much to say and so little time to explain.

During my recovery period, a guest minister preached at my church. One Sunday evening I sat one row and about five seats away from a young boy who had a butch hair cut. Even though the appearances of our hair, or lack thereof, were similar, the reasons for our short hair were vastly different. In the middle of the sermon, the preacher paused, looked at me, pointed at the boy and asked, "Is that your son?" I smiled and said, "no." I then heard a few chuckles in the sanctuary from others who saw the humor in the preacher's unexpected comment. Though I wanted to explain to the preacher after the sermon the reason for my short hair, I didn't have the opportunity to do so. Had I told him about my recent surgery, I'm sure he would have been humbled for having drawn attention to my "unusual hairstyle." In the midst of recovering from a major operation, this preacher's innocent remark added a unique touch of embarrassment and humor to my circumstance.

The light shown continuously through recovery as I anticipated no more periods of darkness and mental isolation. Still, the aura-like-sensations I had experienced only days before continued to haunt my mind. Along with those unusual feelings, I also had experienced several different things that were in some way, associated with recovering from brain surgery. Among those unusual episodes were a ticking sound in my skull, a jittering feeling in my eyes, insomnia, depression, extreme highs in my emotions, and I was unable to open my mouth all the way due to the reconstruction of my skull.

I figured that the ticking sound in my skull was my skull healing. I could understand that one, but it was quite unusual. I

believed that my skull was settling in a very minor way and would eventually lie firmly positioned in place. I also speculated that my optic nerve may had been affected by the surgery and was creating the jittering in my eyes. Another one of my analogies was that because my brain was used to an occasional electrical discharge which was no longer happening, my brain may have substituted other processes in place of having a seizure. The unusual experiences I was having may have been the results of the physical changes that had occurred, and the healing that was continuing to take place my brain. This conclusion was not based on medical evidence, but was only intuition.

Along with the natural healing that was taking place, I was experiencing insomnia. I usually stayed awake until two, three, or four in the morning. Because I was recovering from a major surgery, getting enough sleep was very important. Nevertheless, I was getting four to five hours of sleep each night.

The most unusual episode I experienced during recovery was the feeling of a bug crawling on the side of my head. The first time this happened, I tried to shoe-away the "bug" with my hand, only to find out there was no bug there! The feeling was obviously internal and most likely in or near the skull plate that had been removed. I had just hoped it wasn't a live bug that I had acquired prior to my skull being put back in place! Later, this same sensation felt more like a trickle of water running down my skull. Although I was experiencing some things I had never experienced before, my attitude remained positive as I anticipated a life free from sudden darkness.

> *God will not look you over for medals, degrees or diplomas, but for scars.*
> — Elbert Hubbard

Chapter 28

Victory

"He hath delivered my soul in peace from the battle that was against me: for there were many with me."
Psalm 55:18

August 3 & 4, 1994

The sun set over Lake Erie as Dad, Mom, and I sat in a hotel room in Cleveland the night before my six-week checkup. On CNN, a news spokesperson said, "And next, the dangers of Felbatol, a new seizure medication." We all sat on the beds, eager to hear the next newscast. Within a few minutes, the broadcast resumed.

"Felbatol, a new seizure medication, has killed three people in the United States. Anyone who is currently on Felbatol should contact his doctor immediately. Felbatol is being "black boxed" which means that no patient can take Felbatol except in rare cases where a patient's condition is dependent on Felbatol and no other medication is effective in controlling one's seizures. Again, if you are on Felbatol, talk to your doctor immediately."

Dad, Mom, and I all shared the same response. We were in shock! I had been on Felbatol, a possibly fatal medication, for eight months. Fortunately, we were going to see my neurologist and brain surgeon the next day. Surely my doctor would switch my medication. The next day came soon enough. The doctor entered the examination room where Mom and I sat patiently waiting.

The neurologist had a smile on his face when he asked me what medication I was taking. Without hesitation, my neurologist

made out a schedule for me to switch to Mysoline, the seizure medication that gave me the best seizure control and fewest side effects prior to surgery. I was so fortunate that I had an appointment with the doctor when I did. Because so many seizure patients were on Felbatol, neurologists were receiving phone calls from several patients with the same concern. Many peoples' medications needed to be switched. Because I had an appointment with the doctor in the midst of the scare, I immediately received orders and a schedule from the doctor to change medications.

Aside from the situation with Felbatol, my six-week check-up brought more encouragement to my parents and me about the success of my surgery. Based on the doctor's evaluation of my condition, I was well on the road to a great recovery. My neurologist explained that although I had not had a seizure since surgery, he wanted me to remain on seizure medication for two years after surgery. He explained that there was still a slight possibility of my having a seizure and that it would be best if I remained on an anticonvulsant medication until my two-year checkup. At that point, if I remained seizure-free, he would then begin to taper off my medication.

After the appointment with my neurologist, I met with Dr. Comair who evaluated the healing of my incision. He assured me that my scar was healing as it should, and he was pleased with how I was recovering. As Mom sat next to me listening to Dr. Comair explain certain aspects of the surgery, I marveled at not only having made it through the surgery with my personality still intact but also at having gone six weeks without experiencing a seizure. Mom shared similar thoughts. After Dr. Comair finished his examination of me, Mom expressed her thankfulness for the procedure the surgeon had performed.

"You are a wonderful man," she expressed with tears in her eyes.

With his head hanging in humility, he replied, "Don't thank me." He looked and pointed up. "Thank Him." Mom and I nodded our heads in agreement.

"You're right," Mom replied. "Amy could not have gone through with this if it weren't for the power of God. But you deserve some credit as well for the work that you did. You're a

brain surgeon! Just look at all the lives you change. You have a God-given talent that you are using to help others live healthier lives. That's wonderful. I appreciate all the care that you have given Amy. This is a miracle."

"Yes," Dr. Comair replied in his Lebanon accent. "But really, God is the one who performs miracles. He is just using me as an instrument to do his work. It's Him," he reiterated as he pointed up.

At the conclusion of this meeting, Mom and I walked out of the office in awe over my surgeon's response to our expression of thankfulness. He too was a believer and had seen the power of God in the operating room on June 17, 1994, and on all the other days when he had performed brain surgery on individuals whose epilepsy could not be cured by medication. The power to heal came not from the surgeon, but from God.

A few weeks later I began student-teaching in the same small town as I went to college. As I faced a class of students each day, I held within my soul the fear of life itself. Although I had not experienced a seizure since my surgery, I still did not have the assurance that a seizure would not occur in the midst of the stressful circumstances of the classroom. My neurologist had mentioned that there was a slight possibility of my having a seizure through the recovery period.

One day as I lay on my bed preparing lessons for the next day, tears rolled down my cheeks. For several hours, I had no idea as to why I was crying. A few days later, I started to realize the reasoning for my being depressed. Emotional turmoil and pain had always been part of my life. I reflected on my past and the possibility of having been cured of my epilepsy. The disorder that I had always known had disappeared. To others, my receiving a renewed life appeared wonderful from the outside, and yet inwardly I struggled with the thought of living a life I had never known. The thoughts of taking my life surfaced into my mind as I realized how much I had missed over the years and the world of opportunities that lay ahead. Although I didn't want to die, I was afraid to live.

Several days passed and I continued experiencing hours of depression each day. After hours of crying, I often experienced the opposite: a complete feeling of happiness and sometimes uncontrollable laughing. My extreme range of emotions began to affect my security in my everyday life. During a few of my moments of depression, I experienced anxiety attacks. My breathing became rapid as my body trembled. As were my thoughts earlier in life, I again feared what the future held.

After weeks of enduring emotional anguish and trying to be strong through the crying spells that I did not completely understand, I called the Cleveland Clinic. My nurse explained that the cause of my depression could have been a chemical imbalance and/or my having gone through brain surgery and having to cope with a significant life change. In brief, all that my doctor could do for me was to prescribe an antidepressant. The thought of taking another pill brought more fear. Along with my wanting be to seizure-free, I wanted to be rid of the necessity of taking pills and the possibility of becoming dependent on medication.

Again I lay with my head buried into my pillow and wept from every corner of my heart. The darkness of my epilepsy had passed, my life had been permanently changed for the better, and yet I had a sense of brokenness within my soul. Only three months before that night, I was on the operating table having a damaged long-term memory bank removed from my brain. With an abundance of tears, reality again struck my mind. I still had one memory bank that held—and still holds today—my memories of being afflicted by seizures, being overdosed on medication, and the emotional turmoil I had encountered in my childhood and young adult years. Although I deeply rejoiced over the life that I had been granted, I realized that no brain surgeon could remove the memories of fearing to go through another day or the thought of death that accompanied a grand mal seizure. While hoping that having had surgery would result in my having a more prosperous and healthy life, I knew that only time and healing could give me the assurance that I would no longer face the fear of death as a result of having seizures. Living and experiencing the continuous light was the only way I could overcome the fear within me.

VICTORY

During the darkest hours of my life, I remembered the hope that I had as a child to *one day* obtain victory over my epilepsy. As emotional turmoil continued to tremble my soul, I grasped onto hope as I had in my childhood that I would overcome the trauma in my life. When my emotions were at their worse, it was that fervent hope and ultimately the power of God that sustained my life and gave me strength to carry on. Deep in my heart, I knew that God was leading me to a higher ground that I had yet to encounter.

As I closed my eyes one night after grieving many hours, I reflected on the victory that I obtained on the operating table only three months before that night. *One victory at a time, Amy. One victory at a time.*

The next day I stood in the kitchen after hours of emotional darkness, and the lady that I was renting from asked me if I was all right. I responded with a quiet "yeah," and then I went outside for a walk. I soon sought counseling at the college and was blessed with visits from Pastor Phil who provided me with emotional and spiritual strength. After a few talks with Pastor Phil and several counseling sessions at the college, I realized I had to live. I knew that I had lived with seizures and had gone through brain surgery for a reason. *I had to live.*

A few weeks later I sat at the piano trying to control my emotions. I was still unsure if my state of depression was only temporary or if I had acquired a whole new set of problems that would be with me the rest of my life. As I reflected on my recent thoughts and the uncertainty I had about my future, I started playing a hymn. Although I had not mastered piano playing, I knew the basic chords and had the ability to play some melodies. Soon I started to sing as my fingers played a melody. *Because He lives, I can face tomorrow. Because He lives, all fear is gone. Because I know, He holds the future. And life is worth the living, just because He lives. Because He lives, I can face tomorrow . . .*

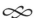

I never tried to take my life, but that thought was there. Through this experience I came to understand the seriousness of clinical depression and the importance of being humble when faced with unexplainable and reoccurring sadness. Through counseling I came to my senses that life is too precious to take into one's own hands. The people who helped me through this time of emotional turmoil unknowingly informed me that *life is worth the living.*

Because of my reoccurring depression, my doctor prescribed Prozac, which I took for the first year after surgery. This medication did significantly aid in stabilizing my emotional state, but so did the passing of time and the growing assurance that I could live life without the interruption of darkness. Only through time and with the power of God did I become emotionally stable and able to live an active and healthy life. As I began substitute teaching the following spring, I thanked God for each day of living. *Yes, I wanted to live. Each day was a gift from God.*

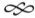

During this time, I remained on seizure medication. December marked my having gone six months without a seizure; as a result, I was eligible to apply for a driver's license. In March of 1995 at the age of twenty-four, I received my driver's license and purchased my first car. Upon acquiring a driver's license, I joyfully made full use of my driving privileges.

The summer after my surgery, I went on a trip to Wyoming as a supervisor for the teen youth group and helped with driving the van. Although I would have responsibilities such as leading a group of teenagers, I looked at this opportunity as a vacation away from my everyday life and as a way to enjoy seeing another part of the country. After my having been through brain surgery, having graduated from college, and having experienced some emotional struggles, the thought of taking a trip out West sounded exciting and refreshing.

During a five-day hike in Grand Teton National Park, I viewed the Rocky Mountains and many beautiful fields of wildflowers and evergreens. After having hiked five hours in one day, I was reassured that my surgery had been a success. I

realized that I had hiked through mountains and valleys in high temperatures without having a seizure. I also had excitement about the scheduled events without being overtaken by darkness. As I viewed the orange and yellow wildflowers in an open field, I remembered the days when I was on the ball field and the internal heat rush that engulfed my body and mind. The days on the ball field faded away as I viewed the beautiful wildflowers in the mountainous field. As I rested in peace in the green pastures of the Rocky Mountains, the sunlight shone over the mountains and the valleys as I looked forward to another day of hiking and filtering water from the streams.

One evening after hiking several hours with the teens, I sat alone while looking across the horizon over Terquise Lake. The mountains appeared to go on for infinity. Resting on a massive three-tone gray rock, I reflected on the valleys and mountains that once existed in my life. The enormous mountains reminded me of the part of my life that was put behind me only one year before. Still amazed at having received the victory over my epilepsy, I recalled my desire to climb the mountain that had always been a part of my life. Ever since age eight, I had longed to reach the other side of the mountain and abandon the valley of darkness and confusion that abruptly appeared in my life. For fourteen years, I tried to climb the mountain, only to find discouragement and to fall again and again. As I rested on the mountain rock, I marveled over having walked a path that led me to a life of good health and continuous light I had not previously known. After more than twenty years of traveling and enduring affliction, I had reached my destination. The *one day* came on which I completed my personal journey.

I continued reflecting upon how I had been seizure-free for slightly over a year and how the Lord carried me through the toughest times in my life. As I looked over the enormous Rocky Mountains, it occurred to me that the One who created the mountains, waterfalls, and the beautiful wildflowers is the same One who picked me up when I was weak. The solution to the medical battles I had experienced had probably seemed so simple to God. And the psychological turmoil that I had experienced as a child was God's way of preparing me for the major life transformation that brought both sorrow and joy. His plan

made perfect sense. My life revealed that "darkness can sometimes diminish the light and occupy the human mind, but the light can ultimately shatter the darkness and transform a person's brokenness into zeal for life." This truth I learned through firsthand experience.

Although memories of my darkest days still remained, I rejoiced in the light, knowing that the mountain had been climbed and conquered. *I rejoiced in the light knowing that my medical battles were only memories. As the sun set over the mountains, I had faith and assurance that the sun would rise again come morning, and it would continue shining throughout the day and each day to come. To this day, the light remains—yes, the light remains.*

And God shall wipe away all tears from their eyes;
and there shall be no more death, neither sorrow,
nor crying, neither shall there be any more pain:
for the former things are passed away.
 Revelation 21:4

Rejoice in the Light
(Written during the compiling of my book
in *memory* of my right hippocampus!)

Rejoice in the light that shines day and night,
Oh, "Silent Night," Oh, "Silent Night."
From lightness to darkness to shadows of death,
The old passes away with each new breath.

Though memories of darkness seems as if it were
 yesterday,
New rays of light are with me to stay.
Yes, one could say the war is gone forever,
But some memories remain that can't be severed.

Yet, rays shine brightly, even at night,
A heart filled with peace without the strife.
This quiet spirit is not what it seems,
Thankfulness for life creates such subtle beams.

Each day I live—no darkness appears,
Inner storms and tremors are no longer my fears.
Only the memories bring sorrow and pain,
But today I live the victory—my childhood dream
 obtained.

During moments of my childhood when I faced discouragements and darkness surrounded, Mom would often say to me "Count your blessings, Amy. You have a lot to be thankful for." As a child, I didn't completely understand the significance of this statement. Now, however, I can identify with what it means to count my blessings.

In honor of one of my mom's favorite sayings, I started writing this poem soon after my two-year follow-up appointment when I heard for the first time that I was cured of my epilepsy. I completed this personal poem during the compiling of my book and gave a copy of this poem to my mom on Mother's Day in 1999.

Count Your Blessings

Supporting the head of her new baby girl,
She lay her down and said a prayer.
"Lord, keep her and bless her with many more days,
May she grow healthy and never astray."
The little one grew and a dark cloud appeared.
The blue eyes unaware of the episodes Mom feared.
"Lord, I don't understand—how this can be,
She is so precious—and part of me."
Weeks became months and months became years,
As morning smiles lessened Mama's fears.
A new bike to ride, from Mom and Dad,
The surprise on her face—she was so glad.
It wasn't long and smiles became tears,
The first big fall, and Mama was near.
A wet cloth and bandage lessened the pain,
Her knee was scraped, her jeans had a stain.
Once refreshed and ready to play,
Hugs were exchanged, and the fall was explained.
"But it hurt so bad, I thought I was dead!"
"Count your blessings, Honey; it wasn't your head."
The day came to ride the bus,
A bug from Ma and just a little fuss.
Time went by and she was not that old,
Questions developed, and the story was told.
"You had a high fever and convulsed so intense,

You've had spells and taken medicine ever since.
But count your blessings, you're a bright girl,
I love you, Honey—you and your curls."
The words sounded uplifting and sincere from the heart,
Which gave her encouragement to make a new start.
The years wore on—it was graduation day,
The family came to celebrate that warm May.
Still week after week the darkness reappeared,
Now a young woman—"Will I ever be cured?"
The news then came to pursue a new life,
One unknown—away from the strife.
Joy and excitement, with fear mixed in,
She wanted victory; yes, she wanted to win.
"Count your blessings," was Mom's reply.
"You have a life. . . . What if you die?"
"But I can't pass it up—my life will be new,
I'm one of the chosen—just one of the few."
The awakening came, and there were smiles of joy,
With laughter and no hair—she looked like a boy.
Mom reached for her hand—oh how she cared,
The victory won, not many have dared.
We reflected upon the days of my youth,
We had shed many tears, and lost more than a tooth.
As I held Mom's hand and witnessed a tear,
I whispered, "My head is in pain, but count your
 blessings. I'm alive. . . . I'm well. . . . I'm here."

from September 1996 to May 1999

SUMMARY OF PERSONAL DIFFICULTIES RESULTING FROM EPILEPSY

- Memory loss
- Total exhaustion as a result of having several seizures in one day
- Falling asleep in class due to being overmedicated
- Disorganized thoughts as a result of the side effects of seizure medications
- Fear of death
- Insomnia
- Depression
- Anxiety attacks

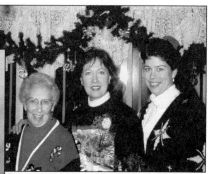

Grandma Belcher, Brenda, and Amy during the Christmas of 1998.

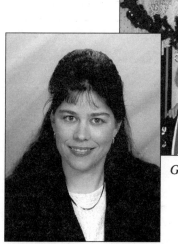

Amy is pictured here, five years after her surgery, at which time she was pursuing her Masters in Special Education.

Afterword

My hope is that you have learned much from reading my story and that you now have a clearer understanding of the many aspects related to epilepsy. The success of my book depends in part on other peoples' desires to gain more knowledge of epilepsy and the willingness to learn of a unique experience. From the depths of my heart, I thank you for your support and for taking the time to read my story.

Since surgery, I have had no seizures and have experienced a life that is full of good health and new experiences. Fifteen months after my surgery, I stopped taking antidepressant medication and remained emotionally stable thereafter. At my two year checkup, an EEG showed that there was no seizure activity in my brain. For the first time in my life, I heard from a neurologist that I was cured of my epilepsy. At that point, I was tapered off of all seizure medication. Since then, I have had only a few episodes in which an unusual sensation has come over me. These sensations were similar to an aura, but they did not develop beyond sensations. I personally refer to these sensations as my "epileptic ghost." These occasional sensations occur no more than once a year and are a gentle reminder of the affliction that was put behind me on the operating table on June 17, 1994.

Until the publication of this book, my entire personal story was known only to God and me. Through writing the chapters that brought memories of grief and pain, I gained a stronger desire to tell my story, knowing that *one day* people from all walks of life could read about my personal experience with epilepsy, and that other peoples' lives could be changed as a result of reading about the challenges and victories that God brought me through.

I write these final words for every boy and girl whose life is afflicted by the darkness and mystery of epilepsy. My revealment of the heartache that I experienced as a child and as an adolescent is for the sake of every child today who has emotional struggles as a result of having seizures—those episodes that sometimes bring thoughts of death. It is my blessed hope that I have shed some light to parents, teachers, and medical personnel about the emotional affect that epilepsy can have upon a child.

For those of you who connect personal experiences with some of the events in my story, I hope my writing has been an encouragement to you. When you find your life being taken over by the uncontrollable force of seizures, or you fear to go through another day, pick yourself up and look at the light that shines in your life. The darkness of your epilepsy does not need to be your main focus. No matter the severity of your seizure disorder, your outlook and perception of your disorder greatly influence your quality of life and how successful you will be in other areas of life. To every reader, healthy or afflicted, young and old, patients and doctors, college students and parents; rejoice in the light that surrounds your life.

<div style="text-align: right;">Amy Crane</div>

P.S. For the convenience of the reader, additional information and research on epilepsy is provided in the Appendices.

About the Author

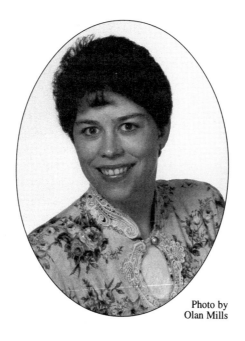

Photo by
Olan Mills

Amy Crane holds a Bachelor of Arts in Elementary Education and a Masters in Special Education. Amy resides in Greenville, South Carolina where she teaches students who have special needs.

*In the midst of minor difficulties, I say to myself,
"This isn't brain surgery."*

Appendices

APPENDIX 1
PERSONAL NOTES AND SUMMARIES

Personal Advice on Coping with Epilepsy

General

- Educate yourself about epilepsy. Understanding the disorder will help you to cope better with all the varied aspects related to seizures.

- Find a neurologist you are comfortable with and do not be afraid to ask questions. Get a second medical opinion before receiving long-term care from any one doctor.

Diet and Nutrition

- Diet and nutrition play an important role in seizure control. Eating too many sweets can cause seizures, especially if a seizure patient eats a sweet item right before a meal or in place of a meal. Eating a regular meal is a basic step in seizure prevention. In addition, a seizure patient should eat as soon as possible after he becomes hungry. Going an extended amount of time on an empty stomach increases the likelihood of having a seizure.

- Artificial sweeteners can trigger seizures. Check the labels of food items, especially low-fat items to see if there is an artificial sweetener added. It's best to avoid all foods that contain any artificial sweetener.

- Taking a magnesium supplement can decrease the likelihood of having a seizure, especially during times of high physical activity. A supplement that contains calcium, magnesium, and zinc is highly recommended. Name brands may be more effective since they do not contain fillers.

- Overeating might cause an epileptic to have a seizure.

- A seizure patient should not consume any alcoholic beverages. In some cases, even foods that are cooked with alcohol can trigger a seizure; as a result, one should avoid consuming large amounts of foods that contain extracts.

- Cough drops and any cold medicine that contains alcohol can trigger a seizure.

- Establish a schedule for taking your seizure medication and stick to it. Allowing a one hour time frame of when a given dose of medication should be taken is a good rule to follow. For example, you may decide to always take your seizure medication between 7:00 a.m. and 8:00 a.m., and then again between 3:00 p.m. and 4:00 p.m. For some patients, taking their medication at a specific hour may be more crucial. Being consistent in taking your seizure medication on a regular basis will decrease seizure frequency.
- Go by your instinct. If a certain level of medication sounds too high, or if you have reason to believe that a certain food is triggering seizures, express your concerns to your doctor and make the necessary adjustments.
- Women with epilepsy who have an increase of seizures while on their menstrual cycle should talk to their neurologist about increasing their dosage of medication during their period.
- Start a journal in order to record the times of your seizures, their intensity, and how long they last. Also, record what you eat and see if there is a cause-and-effect relationship between what you eat and the timing of your seizures. For example, if you always have a seizure within an hour of eating a donut, chances are that eating a donut triggers seizures. A lack of nutritional foods eaten at a given meal can also trigger seizures. Let me emphasize again—watch for cause-and-effect relationships!

Lifestyle
- Get plenty of sleep each night. Staying up late or not getting enough sleep can increase seizure activity and can also intensify seizures.
- Live an active life as much as possible. Know your limitations, but make the most of every opportunity. Do not allow your seizure disorder to place unnecessary limitations on your learning experiences and leisure activities.
- Seizure patients should take extra precautions to prevent seizures when they plan on being more physically active. Adequate rest and nourishment prior to sporting activities

or highly strenuous activities can help to prevent seizures. Frequent rest times are also encouraged during activities that require lots of physical work. (i.e. basketball, baseball, jogging, or strenuous yard work)
- For better seizure control, a seizure patient must have a balance in his life. There needs to be a balance of sleep, physical activities, social activities, and quiet time. Too much excitement, continuous laughing, or stress can trigger a seizure.

Education

- Many children with epilepsy are very capable of learning just like anyone else. Some children with epileptic seizures can have his or her needs met in the regular classroom. However, the use of additional resources is encouraged in cases where the patient shows a clear deficiency in one or more academic areas.
- Use the intellectual ability you were given to its full potential. Do not underestimate your learning abilities or use your seizure disorder as an excuse for not attempting to learn something new.

Social

Parents:

- For the most part, treat your child who has epilepsy just like a normal child in the areas of discipline, academic opportunities, and your personal interaction with that child. Take precautions when needed, but allow your child to participate in sports and other activities that will further his or her physical and intellectual abilities.

To those who know someone with epilepsy:

- A person's seizure can easily intensify when he is touched or communicated to by another person. In most circumstances, a person who is observing someone in a seizure should avoid physical contact and verbal communication with the person who is having a seizure. Protect the seizure patient from danger but let the seizure run its course.

- Those who are close to a person with epilepsy should be understanding of the epileptic's needs after a seizure by allowing him to sleep or to get a beverage with caffeine during those times when sleeping is not an option.
- Though it is often not necessary to call an ambulance for a seizure patient, please be advised that if a seizure lasts for more than ten minutes, an ambulance should be called. In some cases, it may be necessary to call an ambulance before the ten-minute mark.
- About fifty percent of the emotional turmoil that an epileptic goes through can be eliminated if his family, friends, teachers, and coworkers take the time to understand epilepsy and learn how to react appropriately to the incidences that relate to a person's seizures.
- Treat each epileptic individually. When you meet a person who has epilepsy, you should reflect on what you know about epilepsy, but do not assume that you should react the same way to every persons' seizures. The level of assistance needed during and after a seizure varies from patient to patient.

To the patient:

- Find the right moment to inform other people about your seizure disorder. Let your teachers, friends, and coworkers know what they should and should not do in the case that you have a seizure around them. They will appreciate your telling them, and they will be more likely to react appropriately if they know about your seizures before they see you experiencing one.
- Although no one besides yourself will truly know and understand everything you go through, find a trustworthy friend who will listen to your burdens. Allowing a friend to have a vagueunderstanding of your situation is better than having a friend not understanding at all.

Emotional

Parents:

- My advice to parents is to communicate clearly to their child who has epilepsy the truth about epilepsy and to provide words of comfort that will lessen their child's embedded fears and anxieties. Although you should not assume that your child will experience every traumatic event that I experienced, you should counsel him about his thoughts regarding his seizures and explain the reality of his condition in such a way that he will have a certain amount of ease about his epilepsy. As with any area of life, by gaining truth, one can begin to accept reality and deal appropriately with the circumstances.

To the patient:

- The degree of affliction depends partially on your attitude toward your condition. There are two conflicting perspectives you can take: 1) the view that your life is completely consumed by seizures and the side effects of medication and that living a normal life seems next to impossible, or 2) you have the inner hope and determination that pierces through each heartache and every moment of affliction. No matter if you become cured through brain surgery or not, you make full use of your talents and abilities. You live each day to the fullest!

Environmental Factors

Seizures are sometimes triggered by factors in the environment. These include, but are not limited to, the following:

- flashing lights
- high-pitched voices
- becoming overheated as a result of high external temperatures or physical exhaustion
- stressful circumstances

FACTORS ASSOCIATED WITH EPILEPSY

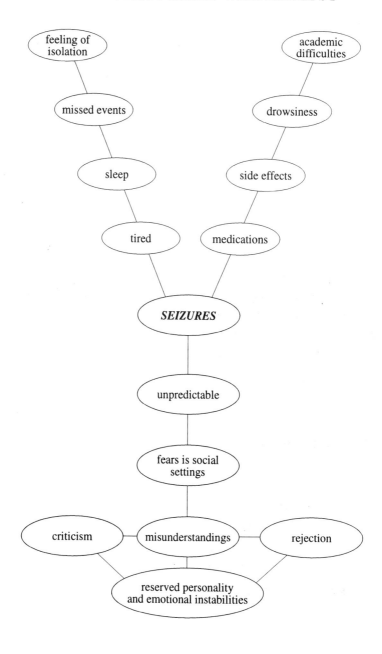

A Further Explanation of Postoperative Depression

In a similar manner that I came to accept my epilepsy when I began college, after surgery I needed to accept my life as one *without* epilepsy. In both cases, I needed to accept the pure reality of the status of my health. During my recovery, the trauma of my past seemed so recent and vivid in my mind while life without seizures was still new and unfamiliar. At this milestone in my life, I needed to begin healing emotionally from the traumatic episodes of my past. After coming to acceptance about being seizure-free, I could then live a more prosperous life.

My acceptance of my life after surgery came through encountering many months of continuous light and living without the onset of darkness. As with any person who has never experienced a particular circumstance or way of life, the only way that I could learn a different way of life was through experiences. As I experienced life without the onset of darkness, I gradually adjusted to my new life.

During the compilation of this book, I read about other patients' experiences of recovering from epilepsy brain surgery and found that postoperative depression is very common in patients who undergo this surgery. As previously mentioned, one probable cause of depression in post-operative epilepsy brain surgery patients is that the patient must adapt to living without seizures. Having a "normal" life is initially unfamiliar to a patient who had epilepsy in his childhood and never knew life without it. A second probable cause for postoperative depression is that there might be a chemical change that occurs naturally in the patient's brain and/or body as a result of having brain surgery. A chemical change could result in depression.

There is a third possible cause of postoperative depression that will require medical research to prove, and if valid, can be

considered a possible cause only in those patients whose scar tissue was located in the hippocampus. This possible cause relates to the removal of the amygdala, which is attached to the hippocampus and is thought to process emotions. As in my case, my right hippocampus and amygdala were removed. Although both areas were damaged, I speculate that prior to my surgery, my right amygdala had some role in controlling my emotions. If this analogy is a fact, then it can be concluded that after surgery the control system for my emotions became weaker than it was prior to surgery. As a result of my not having one of my amygdalas, I experienced highs and lows in my emotions. Likewise, other patients who undergo temporal lobe epilepsy brain surgery and have their hippocampus and amygdala removed might be at a high risk of experiencing postoperative depression. With this presupposition, it may take months for the opposite amygdala to adapt to being the only area of the brain that controls emotions.

The previously discussed causes are great possibilities, and each one of these potential causes should be considered for each person's situation. In any case, however, there might be more than one attributing factor to the onset of postoperative depression. Nevertheless, there are psychological and/or physiological reasons for recovering epileptic brain surgery patients experiencing clinical depression. And in case there is any doubt in the reader's mind, postoperative depression *is* real. Postoperative depression is not an act on the part of the patient to get attention. A patient who goes through postoperative depression, no matter the cause, must receive professional counseling. The symptoms must be taken seriously. These patients often encounter emotions that the typical person cannot identify with and experience a type of grief that extends far beyond having a stereotypical bad day. Often the patient's deep state of depression leads to thoughts of suicide.

One aspect of this type of depression involves unexplainable emotional anguish. More specifically, the sudden onset of depression creates a form of anxiety and fear about one's mental stability and future. The moments when the patient is in a complete state of mourning, life seems totally unbearable. In

addition, the instability that occurs along with postoperative depression can lead the patient to reflect on the instabilities that he encountered as a result of having seizures, and consequently, can lead him to an even deeper state of depression.

Although I believe that the previously mentioned probable causes are valid and should be further researched, I think that the *primary* cause of this severe state of depression is the patient's emotional response to his realizing that he must move onward beyond a life with seizures and emotional instability. Acceptance of the fact that certain trials and tribulations will no longer occur requires the patient to make a mental adjustment to a new life. In order for a patient to adjust, he must first grieve over the loss of his disorder that—nevertheless—was part of him. A person who grew up with a disability has never known life *without* affliction. The same individual who is cured of his affliction after years of living with it must learn what life is like without that affliction. That, my friend, is the reality of a person's psychology who once had a disability that affected his daily life and who becomes cured later on. After thinking that life is nothing but severe affliction, he must adapt to a life of good health and peace.

Lifelong Lessons I have Learned from Coping with Epilepsy

James Fitz-James Stephen once said, "Originality does not consist in saying what no one has ever said before, but in saying exactly what you think yourself."

In the valleys and on the mountaintop, in sickness and in health, apply what I have learned from having lived through affliction, darkness, and light.

Medical

- Outward appearance does not always reveal an inward disability.
- With courage and determination, one can usually complete what he has set out to accomplish, even when experiencing some limitations in his physical or mental health.
- Medical knowledge that is acquired from human experience should always be acknowledged, even if that same knowledge has not been demonstrated in the lives of mice.
- The term *affliction* is not just a word defined in the dictionary. *Affliction* is defined in every area of life of the afflicted.
- A child's discovery can become a proven medical fact in a future generation.

Emotional

- Blame and guilt should not result from an uncontrollable circumstance.
- A known external problem can trigger unknown internal problems.
- Silence is often the response to the loud voices of pain that occupy one's heart.
- Hope is like a continuous lit candle in a darkened room; while darkness surrounds the occupant day after day and year after year, the light holds his attention and encourages him during times of brokenness.

- One's enthusiastic spirit can turn to a sorrowful spirit as a result of sudden turmoil.
- Half of one's emotional pain can be healed by another person's halfway understanding.
- Within one tear lies multiple emotions.
- One man's laughter is another man's sorrow.
- Words can heal the heart or pierce the heart.
- Modern medicine can cure a person's physical aliments in minutes, but emotional healing takes years.
- One of the most amazing and important healings that can occur in one's life is the subtle healing that occurs over many years.
- If fear doesn't *break* the human spirit, fear will *form* the human spirit.
- Words of criticism toward a man's disability linger in his heart, but sincere words of inquiry comfort his fearful heart.
- There are times in one's life when the only light that shines is the light of hope within his heart.
- Any major surgery, directly or indirectly, is heart surgery.
- *Victory* means having put in the past the traumatic occurrences and the resulting pain in one's life and allowing peace to fill the heart.
- There are three types of afflicted people:
 1. There are *Surrenderers*: those who give up fighting their affliction and let their affliction control their lives.
 2. There are *Accepters*: those who realize that their affliction will be with them their entire life, so they cope appropriately with their illness and live as active a life as possible.
 3. And then there are *Fighters*: those who are determined to overcome their affliction.
- There are two types of risk takers in this world:
 1. *Impulsive Risk Takers*: those people who act foolishly without considering the consequences of their actions.

2. *Informed Risk Takers:* those people who become educated about a matter and understand all the known pros and cons of that event before agreeing to follow through with a life-changing endeavor.

- You might view certain individuals as "different." But give that so-called "different" person a "normal" life that he has never experienced, and he will be able to say that his life is "different."
- After the victory of a long lasting war comes an overwhelming emotion. In the retired soldier's heart is a voice that says, "The war is over. I can now rest in peace." As the soothing comes, the soldier sighs, "So this is peace. . . . This is peace."
- Smiles that occur during one's quiet times are smiles from the heart.

Lifestyle

- When opportunities are limited, utilize your limited opportunities.
- The *extent* of one's affliction is often determined by one's *intent* to succeed and overcome.
- One must have a balance in life between work and leisure.
- Diet and nutrition greatly affect a person's mental and physical health.

Education

- A child's level of academic achievement is the result of multiple factors.
- Receiving a perfect score in classwork should not be one's ultimate goal, but any achievements should be commended.
- Living with an affliction is an education in itself.
- Only through experiences does one truly obtain knowledge and understanding.

Philosophy

- People are like days: each one is so precious and uniquely different.
- Before a man reaches the mountaintop, he must first walk through the darkest part of the valley.
- A once in a lifetime experience can impact the course of events of the days that follow.
- Some people see valleys from afar, while others go through the valleys and *wish* they were afar.
- When you focus entirely on a problem, a larger problem becomes your focus.
- The one who walks a wooded path that is full of rocks and gullies looks down toward that which might cause him to fall, rather than looking up at the sunrise that could guide him through the wooded path.
- The more intense the war, the stronger the soldier must be.
- May the unafflicted appreciate the value of life before the moment of affliction arises.
- God creates a human in a moment's time, but He creates the inner man through the sorrowful and joyful experiences over many years.
- Any component of any system is taken for granted until that component temporarily or permanently malfunctions.
- People are often afraid of what they do not understand.
- Women CAN be doctors!
- Some mountains take years to climb; other mountains take only days and good physical and emotional strength to conquer.
- Never underestimate the potential of a person with a disability. You might be looking at a future author or speaker—a soul that will one day possess words of inspiration that will touch the discouraged at heart.
- God has ordained all reality. Through faith and trust in God, one comes to accept reality.

- One views life as having deeper significance after the occurrence of a devastating storm.
- The mystery of one's life can one day become a miracle and a ministry.
- The extent of a person's success is not based entirely on the *quantity* of brain cells he possesses. The extent of a person's success is in part the result of his *utilizing* the brain cells he possesses.
- One doesn't see beauty while walking through dark valleys; however, when he reaches the mountaintop, then beauty radiates in the path between the valley and the mountain.
- Some say, "Life isn't fair." I agree. Life isn't fair—Life is great!
- Obtaining peace in the heart is the first piece of a prosperous life.
- A circumstance that seems permanent can be changed permanently by a miracle.
- Memories of the darkest night still remain in the brightest light.
- Any person who obtains victory over a heartbreaking circumstance should become an author!
- Look not just at where a person is in life, but where he has been.
- Rise with the sun and utilize the light. When darkness surrounds—rest—and know that the sun will rise again.

Future Epilepsy Research: A Personal Proposal

During my lifetime, research on epilepsy has advanced significantly. In my childhood, the side effects of Phenobarbital were not yet realized while brain surgery for epilepsy was in its primitive stages of development. Along with there now being a possible cure for some people with epilepsy, studies have been done that support that certain vitamins and minerals play a significant role in seizure control. Some include vitamin B_6, manganese, and magnesium. And yes, medical tests have been conducted on rats that prove that artificial sweeteners can trigger seizures! There are several other advances in epilepsy research of which I and many others are very grateful. Due to experiences and the in-depth studies that have been done on the possible causes and triggers of seizures, we are now at a new plateau in understanding the complexity of epilepsy—a disorder that was once considered a mystery.

Although great medical breakthroughs have been made in recent years in helping people with epilepsy to live more productive lives, there is still much to be learned about the triggers of seizures and how to prevent these unpleasant experiences from occurring. There is one area of epilepsy research that I believe needs to be researched in order for the medical field to reach another level of understanding. From closely evaluating the possible triggers of my seizures and thoroughly studying the functions of the brain during the writing of my book, I have come to believe that there is one specific environmental factor that played a significant role in the trigger of some of my seizures. I am convinced that the one component of sensory stimulation that triggered some of my seizures is the component of scents. Why would an epileptic patient have a seizure as a result of smelling a certain scent? The research that I have done on the functions of the parts of the brain shows that in addition to the hippocampus playing a role in memory, it is also the area of the brain that processes scents. Dr. Joel Reitter, M.D., from the University of California at San Francisco,

states in his book <u>Epilepsy: A New Approach</u> that seizures can be triggered by sensory stimulation as well as be *prevented* by a certain scent. "Dr. Efron reported that his patient had discovered that she could arrest a developing seizure by inhaling the unpleasantly strong odor [jasmine] at an early stage in her aura" (p. 193). Reiter also explains that the uncus, part of the hippocampus, is where odors are processed.

I believe that Reiter's research on smells being linked to the hippocampus has obtained valid results. Although my seizures were never prevented by inhaling certain scents, I did experience seizures as a result of smelling certain scents. In my case, seizure activity began after I smelled scents such as foods, various colognes and perfumes, and scents in grocery stores and gift stores. The scents that triggered some of my seizures were usually scents that I liked; however, I came to dislike some scents only because of how they affected my life. When I smelled certain perfumes or other scents, I would feel seizure activity begin within a matter of seconds. About fifty percent of the time that I smelled certain scents, my aura would turn into a seizure. My conclusion is that if the hippocampus is a receptor of smells—which it is—then it is possible that various smells could trigger seizures in patients who have scar tissue in the hippocampus.

Considering this medical evidence and my personal experience, I want to propose to the field of neurology and neuropsychology the topic of "smell sensitive seizures" as an area of study as a potential trigger of some seizures in some patients. The research that I have found on the hippocampus of the brain supports the idea that the hippocampus is affected by scents, and therefore, certain scents could *prevent* or *trigger* seizures in patients whose seizure disorder is located in the hippocampus, although I have not yet encountered any literature that directly states this hypothesis. The specific scents that trigger seizures might vary from patient to patient and should be evaluated on an individual basis. As we begin a new century, I hope that any future research that supports the existence of "smell sensitive seizures" will be advantageous to patients with epilepsy as well as to neurologists who seek to provide their patients with the best seizure control possible.

I commend all of those who have worked in epilepsy research and have had a part in making brain surgery possible for me and many other people with epilepsy. I have reaped the benefits of the advanced technology in the field of neurology, and I hope that other patients will reap the benefits of my personal story and research.

In closing, I want you to keep in mind that the knowledge that we have now on the causes and treatments of epilepsy will *one day* seem ancient. The mysteries that exist today about the triggers of seizures will *one day* be revealed. But in order to make another significant breakthrough in helping individuals with epilepsy to live healthier lives, there must be scientists and medical doctors who are willing to conduct studies on the effect of scents on epileptic people and mice. Yes, mice do have their place in this life, but as I said in my listing of lifelong lessons, "Medical knowledge that is acquired from human experience should always be acknowledged, even if that same knowledge has not been demonstrated in the life of mice."

People in History with Epilepsy

There are several people in history who had epilepsy. Although these people were affected by seizures, they made significant contributions to this life. Julius Caesar was one person in history who had epilepsy. He said, "I came, I saw, I conquered," (*Feedback*, Winter 1992). Here are some other famous people who, despite their affliction of epilepsy, achieved great accomplishments.

Lord Byron (writer)
Napoleon (statesman)
Charles Dickens (writer)
Michelangelo (sculptor)
Vincent van Gogh (artist)
Leonardo da Vinci (artist)
James Madison (statesman)
Lewis Carroll (storyteller and mathematician)
Alfred Nobel (founder of the Nobel prize awards)
Harriet Tubman (ran Underground Railroad)
Edward Lear (English painter and poet)
Isaac Newton (discovered gravity)
Alexander the Great (statesman)
Peter the Great (statesman)
George Handel (composer)
Edgar Allan Poe (author)
Socrates (philosopher)
Aristotle (philosopher)

Appendix C

Appendix 2
Surgery and Treatment Centers for Epilepsy

SURGERY FOR EPILEPSY

Some people with epilepsy continue to have seizures despite excellent medical management. In selected patients, surgery may cure or decrease the frequency of these seizures. There are a number of types of surgery that can be performed depending on where the seizures come from in the brain, and the importance of that area of the brain for normal function. The types of surgery chosen may range from removal of a small area of the brain which is abnormal and causing seizures; to removal of a lobe of the brain, such as the temporal lobe or frontal lobe; to removal of half of the brain (hemispherectomy). For some types of seizures, which are not coming from a single area of the brain, cutting the connections of the brain (commissurotomy or corpus callosotomy) may be performed.

To decide if surgery is either possible or potentially useful, and what type of surgery should be done, requires careful evaluation by a highly specialized an[d] experienced team of neurologist[s] and neurosurgeons who are epilepsy specialists. Although most neurosurgeons commonly remove brain tumors, vascular malformations, or other problems which may be associated with seizures, far fewer surgeons or centers are capable of the extensive evaluation of the person whose sole problem is seizures which do not respond to anticonvulsant medications.

An evaluation may include prolonged EEG (brainwave) recordings and simultaneous monitoring of the seizures by television, so that the seizures can be properly classified and their origin identified. Further evaluation may include implantation of electrodes (wires) within the brain or on its surface prior to deciding about surgery. CT scans, MRI scans, and even PET scans may also play an important role in deciding about the possibility and type of seizure surgery. Extensive psychological and neuropsychological testing may also be needed. It is

important to be aware that this testing is costly and cannot always result in surgery; a complete evaluation may reveal factors that rule out surgery for the patient. The risks and potential benefits of surgery should be based on careful evaluation of these studies by the epilepsy team, and discussed with the patient and the family. All of this must be done before the surgery is undertaken!

When you are selecting a center regarding an evaluation for epilepsy or for the epilepsy surgery itself, there are certain questions you should ask:

- What type of surgical procedure does the facility perform?
- How many times a year do they perform this surgical procedure?
- What has been their success rate?
- What is the cost?
- Do they assist you in finding financial assistance?
- Is their facility and location accessible to you?
- Do they provide patient education, and assist patients and families with problems which may be related to surgery?
- Do they assist with epilepsy rehabilitation (vocational, educational, psychological)?

In deciding whether or not to undergo surgery, the patient should discuss the risks and benefits with the physician and surgeon. Risks vary with the type and extent of surgery, and may include weakness, paralysis or stroke, infection, and changes in memory.

There are an increasing number of centers with the capability to undertake these studies and perform epilepsy surgery. **The Epilepsy Foundation does not have the ability to evaluate the strengths and weaknesses of each center, and cannot guarantee the quality of services provided.** We are enclosing a list of centers, which have reported to us that they provide surgical services for person[s] with epilepsy. This list is not all inclusive, but only represents those services about which we have information, and it should not be considered an endorse-

ment of any of the centers enclosed herein. It is important that you consult with your physician on the advisability of your pursuing the option of surgery. You and your physician may wish to contact one or more of the facilities listed to see if they meet your needs.

Clinics and Hospitals that have Surgical Services for Persons with Epilepsy (Organized Alphabetically by State)

UAB Epilepsy Center
University of Alabama Hospital
Jefferson Tower 1235
Birmingham, AL 35294-0007
(202) 934-3866
Contact: Edward Faught, MD

**Scripps Clinic &
Research Foundation**
10666 N. Torrey Pines Rd
La Jolla, CA 92037
(619) 554-8894
Contact: Maung H. Aung, MD

Loma Linda University
Comprehensive Epilepsy Center
Dept. of Neurology
11175 Campus St.
Loma Linda, CA 92354
(909) 824-4907
Contact: Carmel Armon, MD

**Epilepsy & Brain
Mapping Center**
1245 Wilshire Blvd., #810
Los Angeles, CA 90017
(800) 621-2102 or
(626) 792-7300
Contact: Michel F. Levesque, MD

**Comprehensive
Epilepsy Program**
West Los Angeles VA
Medical Ctr.
Wilshire & Sawtelle Blvds.,
Room 3405
Los Angeles, CA 90073
Contact:
Dr. A.V. Delgado-Escueta/
Susan Pietsch (310) 824-4303
Elaine Modiest (310) 319-4533

University of California
At Los Angeles (UCLA)
Department of Neurology
Room 1250
Reed Neurological
Research Center
710 Westwood Plaza
Los Angeles, CA 90095-1769
(310) 825-5745
Contact:
Jerome Engel Jr., MD, Ph.D.

University of California
Irvine Medical Center
101 City Drive South
Orange, CA 92868-7910
(714) 456-6011

Northern CA Comprehensive
Epilepsy Center
400 Parnassus Ave., Room A889
Box 0138
San Francisco, CA 94143-0138
(415) 476-6337
Contact:
Dr. Kenneth D. Laxer, Director
Ms. Bonnie Becker

Stanford Comprehensive Epilepsy Ctr.
Dept. of Neurology & Neurol. Sciences
Room H3160
Stanford, CA 94305
(650) 725-6648
Contact: Michael Risinger/ Mimi Callanan, RN, MSW

Santa Monica Hospital Medical Ctr.
1250 Sixteenth Street
Santa Monica, CA 90404
(310) 319-4472
Contact: Ms. Shelley Snyder

Yale Epilepsy Surgery Program
333 Cedar Street
New Haven, CT 06520
(203) 785-2808
Contact: Dennis Spencer, MD

The George Washington Neurol. Inst.
2150 Pennsylvania Ave., NW
Suite 7-235
Washington, DC 20037
(202) 994-8496
Contact: Ann Robey, RN

Emory University Hospital
The Emory Clinic
1365 Clifton Rd., NE
Atlanta, GA 30322
(404) 778-5000
Contact: Roy A. E. Bakay, MD

Medical College of GA Epilepsy Program
1120 15th Street
Augusta, GA 30912-2363
(706) 721-4626
Contact: Lynd Adair, Patient Care Coord.

Division of Epilepsy Services
Dept. of Neurology
University of IA
Hospitals & Clinics
200 Hawkins Dr., #2007 RCP
Iowa City, IA 52242
(319) 356-8756

Rush Epilepsy Center
Rush Presbyterian
St. Lukes Med. Ctr.
1653 W. Congress Parkway
Chicago, IL 60612
(312) 942-5939
Contact: Dr. F. Morrell/ Jan Buelow, RN

Beth Israel Hospital Comprehensive Epilepsy Center
330 Brookline Avenue
Boston, MA 02215
(617) 735-3375
Contact: Howard Blume, MD

Maryland Epilepsy Center
University of Maryland Med. Ctr.
22 South Greene Street
Baltimore, MD 21201
(410) 328-6266
Contact: Edie Brooks, RN

Appendix 2—Surgery and Treatment Centers for Epilepsy

Epilepsy Center
John Hopkins Hospital
600 N. Wolfe Street
Baltimore, MD 21287
Contact: Diana Pillas
(410) 955-9100 Pediatric/
Pam Sanders (410) 955-4835/
Patty Preston (410) 955-2822

Children's Hospital of Michigan
3901 Beaubien Blvd
Detroit, MI 48201
(313) 745-5785
Contact:
Charise L. Valentine, MD

MINCEP Epilepsy Care, P.A.
5775 Wayzata Blvd., Suite 255
Minneapolis, MN 55416
(612) 525-2400
Contact: Jan LeMoine

Mayo Clinic – Rochester
200 First Street, SW
Rochester, MN 55905
(507) 284-4037

The Minnesota Epilepsy Group
310 N. Smith Avenue, Suite 300
St. Paul, MN 55102
(651) 220-5290
Contact: Rita Meyer

Washington Univ. School of Medicine
Dept. of Neurological Surgery
Epilepsy Center
660 S. Euclid
Campus Box 8057
St. Louis, MO 63110
(314) 362-3457
Contact: Daniel L. Silbergeld, MD

Duke Epilepsy Center
Duke Univ. Medical Ctr.
Box 3678
Durham, NC 27710
(919) 681-3448
Contact: Rodney A. Radtke, MD

Dartmouth Epilepsy Program
Dartmouth-Hitchcock
Medical Center
One Medical Center Drive
Lebanon, NH 03756
(603) 650-8309
Contact: Peter D. Williamson, MD

Long Island Jewish Medical Center
270-05 76th Avenue
New Hyde Park, NY 11040
(718) 470-7312
Contact: Joanne Loughlin, RN

Comprehensive Epilepsy Center
NYU – Mount Sinai
560 First Avenue
New York, NY 10016
(212) 263-8871
Contact: Orrin Devinsky, MD

Columbia Comprehensive Epilepsy Ctr.
Neurological Institute
Columbia-Presbyterian
Medical Ctr.
710 W. 168th Street
New York, NY 10032
(212) 305-1742
Contact: Office Staff

The Epilepsy Treatment Ctr.
At University of
Cincinnati Hospital
Aring Neurology
222 Piedmont Ave, Suite 3200
Cincinnati, OH 45219
(513) 475-8730

The Cleveland Clinic Foundation
9500 Euclid Avenue
Cleveland, OH 44195-5167
(216) 444-6236
1-800-440-4140
Contact: Harold H. Morris, III, MD

Comprehensive Epilepsy Center
Medical College of Ohio
3000 Arlington
Toledo, OH 43699-0008
(419) 381-3451
Contact: Mark Rayport, MD

Oregon Comprehensive Epilepsy Program
Good Samaritan Hospital & Med. Ctr.
1040 NW 22nd Avenue, Suite 400B
Portland, OR 97210
(503) 413-7241
Contact: Greta Bouwman

Mid-Atlantic Regional Epilepsy Center
3200 Henry Avenue
Philadelphia, PA 19129
(215) 842-4500
Contact: Karen Coughlin

Graduate Hospital Neurological Center
1 Graduate Place
Philadelphia, PA 19146
(215) 893-2322
Contact: Gary Romano, MD

University of Pittsburgh Epilepsy Ctr.
Room 625 Medical Center Building
3515 Fifth Ave.
Pittsburgh, PA 15213
(412) 383-8916
Contact: Dr. Dasheiff

Epicare Center
930 Madison Avenue, Suite 600
Memphis, TN 38103
(901) 522-7700 or
(800) 727-0761
Contact: Kevin Foley, MD

The Vanderbilt Clinic Epilepsy Program
2100 Pierce Avenue
Nashville, TN 37212
(615) 936-0600
Contact: Bassel Abou-Khalil, MD

The Center for Epilepsy Treatment
Medical City Dallas Hospital
7777 Forest Lane, Suite A-415
Dallas, TX 75230
(972) 566-7411 or
1-800-638-7328
Contact: Cheryl Ault, RN, PA-C

APPENDIX 2—SURGERY AND TREATMENT CENTERS FOR EPILEPSY

MCV Comprehensive Epilepsy Institute
Medical College of Virginia of Commonwealth
Virginia Commonwealth University
Randolph Minor Hall
307 College St., 7th Floor
Richmond, VA 23219
(804) 828-0442
Contact: John M. Pellock, M.D.

University of Washington.
Epilepsy Center
Harborview Hospital ZA-50
Seattle, WA 98104
(206) 731-3000
Contact: Ms. Gail Greenwood

Swedish Hospital Epilepsy Ctr
747 Broadway
Seattle, WA 98122
(206) 386-3880 or
1-800-331-7533
Contact: Dawn Colello

University of Wisconsin
Comprehensive Epilepsy Program
CSC H4/612
600 Highland Avenue
Madison, WI 53792-6172
(608) 263-9578
Contact: Melissa M. Maly, RN

CANADA

Montreal Neurological Institute & Hospital
3801 University
Montreal, Quebec
H3A 2B4 Canada
(514) 739-5419 or
398-1976 (leave message)
Contact:
Frederick Andermann, MD

Glossary of Terms Related to Epilepsy and Epilepsy Brain Surgery

Cartoon by Mary Rich

Glossary

angiogram (WADA Test)—a test that shows which side of the brain is dominant for speech and how good memory function is in each temporal lobe. (Cleveland Clinic, *Pre-surgical evaluation information sheet*, p.1

anticonvulsant— "a drug that prevents or reduces the severity and frequency of seizures (convulsions) in various types of epilepsy" (*The Bantam Medical Dictionary*, p. 26)

aura— "an unusual sensation that warns the person who has it [epilepsy] that a major seizure is about to begin" (Epilepsy Foundation of America, *Questions and Answers about Epilepsy*, p. 5)

CAT scan (computerized axial tomography)— "the use of an x-ray transmitter, a series of detectors, and a computer to produce cross-sectional images of the skull and brain" (Cleveland Clinic, *Epilepsy Manual*, p. 6)

complex partial (temporal lobe or psychomotor seizures)— "distinguished from simple partial seizures by alteration in consciousness. The changed mental state is often preceded by an unusual feeling or warning called an aura and followed by semi-intentional movements and altered consciousness. During the seizures, which last one or two minutes, speech and other mental function may also be affected. Afterwards, drowsiness, confusion and lack of recall of the seizure are common." (Cleveland Clinic, *Epilepsy Manual*, p. 2)

convulsion— "an involuntary contraction of the muscles producing contortion of the body and limbs" (*The Bantam Medical Dictionary*, p. 103)

EEG (electroencephalogram)— "This is a harmless, 60 to 90 minute test that charts the electrical activity of the brain through a series of scalp electrodes. To induce certain abnormalities, the patient may be stimulated with light (photic stimulation) or asked to hyperventilate." (Cleveland Clinic, *Epilepsy Manual*, p. 5)

epilepsy— "the condition of having recurrent seizures" (Cleveland Clinic, *Epilepsy Manual*, p. 1)

grand mal seizure or generalized seizure— [seizures that occur] "when the electrical disturbance sweeps through the whole brain at once, causing loss of consciousness, falls, convulsions, or massive muscle spasms" (Epilepsy Foundation of America, *All about Partial Seizures*, p. 2)

hippocampus— part of the brain that plays a role in long-term memory and is connected to the amygdala. There is one hippocampus on each side of the brain.

Ketogenic diet— a diet high in fats and low in proteins and carbohydrates, which results in ketosis, "a factor believed to be partly responsible for a raised seizure threshold." (*Epilepsy A to Z, A Glossary of Epilepsy Terminology*, p. 160)

MRI— "Magnetic Resonance Imaging (MRI) scans take pictures of the inside of the brain. MRI scans may show tumors, abnormal blood vessels, cysts, and areas of brain cell loss or other brain damage." (Epilepsy Foundation of America, Surgery for Epilepsy, p. 4)

PET Scan— "Positron emission tomography (PET) scans measure how intensely different parts of the brain use up glucose, oxygen, and other substances. PET scans may be used in certain cases to help identify where seizures are taking place." (Epilepsy Foundation of America, *Surgery for Epilepsy*, p. 5)

psychomotor seizures— (see *complex partial seizures*)

seizure— "an epileptic seizure is a sudden, yet temporary, alteration of behavior due to an abnormally large electrical discharge within the brain" (Cleveland Clinic, *Epilepsy Manual*, p. 2)

simple partial (focal motor-seizures)— seizures in which consciousness is not affected and the symptoms, such as jerking in one of the limbs, are related to the area of the brain involved (Cleveland Clinic, *Epilepsy Manual*, p. 2)

REFERENCES

A Gift for Mother with Addresses. Downwood, England: The Victorian Collection. Printed and bound in Singapore by Star Standard Industries, 1995.

The Department of Neurology, Epilepsy Unit, Cleveland Clinic Foundation. *Epilepsy Manual*. Cleveland: Cleveland Clinic. n.d.

The Editors of Market House Books Ltd. *The Bantam Medical Dictionary*. 2nd ed. New York: Bantam Books, 1994.

Epilepsy Foundation of America. *All about Partial Seizures*. Landover, MD: Epilepsy Foundation of America, 1998.

Epilepsy Foundation of America. *Questions and Answers about Epilepsy*. Landover, MD: Epilepsy Foundation of America, 1987.

Epilepsy Foundation of America. *Surgery for Epilepsy*. Landover, MD: Epilepsy Foundation of America, 1998.

"Famous People with Epilepsy." Database title. Online.

http://www.floridaepilepsy.org/famous.htm. 5/18/99

"Famous People with Epilepsy." Database title. Online. http://www.iainmacn.mcmail.com/epilepsy/famous.htm. 5/18/99.

Kaplen, Peter W., et al. *Epilepsy A to Z: A Glossary of Epilepsy Terminology*. New York: Demos Vermande, 1995.

KSF Group Publication. *+Feedback: Making Life with Epilepsy More Fulfilling*. Vol. 4, no.1, Winter 1992.

Murphy, D., R.N. *Pre-surgical evaluation information sheet.* Cleveland: Cleveland Clinic, 1991.

Richard, Adrienne & Reiter, Joel, M.D. *Epilepsy: A New Approach.* New York: Walker and Company, 1995.

Order Form

To receive additional copies of *Rejoice in the Light*, please send a check or money order addressed to the following:

Agape Publishing
P.O. Box 4203
Greenville, South Carolina 29608

Price per book: $21.95

Price includes postage.

Please add 5% state tax for books shipped to South Carolina addresses.

Number of copies of *Rejoice in the Light*: _____

Total: $ _____

Name: _____

Street Address: _____

City: _____

State: _____ Zip Code: _____

Telephone: (_____) _____

E-mail address: _____